The Cultural Leadership Handbook

The Cultural Leadership Handbook

How to Run a Creative Organization

ROBERT HEWISON and JOHN HOLDEN

GOWER

Gower Applied Business Research
Our programme provides leaders, practitioners, scholars and researchers with thought provoking, cutting edge books that combine conceptual insights, interdisciplinary rigour and practical relevance in key areas of business and management.

Published by
Gower Publishing Limited
Wey Court East
Union Road
Farnham
Surrey, GU9 7PT
England

Ashgate Publishing Company
Suite 420
101 Cherry Street
Burlington,
VT 05401-4405
USA

www.gowerpublishing.com

British Library Cataloguing in Publication Data
Hewison, Robert, 1943-
The cultural leadership handbook : how to run a creative organization.
 1. Arts--Management. 2. Cultural industries--Management.
 I. Title II. Holden, John, 1954-
 700.6'8-dc22

ISBN: 978-0-566-09176-6 (hbk)
ISBN: 978-0-566-09177-3 (ebk)

Library of Congress Cataloging-in-Publication Data
Hewison, Robert, 1943-
The cultural leadership handbook : how to run a creative organization / Robert Hewison and John Holden.
 p. cm.
Includes bibliographical references and index.
ISBN 978-0-566-09176-6 (hardback) -- ISBN 978-0-566-09177-3
(ebook) 1. Leadership. 2. Creative ability. 3. Information technology--Social aspects. 4. Culture and globalization. I. Holden, John,
1954- II. Title.
HD57.7.H495 2011
658.4'092--dc22

2011009093

MIX
Paper from
responsible sources
FSC® C018575
www.fsc.org

Printed and bound in Great Britain by the
MPG Books Group, UK

Contents

List of Figures

List of Tables

Introduction

One of the most misleading terms applied to organizations that operate in the cultural sector is that they are 'not-for-profit'. An organization that failed financially would not last very long, yet too often what is meant by 'not-for-profit' is 'expecting-to-make-a-loss'. The losses are made up by public subsidy, private generosity, or people working for next to nothing because they believe so strongly in what they do. We don't want people who work in culture and the arts to make a loss. We want to them to create a success.

What 'not-for-profit' really means is 'not-profit-*distributing*', where the profits that are made are ploughed back into the organization in order to sustain and develop its creative activity. It is the result of that creativity – performances, exhibitions, individual works of art and all the different ways in which a cultural organization gives pleasure and encouragement to its audiences and visitors – which is the true profit. The more that activity can be financially self-sustaining the better – and achieving that is the ultimate aim of *The Cultural Leadership Handbook*.

The economics of the arts mean that external help is often needed, and we show how to get it, but the 'not-for-profit' label is a discouragement to entrepreneurialism. Entrepreneurs turn good ideas into good businesses. Entrepreneurs are innovators, and that means taking risks. Good artists take risks all the time. This book is intended for anyone wanting to work, or already working, anywhere in the cultural sector, anywhere in the world. Its aim is to give you the edge that will enable to you to show creative leadership at any level in a cultural organization, regardless of whether your particular interest is the performing arts, museums and art galleries, heritage, publishing, films, broadcasting or new media.

Culture in the 21st century is in a new situation, and has a different meaning and significance. Creative and cultural relationships have changed, and that calls for new skills, new ways of working and new organizational forms. It calls for the cultural entrepreneur to rebalance that combination of different sources of funding and ways of earning a living known as 'the mixed economy'. Except for a lucky few, there is very little training available in cultural leadership, and there are no structures to support those who become leaders, and who more often than not find it very lonely at the top. The need for support is all the more urgent as one of the principal props of cultural life – national and local government encouragement and involvement in culture as a vital part of the public realm – is weakening, at least in the Western world. Those who believe in the value of the arts and heritage will need even deeper personal resources and even greater self-confidence. *The Cultural Leadership Handbook* sets out to build the personal capital that you will need.

So this book is not just about how to be a capable arts administrator; it is about how to use your creative talents to become a cultural entrepreneur. It is about making 'not-for-profit' turn a true profit, which is the Cultural Value that you generate.

Because the conditions in which people in the cultural sector have to work are always challenging – and they are even more challenging at this moment – our book is not written as chapters, but 'Challenges'.

A challenge is a test, and throughout this book we offer ways of testing your knowledge, your aspirations, and your experience against the situations we describe. We mainly use case studies and draw on resources in the United Kingdom because that is where we are based, and where we get our experience from, but the principles we discuss and demonstrate can be applied anywhere in the developed world. At the end of each challenge we ask you to engage with a longer case study, where there is an opportunity to bring together the themes that we have been focusing on.

Nowhere do we try to give you the 'right' answer, because there are no single answers, only good judgements. But in each challenge we do offer a 'toolbox' to deal with the issues that have been discussed. Some of these tools will be techniques, some will be useful ways to approach a problem, and others will be simply ways to behave in certain situations. At the end of each challenge, after a summary, there is a section giving details of resources and reading materials that you might like to follow up. There is also a full bibliography to help you track down sources.

Challenge 1 has to be the new, post-world-recession conditions in which people working in the field of culture find themselves. The challenge to them is to know themselves, their motives, and their values. Challenges 2 and 3 are all about understanding how leadership works, the different ways of doing things, and knowing what motivates you. Not surprisingly, since two people have written this book, we argue that creativity depends on collaboration, and that there is a way to demonstrate the expressive, the social and the economic worth of what you do through the concept of Cultural Value. Being creative is in itself a challenge, so in Challenge 5 we discuss the creative process, emphasizing the importance of collaborative leadership within a cultural organization.

Creativity, however, does not come out of thin air. It is a challenge to find the resources (Challenge 6) that you will need, in terms of both people and money, and there is a whole set of skills (Challenge 7) that you will need to be able to apply to turn the idea of being a creative leader into practical results. At the end of the book (Challenge 8), we draw our argument together into a scorecard where a creative leader can check the performance of their organization against the ideas that we have presented.

There is no more important time than now to read this book. The arts and heritage play a vital part in keeping economies going and also, more importantly, in making life worth living. As the 21st century shapes up, it seems that governments are retreating from their responsibility to ensure that we enjoy the collective benefits of civilization, rather than merely endure the minimum terms offered by society. It needs creative leadership to fill the gap that is opening up.

Robert Hewison and John Holden, June 2011.

1 Challenge: Context

'There is no wealth but life.'

John Ruskin

1.1 INTRODUCTION

The first challenge that faces any kind of leader is to understand the territory in which they will have to operate. For you, the challenge is to make sense of the new context in which the cultural sector will operate following a deep economic recession. You also need to understand how technology and the forces of globalization have reshaped the cultural landscape and, indeed, have changed the meaning of the word 'culture'. These changes call for a new approach to building and running organizations, and a creative approach to cultural leadership itself.

1.2 IT'S A NEW AGE …

This book has been written as the economies of most developed countries try to recover from the worst economic recession the world has experienced since the 1930s. That may seem an odd way to start a book on cultural leadership, but recession affects everybody, and has already begun to change the cultural economy: individuals have less money to spend on cultural activities; private donors and foundations that help to fund culture have less money to give because their investments have shrunk and their incomes are down; local and national governments are having to reduce their spending in order to lower their debts – they want to concentrate their resources on what they regard as 'essential' areas of responsibility. By and large, culture is not one of them.

The recession that struck the Western economies in 2008–9 exposed the weaknesses of different cultural economies in different ways. In the United States, where national and individual state funding for culture is weak in relation to private-sector donations and sponsorship, the over-reliance on corporate and foundation giving was exposed when these funds suddenly started to dry up. In Britain – and even more in continental Europe – corporations, trusts and foundations, and individual donors play a smaller role, so cultural organizations have relied more on public subsidy in one form or another. But the good times are over as far as generous government support is concerned. In the United Kingdom what has been called 'a Golden Age' in terms of government funding for the arts came to an end in 2010, as the economic crisis forced central government to start cutting its support for cultural activities.

In October 2010 it was announced that over a four-year period the relatively tiny amount the government spent on culture (less than 0.5 per cent of total government expenditure) would be cut by 24 per cent. This did not simply mean that there would be less money available to subsidize cultural activities. A number of intermediary bodies, who decided on behalf of the government where these subsidies should go, were abolished, and the government's own ministry for culture, the Department for Media, Culture and Sport (DCMS), would be halved in size. Central government support for local government was also cut, which in turn badly affected local authority cultural budgets. All the indications were that the government not only wanted to spend less money on culture, it wanted to reduce its involvement in culture as a whole: it wanted to shrink the size of the cultural state.

As in other parts of the economy (and this applies to all countries where neo-liberal economic theories are popular) the idea was that if the public sector got smaller, the private sector would take up the space vacated by the state. That is why we present this new cultural context as the first challenge to a creative leader. In both the public and the private sector, the cultural economy is changing, and whatever part of the arts or heritage that you choose to work in – museums, the performing arts, digital media – it is clear that you are going to have to adopt different strategies. Right across the developed world, leaders are going to have to find new ways of working, and new ways of financing their projects and programmes. Above all, they are going to have to be more reliant on their own efforts: whether they choose to work within or outside a smaller public sector, they are going to have to think of themselves not as managers or administrators, but as entrepreneurs.

1.3 ... WITH A NEW WAY OF DOING THINGS

Although the financial crisis that started with problems in the financial sector in 2007 has created the immediate context in which you can expect to have to work, long-term technological and social, as well as economic, change has radically altered the framework within which culture is made and enjoyed. As we will argue a little later, this has changed the nature and meaning of culture itself. If we had been writing this book a decade ago, the task would have been a lot simpler. Most leaders in the cultural sector would have been in charge of either a not-for-profit organization such as a charitable company limited by guarantee, or working with a cultural organization such as a museum that was run by local or national government. The funding for those organizations would have come mainly from public sources – in the United Kingdom, public money distributed through the Arts Councils and local authorities – with a bit of corporate sponsorship thrown in for good measure. 'Marketing' would have meant selling tickets and striving to find 'new audiences'; 'education' (not, as it is now called, 'learning') would have been about working with schools. The meaning of such words as 'art', 'culture', 'expert', and indeed 'leader' would have been more settled.

Looking at the big picture, what has changed and disrupted all this is the process known as globalization. Although this process is very uneven, globalization is producing a single world economy – which is why the recession has affected most of the Western developed world and slowed growth elsewhere. Technology has played a powerful part in bringing the world together, because modern communications compress both time and space. Things happen more quickly, and in several places at once. National barriers are broken down, so that money, people and, above all, ideas move more and more freely. There are advantages and disadvantages to this. On the downside, rich countries with powerful business corporations, such as the United States, can create and dominate a global market for their cultural products, for example Hollywood cinema. On the upside, local cultural movements, such as the music of Mali, can, in the right conditions, become appreciated and profitable worldwide. It is true there are some global brands that can crush local enterprise, but when it comes to culture there doesn't seem to be the loss of diversity that people fear. Diversity is essential for creativity, it generates the mixing and changing that takes place along the borders where different ideas meet. Modern technology allows those encounters to happen more easily and more widely.

Digitization, the internet, ever-greater computer power and ever-smaller miniaturization, as well as faster and cleverer forms of data transmission, are having a transformational effect. But these technologies do not

transport *things*, which have to travel by container ship; instead, they communicate *ideas*. As the amount of raw data increases exponentially, so the demand increases for the human brainpower that can turn information into knowledge. This capacity is what turns data into experience, creates explanatory narratives, and generates the symbols we use to make sense of the world. Artists are good at doing that.

Technology has not only made it possible for many more people to express themselves, in words, music and images, and exchange these self-expressions easily and anywhere through the new social media. It has also made those who are particularly good at expressing their experience and generating new ideas from them more valued by more interests than ever before. In a world economy where the emphasis has shifted from the manufacture and distribution of mere objects to the manufacture and distribution of objects that have symbolic power, this ability to generate such symbols – through the aesthetics of design and the creativity of storytelling – carries an ever-higher premium.

That is why the 'arts' – which once were thought to be valuable only for their own sake, just as organic 'culture' was the opposite of mechanical 'industry' – are now treated as the drivers of the 'creative and cultural industries'. These industries produce all sorts of consumer goods – both the means and content of entertainment, fashion and design – and the culturally rich forms of communication such as advertising. Over the past decade these industries grew at a much faster rate than the rest of the economy, and there is no reason to think, as the service economy steadily replaces manufacturing in mature economies, that they will not play an important part in rebooting production and consumption in the aftermath of the recession.

Consumption has become a form of self-expression: you are not only what you eat, but what you wear, what you do, where you go, what you like. Cultural consumption has always been partly to do with one's sense of identity and social status, but cultural goods also have emotional, even moral, value. That means that artists – that is to say, creative people – who have always been in the business of producing and reproducing symbolic value in the shape of words and images, moral messages and personal feelings, have the opportunity to play a bigger part in this new economy, without changing the essence of what they do – though they may change the way in which they do it.

The technological developments that make the cultural industries possible have affected culture itself. As we will show in more detail shortly, the lower entry-costs to self-expression have reshaped the way culture is made and

managed. It has generated new possibilities for creativity, and it has made possible new forms of cultural exchange. As is the case for everyone else, it is much easier to get your message across – so the competition is fiercer – but the compression of time and space means that you can create virtual 'communities of interest' in specialisms and niche markets. It is also easier to turn your creativity into an enterprise: commercial operations such as accounting and marketing have become cheaper and much more efficient. But the ease with which information can be transmitted and exchanged also raises problems: creativity generates Intellectual Property, and you will need to know how and when to protect your copyright – and when it is in fact more productive to give it away. Creativity, as we will argue in Challenge 5, depends on collaboration, and the new communication technologies make not just local, but global collaboration ever easier.

The creative entrepreneur therefore faces a cultural context that is full of possibilities – and uncertainties. The recent economic crisis has shown that globalization creates its own problems, and we cannot count on permanent progress and expansion. Previously monolithic, hierarchical structures of production and distribution have been hollowed out into lots of different units. The new economic model is the network, where there are nodal points, or hubs, of power, but no centre, and no edge, and a mutual dependence that means that an organization or an individual's strength depends less on their own skills and financial clout, and more on their ability to make and manage a multiplicity of connections with others. Above all, a cultural context and economy that might once have seemed linear, even fixed, is becoming more freewheeling and fluid. As the Dutch cultural theorist Bert Mulder has written:

> We move from hierarchies to networks, from static to dynamic, from products to process, from events to flows, from solid to fluid, from being to becoming, from explicit order to implicit order, from predictable order to unfolding order. (Mulder 1998: 46)

The creative entrepreneur must be ready to go with this flow. One of the first things to be understood in this new cultural context is the way that the very word 'culture' has reshaped its own meaning.

Exercise

Make a list of your ten favourite cultural artefacts – they may be books, paintings, music, films, etc. Note their country of origin, and in what form you are able to enjoy them, using what technology. Are there links between them?

9

1.4 'CULTURE' AND ITS NEW MEANINGS

Throughout this book we use the terms 'culture', 'the arts' and 'heritage' interchangeably. Though comfortable enough to use in practice, these words are nonetheless difficult to define. The critic Raymond Williams wrote that culture was 'one of the two or three most complicated words in the English Language' (Williams 1983: 87).

Originally, the word was associated with the idea of growing things (remember, yoghurt is a culture). Culture meant cultivation, but gradually the idea was transferred from growing things in the ground to growing the power of one's mind, from cultivating the soil to cultivating the soul. It is this moral, as opposed to practical, dimension which makes dealing with culture different in terms of public policy. It is assumed that culture will be good for you, but there has always been a fear that culture can do you harm: it can give too much pleasure, or introduce ideas and emotions of which the controllers of society do not approve. That is why states have always censored culture, at the same time as promoting those aspects of culture that reinforced their power.

By the mid-20th century, 'culture' was principally used in two senses, and many people still think of culture in this way. On the one hand it meant 'the arts' – and the arts were an established set of art forms: opera, ballet, poetry, novels, painting, sculpture, music and drama, whose leading works constituted a hardly changing canon of regularly presented or referred to works, and including, by extension, the places such as historic buildings, museums and art galleries that housed them. These art forms each contained their own hierarchies of what was considered 'better', and they tended to be enjoyed by only a small part of society, one that generally speaking was well educated and well off – the richest of them actually owning some of the stuff. This group defined its own social standing not just through power, money and education, but through the very act of appreciating the things that they had been brought up to enjoy. Since they had social power and status, they had cultural power and influence, too, so that cultural consumption and social status became synonymous, causing the aptly named 'high' arts to be labelled as elitist.

But culture also had a different meaning, an anthropological meaning that extended well beyond the arts to include everything that we did to express and understand ourselves, from gardening to football to dancing to watching television – almost everything, in fact, that we did when we were not working, and even then different kinds of work were said to have their different 'cultures'.

Culture, in this meaning, is the way that we have made sense of ourselves; it can be seen as a form of symbolic language that a group of people – from a single family to an entire race – uses to express its most deeply felt prejudices, values and beliefs. In this sense, different nations, communities, classes and faith groups can be said to have internally consistent cultures – features that they share to a significant degree, and that define them in their own and others' eyes. The symbols used in this unspoken language can be as obvious as a flag, or as subtle as the way you cook and serve a meal. Everyone enjoys stories, pictures and music of some kind, and so art and activities of all types and quality are contained within this definition. Culture is what makes different places distinctive.

The two different meanings attached to culture – the narrowly artistic and the broadly anthropological – have led, however, to much confusion because the social values attached to them have become essentially contradictory. As we explained, culture in the sense of the 'high' arts has historically been associated with social and economic power, and the arts themselves have been used to denote exclusivity. Culture in the anthropological sense, especially when understood to mean 'popular culture', has mass appeal, but has been regarded by those with social power as inferior. Whatever your own social status might have been, one form of culture was high, the other low; one refined, one debased. As an individual, you could aspire to high culture, but by definition, high culture could never be adopted by the mass – if everyone adopted it, it would no longer be high culture. Hence the contradiction.

1.5 'CULTURE': THE NEW REALITY

It is, of course, a big generalization, but the old model of culture has been an either/or model. Now there is a new reality. And that means abandoning the old ideas about culture as a set of oppositional binaries of high/low, refined/ debased and elitist/popular. The new reality demands a different way of looking at what culture means, and hence new ways of looking at the value of the arts and culture. It also has implications for organizations and leadership: with culture in flux, new organizational forms are likely to emerge, with a consequent demand for new skills and knowledge, and above all an adaptive approach on the part of leaders.

Commercial

Publicly funded Home-made

Figure 1.1 The three spheres of culture

For practical purposes, there are now three spheres of culture: publicly funded culture, commercial culture and homemade culture. They are not separate or oppositional, they are completely interlinked, but they are still different from each other in important ways.

Publicly funded culture – that is, cultural activity that is funded by public institutions, local authorities or the state – is not defined through theory but by practice. What these public institutions fund becomes 'Culture'. This pragmatic approach has allowed an expansion of what culture, in this sense, means: it has now expanded beyond the original scope of funding museums and the high arts to include things like circus, puppetry and street art. Who makes these decisions about what to fund, and hence what to define as this type of culture, is therefore a matter of considerable public interest. Official responses to the cultural activities of different community, social, ethnic and faith groups have important implications for the definition of what central or local government sees as culture.

Commercial culture is equally pragmatically defined: if someone thinks there is a chance that a song or a show will sell, it gets produced; but the consumer is the ultimate arbiter of commercial culture. Success or failure is decided by the market, but access to the market, whether that is for a first novel, a recording or a chance to go on stage, is controlled by a commercial class just as powerful as the bureaucrats of publicly funded culture. So in publicly funded culture and commercial culture there are gatekeepers who define the meaning of culture through their decisions. If you are going to set up and run your own organization, these are the people you are going to have to deal with.

Homemade culture: this extends from the historic objects and activities of folk art through to the postmodern punk garage band and the YouTube upload, and, as we are all finding out, thanks to the new communication technologies that are driving globalization, has the potential to have wide cultural significance and/or commercial success. Here, the definition of what counts as culture is much broader; an informal, self-selecting, peer group defines it, and the barriers to entry are much lower. Knitting a sweater, inventing a new recipe, or writing a song and posting it on YouTube might involve great skill, but can also can be done without much difficulty – the decision about the quality of what is produced then lies in the hands of those who see, hear or taste the finished article – and pass it on to their friends.

It is important to understand this new reality because the three spheres are very much intertwined and networked. In all three of these spheres individuals take on positions as producers and consumers, authors and readers, performers and audiences. Each of us is able to move through different roles with increasing fluidity, creating and updating our identities as we go. Artists travel freely between the funded, commercial and homemade sectors: publicly funded orchestras make commercial recordings that get sold in record shops and exchanged on file-sharing websites; street fashion inspires commercial fashion; and an indie band may get a record deal and then play at a publicly funded music venue. The career path of today's creative leader is certain to cross the old boundaries.

One of the consequences of these changes in what culture means is that debates about quality have altered. The traditional art forms – opera, theatre, ballet, orchestral music, etc. – no longer have an assumed superiority over other cultural forms such as street dance, jazz or rap poetry. Instead of what was thought of as a pyramidal hierarchy of taste, from highbrow to middlebrow to lowbrow, we can think of a 'long front' of culture, with people free to pick and mix according to their individual preferences. Whether we like it or not, this mixed economy is closer to a market place than a temple.

Exercise

Try mapping your own kinds of cultural activity and interests in relation to the three different spheres we have described. What and where are the connections?

1.6 THE NEW REALITY: A CHANGED PATTERN OF WORK

We have already argued that the process of globalization has reshaped the world economy, and reshaped the organizations that operate within it. Globalization – and in particular the emergence of the cultural industries – has placed a new premium on individual creativity. But it has also changed the nature of work. There are more opportunities for self-expression and self-realization, but at the same time there is more casualization and enforced mobility. The market for labour is demanding ever-greater flexibility in working patterns, which leads to greater insecurity. People change their jobs more often, and more are becoming self-employed. Incomes have become unsteady, and for most people the idea of a 'career' as a regular progression up a single organizational ladder has disappeared. It is more like snakes and ladders as we jump from job to job, organization to organization. To survive, people are having to be more creative and adaptable to circumstances. In a sense they are all becoming freelancers. Everyone, not just in the cultural industries, has to behave more like artists.

As for most artists, work has become more project-based. We move from one project to the next, sometimes within an organization, sometimes moving on to another. Each project will require a different kind of team, with people mixing and matching their skills as the project requires. This fluidity is exciting – but also unstable. The risk of failure is transferred from the organization as a whole to the individuals in the project team. That means you will need to know how to calculate and manage risk. Strong interpersonal and collaborative skills will be needed, not just to maintain the creativity of the project, but to ensure your own survival. Above all, you will need to be as versatile as possible, with a range of skills, especially communication skills such as writing and public speaking, that can be applied across a range of occupations. While a manager may be good at controlling an established function or system, someone who thinks with the enterprise of an entrepreneur is more likely to flourish in the new world of work.

Exercise

Make an inventory of your technical and creative skills. Make a list of your skills and think about how you came by them. How do you keep them up-to-date; how do you refresh your creativity? What level have you attained (be honest), and of what do you think you are capable?

1.7 THE NEW REALITY: A CHANGED FORM OF ORGANIZATION

An entrepreneurial attitude will help you survive in a world where organizations are themselves in flux. Organizational cultures used to be built on 'core strengths' – working from the inside to the outside: 'this is what we do/make/provide, so how do we organize ourselves to deliver that product?' Now, organizations and their leaders have to work in the opposite direction. They have to start with the needs of their users and then develop the organizational capacities and systems to meet those needs. The rapid consumption of ideas and images means that it is difficult to set up a long-run production line – and who in the arts except possibly the producers of Broadway and West End musicals *wants* to set up repetitive production lines anyway? – hence the need for flexible, short-term project teams, working as a network, not a hierarchy.

Not so long ago, the leader of an organization was expected to direct operations. But in an unpredictable world that may be of little use, particularly when the best ideas about how to adapt and improve are embedded in the tacit knowledge of front-line staff rather than in the office of the Chief Executive Officer, the CEO – and still less in the boardroom. A critical task for new leaders is to find ways of unlocking and harnessing this knowledge, and of sharing it amongst the whole organization. They will also have to find ways of managing the huge amount of data that is available on everything from how the arts affect health to the neuroscience of aesthetic responses. There is much more information about audiences, and we are able to analyze it and use it in much more subtle ways.

There are also many more ways of not just communicating to audiences and the public, but also of *listening* to people, and entering into dialogue and discussion with them.

Organizations used to look upwards, to the leader, for decisions. In the absence of a decision there was stasis, often flowing from a fruitless search for consensus. But universal agreement is not a precondition for action and, in any case, in a complex world the correct course of action is not always clear. There will be times when an organization needs absolutely decisive leadership in order to know what direction it is to go in, but in the more fluid and flexible structure that a truly creative organization needs, leaders have to recognize that organizational action does not need to flow either in a top-down direction or from mutual consensus: it happens best when people trust each other's expertise, judgement and goodwill.

Trust and goodwill have to be generated outside the organization, as well as within it. It has become easier, and more necessary, to form networks that make it more efficient to outsource some organizational functions, and to form alliances for all sorts of purposes including programming (setting up a network to present new work, such as the UK's Contemporary Music Network) and sharing promotional information such as listings (as is done by the American-based Showup.com). A network operates in a very different way to a closed hierarchy, and leaders need to know how to persuade across a network, as well as lead their own organizations.

Networks make an organization healthily porous, with an easy flow between outside and inside. Because the technology to make art and culture has become cheaper and easier to use, the old distinction between 'amateurs' and 'professionals' is dissolving, as amateurs attain professional standards. People want to learn and to participate more than they used to, and technology makes it much easier for cultural organizations to help people to learn. Just as important, the organization has to be ready to learn from them.

Exercise

Taking the organization you know best, how flexible is it? Does it face outwards, or inwards? How easy is communication across the organization? Does information flow freely?

1.8 MASTERING THE MIXED ECONOMY

Although we began by saying that the principal challenge in the current cultural context is the gradual withdrawal of governments from their role as cultural providers and supporters, the simple fact is that culture lives in a mixed economy, with a delicate and shifting balance between public money, private philanthropy and a cultural organization's own ability to survive commercially. The complex relationship between the three spheres of culture is reflected in the way cultural organizations support themselves. The advantage is that when public funding shrinks, there are nevertheless other sources of investment; indeed, the shortage of public funds can stimulate commercial ingenuity. Conversely, public funding may be ready to take a risk on an unknown quantity that commercial investors would be reluctant to take on. Contemporary conditions make it very difficult to rely on the market alone and, principally because it is generally believed that culture 'does you good', public and private money will still be available to help you. But running a publicly or privately funded cultural organization doesn't

mean that you will raise all your funding from one source. The cultural entrepreneur has to be a master of the mixed economy.

The best way is to earn your own keep – though that may mean making compromises in order to stay popular, and therefore profitable. But every kind of funding involves a trade-off of some kind. A business sponsor will look for a commercially driven return from their sponsorship in the form of publicity for their generosity and a good image for their company. That means they will usually be unwilling to support unfamiliar, experimental and controversial work. A large donation from a private individual may come at the price of what is known in the trade as 'a naming opportunity'. The National Theatre in London has agreed to change the name of its Cottesloe auditorium to the Dorfman in recognition of a £10 million gift from a donor. Trusts and foundations will have an agenda set by the charitable purpose for which they were set up, which may require some ingenuity in meeting their requirements. A 'friends' organization' or other kind of supporters' club is a great way of creating a constituency for your work, and will keep you in touch with your audience and supply you with volunteers, but there are also costs in terms of benefits and privileges for members – and friends' organizations can become distinctly unfriendly when you decide to take the organization in a new direction.

Nor is either state or local government support disinterested. In the United Kingdom the term 'the arm's length principle' is used to describe the proper relationship between the givers and receivers of public funding. It implies that there is a certain distance between the source of the money and the operational use to which it is put. While it is true that distributors of what begins as taxpayers' – or in the case of buyers of National Lottery tickets, punters' – money are constitutionally separate from the government, and that they in turn cannot control every decision made by the cultural organization that receives the money, it is also true that the distance represented by the arms' length has grown progressively shorter. Governments of all persuasions have recognized that culture has economic effects in terms of employment, urban regeneration, attracting foreign tourists and so forth, and that culture also has social effects, in bringing communities together, encouraging a sense of local or national identity, educating people and making them happier. As a result, they have become more and more prescriptive about the economic and social benefits that they expect in return for what used to be called subsidy, and is now called investment.

Since culture does produce economic and social benefits – and we have much more to say about this in Challenge 4 when we suggest a more sophisticated approach to the value of culture – there is no point in trying to ignore

the expectations of public funders, anymore than there would be in not responding to those of commercial or private sponsors. These expectations are part of the cultural context in which today's leaders will have to operate. The skill they have to learn is firstly how to understand these sometime conflicting motives, and then how to manage them.

Exercise

Analyze the sources of funding for the cultural organization you know best. How well balanced is its economy between public, philanthropic and commercial funding? What compromises does it have to make to secure the external funding that it receives?

1.9 AND THE MIXED ECONOMY WILL KEEP ON CHANGING ...

The new cultural context in which you are going to have to operate is a product of the technological, social and economic changes that we have described, and these will have consequences for the next decade at least. The big changes that we have talked about mean that people's needs, aspirations and capacities will evolve and that all organizations, not just in the cultural sector, will have to change in order to serve those needs. Exactly how that will happen is up to you. Because organizations are changing, leadership has to change. The leaders of the future, and the readers of this book, are likely to be impresarios, negotiators, influencers and organizers rather than administrators, commanders or specialists. They will be a species that evolves with its environment, not one that dies out as the world around them changes. They will be leaders modelled not on the past, but able to adapt to – and enjoy – the future.

That is why, having taken the measure of the cultural context, your next challenge is to learn how to conduct yourself as a leader within it.

1.10 TOOLBOX

As you prepare yourself to tackle Challenge 2: Leadership, here are some of the actions, skills and ways of behaving that you will need in order to make the best of the context in which you are going to have to operate:

- Leaders need to be aware of the current context and to anticipate how that context might develop. Keep yourself well informed through the specialist and general press, and subscribe to newsfeeds, newsletters and blogs. Stay abreast of current thinking by attending events and conferences, and ensure your generalist reading includes new thinking in areas that could be relevant to your work.

- Learn to scan the horizon, searching for signals of events that might affect you. Some of these will be predictable, such as the timing of local elections, others less so, such as the development of border controls affecting visiting artists.

- Be adaptable, flexible and ready to think and act outside the traditional limitations of cultural sector structures – what is the *Financial Times* saying about the strength of the euro, and how would that affect your touring plans?

- Leaders need a sophisticated understanding of data – where to find it, how to marshal and organize it, and how to use it. They need to make things happen and to gather their resources more quickly than they used to.

- In a world where the operational context is subject to severe and rapid change, the leader cannot possibly control all the ways in which their organization responds. Because of this, leaders must learn to delegate; they must understand how networks work; and they must build the relationships of trust that enable organizations spontaneously to adapt.

1.11 CASE STUDY

Take the organization you know best, and work out the ways it can best adapt itself to the cultural context that we have described. Is it outward facing or concerned only with its own way of doing things? How flexible is it? How easy would it be to change policy or change direction? What are the strongest outside influences on it? Does it feel like a hierarchy or a network? How balanced is its financial model? In short – just how creative is it really?

1.12 SUMMARY

Over the last ten years a lot has changed: at the macro-level, as a consequence of globalization, the economy, social attitudes, lifestyles and work patterns have all changed; at the level of the sector, new forms of organization and new ways of running them are emerging. Our understanding of what we mean by culture has also changed: there is more hybridity of art forms, and audience behaviour and expectations have changed as a more democratic idea of the relationship between artists, cultural organizations and their audiences has developed. In spite of economic recession, cultural leaders are now faced with a wealth of new opportunities: new audiences, new art forms, new distribution channels; but they also need to find new ways of doing things. Relying on the old ways of bureaucratic management will no longer do. Enterprise will win the prize.

1.13 READING AND RESOURCES

If you are interested in finding out how governments approach questions of cultural policy, David Throsby's *The Economics of Cultural Policy* (Throsby 2010) will take you through all the different aspects that a government has to consider, from the arts in education to urban regeneration. He gives a good description of the development of the cultural and creative industries, and shows how economic considerations are the principal drivers of governments' attitudes to policy. *Staying Ahead: The Economic Performance of the UK's Creative Industries* (Work Foundation 2007), a report by a think-tank called the Work Foundation, is a useful assessment of the state of development of Britain's cultural and creative industries at that date. The big book on globalization and the development of networks is Manuel Castells' *The Rise of the Network Society* (Castells 1996). The think-tank Demos has produced a useful collection of essays, *Network Logic: Who Governs in an Interconnected World?* (McCarthy et al. 2004). And the American academics Nicholas Christakis and James Fowler have written about the power of networks in their book *Connected: The Amazing Power of Social Networks and How They Shape our Lives* (Christakis and Fowler 2009).

All of the broadsheet newspapers carry regular coverage of arts and cultural issues, but in the UK the *Guardian* is probably pre-eminent in its range of printed and online coverage. On Radio 4 there is a programme every week (with its own weekly podcast), *Front Row*, that reports on current issues as well as new shows and performances. In order to expand your range of reference, why not try buying a different serious magazine every week, or month, for a year? There are many to choose from, and they will all tell you something

you didn't know – *The Economist, Monocle, Wired,* the *Art Newspaper* and the *Journal of the Royal Society of Arts* are good places to start.

As you would expect, the internet is alive with news and comment on the arts. Many of the campaigning and professional organizations, such as the National Campaign for the Arts and the Arts Marketing Association, produce regular email updates. One of our favourite news-and-blog sites is Doug McLennan's ArtsJournal. It is based in the USA and covers global news. The world's media is your oyster.

2 Challenge: Leadership

'Good leaders are made, not born.'
US General Colin Powell

2.1 INTRODUCTION

So, the challenge you now have to face is how to adapt both yourself and your organization to rapidly changing times. You and your organization are going to have to rely more on your own resources than on the sort of support that was available in the past from organizations that distributed financial help and advice, such as central government and local government, or charitable trusts and foundations. And if you happen to be working in any of those places, you will know that they too are going to have to adapt to very different circumstances. Everyone working in the cultural sector is going to have to change and become more entrepreneurial. But who is going to deliver this change? The answer is: creative people with the ability to lead.

To meet this challenge we describe the way leadership is thought about and talked about, and the practical skills and the ways of behaving involved, and we also give you a chance to test your own experience against the theoretical concepts. We explore the way power works in an organization, and give a thought to the people leaders too often ignore: their followers. We end by showing how one organization transformed itself by changing its style of leadership.

2.2 WHAT IS LEADERSHIP?

There are as many kinds of leadership as there are leaders, and just about as many books on leadership, too. Leaders are people who know where they want an organization to go, who can communicate that vision to other people, and who are able to influence others to help them fulfil that vision. When we made a study of the way that was done at the Royal Shakespeare Company, we came up with a slightly more elaborate formula. Effective leadership:

> is the ability to marry rhetorical power with practical innovations so as to create a sustainable, resilient, well-networked organization, capable of growing its own capacity to act, and providing high-quality results for its customers, staff and funders. (Hewison et al. 2010: 117)

But before we go any further, ask yourself what it is that someone running a cultural organization – it doesn't matter if that person is called an administrator, a manager, a leader or an entrepreneur – has to know, and what that person has to know how to do.

We suggest that the things you need to *know* are:

- the context in which you and the organization are working;

- how leadership and power work;

- yourself, your strengths and weaknesses;

- how culture contributes to society – what its value is;

- what your values are.

We suggest that the things you need to *know how to do* are:

- how to manage your resources – people, money and hardware – and how to handle governance and regulation;

- how to deliver your vision, how to communicate it, how to listen to other people and how to stay fresh by always learning.

And – as you may have noticed – that is how we have organized this book. Some of the answers to the challenges of cultural leadership lie in knowledge, some in skills and some in behaviours. Challenge 2: Leadership treats anyone

in the cultural sector – administrator, manager, leader or entrepreneur – in the same way. In our view, they all need to know both how to manage and how to lead. They all need knowledge and skills – and they all need to know how their behaviour affects other people, and what other people look for in them.

2.3 LEADERSHIP BEHAVIOUR

In leadership, it is not just what you do; it is the way that you do it. Regardless of what the job is, you need certain personal attributes and to know how to behave in ways that will encourage others to follow. So what do you look for in a leader?

Exercise

Write down a list of the seven most desirable characteristics of a leader. Then check your list against the set of characteristics found below. The American researchers James Kouzes and Barry Posner have been publishing regular surveys that they have conducted since 1987 in North and South America, Europe, Asia, Africa and Australia to establish the dominant characteristics of leaders that the people surveyed most admire. Each person could choose seven out of the following twenty characteristics, and the devisors of the survey then ranked them in order of importance according to the answers they received. The percentages show that most people agree about the top four characteristics, but there is quite a range among the rest.

Check your own selection of the seven most important characteristics of a leader against this list. Then check your own strongest characteristics against the same list.

		The most important seven	Your own strongest seven
Honest	89%		
Forward-Looking	71%		
Inspiring	69%		
Competent	68%		
Intelligent	48%		
Fair-minded	39%		
Straightforward	36%		
Broad-minded	35%		
Supportive	35%		

Dependable	34%		
Cooperative	25%		
Courageous	25%		
Determined	25%		
Caring	22%		
Loyal	18%		
Imaginative	17%		
Ambitious	16%		
Mature	15%		
Self-controlled	10%		
Independent	4%		

Source: Kouzes and Posner 2007

2.4 LEADERSHIP RESPONSIBILITIES

The previous list identifies the way leaders are expected to behave – their moral qualities, if you like. But character is revealed by action: in the way leaders go about fulfilling their responsibilities. But then, what, in general terms, is a leader expected to do? What are the most important tasks they have to think about in relation to the organization?

Exercise

Make a list of at least seven things a leader has to do to lead an organization.

There are a great many things that a leader may have to do, from being first to get to work in the morning, to making the tea, to being last one out at night to lock up, but here are some generally agreed areas of responsibility.

A leader has to:

- make sure the organization knows what its mission is;

- be a figurehead for the organization as a whole;

- in a limited company or a charity, represent the organization to the board of directors;

- represent the organization to external partners, investors, funders and the rest of the world;

- allocate the organization's resources, in terms of money, people and time;

- make sure the organization's structure makes the most of those resources;

- keep an eye on how the organization is performing – in how it is meeting its mission, and how it is managing its money, people and time;

- make sure all members of the organization are able to, and are doing, their best;

- make sure the right people join the organization – and the people who are not right leave it;

- be able to resolve disputes within the organization – personal and professional;

- plan the organization's future.

2.5 LEADERSHIP ROLES

Remember, we are talking about a leader's responsibilities, not their precise functions. Even in the smallest of organizations, there will be people whose job it is to help you make sure these responsibilities are met. But within the overall job of being a leader, it is clear that a leader has to play a number of different roles – roles that echo the personal characteristics that they need in the first place.

A leader has to be:

- an inspirer, to get the organization moving;

- a direction setter – to get it moving in the right direction;

- a communicator – within the organization and to the outside world;

- a problem solver;

- a listener – to the organization and to the world;

• a supporter – of people in the organization;

• and a controller – to make sure the mission is being achieved.

The role of controller has to be played in a number of different ways:

• by delegating – getting someone else to perform the task that needs doing, so as to free you up for other things. Always remember that you can delegate tasks, but you can't delegate responsibility. Being ready to delegate is crucial in generating trust;

• by participating – it is essential to remember that even if you do delegate certain tasks, you are still part of a team, and you will learn more about people and how well they are doing by working alongside them;

• by 'selling' – this is when your communication skills are needed, to convince individuals or the team that your idea is the right one;

• by 'telling' – there will be times when people will have to be told what to do (and when they will want to be told). You will need self-confidence to make sure you do this in the right way;

• by monitoring – by keeping one eye on the organization's long-term goals and the other on the way people are working towards it.

2.6 TYPES OF LEADERSHIP

Successful leadership depends on bringing the right personal characteristics and the right behaviours together to carry out the responsibilities and roles that will enable the organization as a whole to carry out its mission. No two leaders behave in exactly the same way, nor do all leaders possess exactly the same personal characteristics. But in our experience (and in that of many leadership theorists), there appear to be three broad types of leadership style. We have listed them and their principal characteristics below, using the generally accepted name used by leadership theorists for each one:

Transactional leaders:

- organize

- control

- set targets

- produce order

- produce predictability

- produce guaranteed results

- motivate by material rewards.

The reason for calling this type of leadership transactional is because it involves an exchange between the leader and the led – the leader takes responsibility by making sure that everything is running smoothly, that everyone knows what they are supposed to do, and that the organization does what it has set out to do on time and on budget. In return, the team makes this happen. There is an exchange: the leader sets targets; the led do as they are told and get security as a result. The led may be rewarded for their efforts and loyalty by steady wages, but overall it is their self-interest that is being appealed to by the transaction. They are not engaged in the operation by being motivated to be creative themselves.

In fact, they are being managed, not led. If you do want to make a distinction between being a manager and a leader, then the sort of things that transactional leaders do is to produce the order and predictability that managers are hired to ensure. There is nothing wrong in being a manager, but for an organization to be creative its managers need to be led – and the managers themselves should think of themselves as leaders. That is why other leadership styles are in demand.

Transformational leaders:

- create visions

- inspire

- motivate

- drive

- exercise charisma

- take organizations in new directions

- produce change

- raise everybody's game

- reward with the success of the organization.

As the name suggests, transformational leadership is about change. The leader has an open vision, not a fixed target. That vision inspires and motivates people in the organization to want to make the vision a reality, and the leader is there to urge them on. One way of doing that is by having a certain charisma, though charisma really exists in the eye of the beholder. It is a quality attributed to people, rather than consciously acquired by them. The charisma comes from the sheer conviction the leader has in the rightness of what they want to do and the success that has been had, so far.

What this kind of leader wants to do is to take their organization in a new direction – do new kinds of work, acquire a new building, find a new way of doing things. That produces change – and uncertainty. People are disturbed by unpredictability, which is why it is important not just to transform the organization, but to change the way people in the organization think about themselves and their capabilities, to challenge them to raise their game. There is always risk in change, but transformational leaders take everyone in the organization along with them. The people in the team get their greatest personal satisfaction from the success of the organization as a whole. But you will notice that that success will still depend on the ability of the leader to persuade the team of the need for change. The third type of leader does something subtly different.

Relational leaders:

- create shared visions

- inspire

- motivate

- communicate

- exercise charisma

- share

- enable

- nurture

- produce change

- create trust

- produce stability

- reward through collective ownership of success.

The emphasis in relational leadership is on the quality of the relationship
between the leader and the led. That relationship is seen in terms of a
group of people moving forward together, rather than a group following
an individual, as in transformational leadership. Relational leaders inspire
and motivate, but their communication skills make them much more sellers
than tellers. Because they are successful, people will feel their charisma, but
it will be of a quieter, gentler kind than that of a transformational leader.
Transformational leadership is sometime known as 'heroic' leadership, with
all the sound and fury the word conjures up, while relational leadership is
sometime referred to as 'silent leadership', or 'servant leadership', where the
leader puts the interests of the organization first.

Although we do not believe that gender is a significant factor in being a
leader, we have noticed that women are often better at silent leadership than
men. That is because they are not just thinking about themselves in relation
to the organization, they are ready to enable and empower people by genuine
delegation, and they are ready to nurture other people's talent. That is why,
when they want to achieve change, they also produce general agreement
about the need for change and the direction to go in. The result is a much
more stable organization, where people do not just feel proud of the success
of the organization, they feel they own it. Whereas a transformational leader
is definitely seen as being out in front of the organization, the relational
leader will be at the centre of it.

Exercise

Tick off those aspects of leadership behaviour that you think are most important, regardless of which category of leadership style they appear in.

2.7 THE DARK SIDE OF LEADERSHIP

Each of the three styles of leadership has its advantages: you will find that you will have to be ready to adapt your style according to different contexts. But each also has disadvantages, of which it is important to be aware.

Transactional leadership: the drawback of focusing on reliability and predictability is that the cultural world is neither reliable nor predictable, and leaders have to be adaptable and ready for the challenge of change. To be able achieve order and reliability is a great thing, but, in the cultural sector, it does not feel very creative. The organization plods along predictably even though the outside world moves on; there is no thought to development; and the work the organization does gets stale and boring. Challenges may come from the outside – or from within the organization when frustration builds up. Systems tend to atrophy. It is no good doing something 'because we've always done it that way'. An organization that focuses too much on monitoring and targets tends to be low in trust, because people feel they have no freedom to be creative and are being watched all the time.

Transformational leadership: because so much depends on the visionary individual at the top, the rest of the team feels disempowered, not inspired. This happens, for instance, when the leader is getting a lot of positive media attention while things are going wrong with the ordinary managerial business of professional routine. People in the organization may feel that their own sense of themselves is so wrapped up in the leader that they lose the ability to criticize, or warn when things are going wrong. The charismatic status of the person taking a decision can matter more than whether the decision is a good or bad one. Part of the problem in the cultural world is that the dominant tradition focuses on the individual artist and their work, failing to see – as we will argue in Challenge 4 – that creativity in the arts depends upon a network of cooperation among many people. Similarly, in the wider creative industries, much attention is given to the individual entrepreneur, whereas in fact, as in the arts, teamwork, networking, peer competition and cooperation are all vital.

The transformational leader's greatest personal threat is narcissism: the leader sees the world as their own reflection, even creation, and as a result the leader

either does not see, or does not allow others to see, when things are going wrong. Their vision, unchallenged by their subordinates, becomes a fantasy and they distort or withhold key information in order to sustain it. They don't listen to people, can't be bothered with details and show no courtesy to the people who work for them. We have noticed that transformational leaders rarely appoint anyone to the organization who might threaten their position by being as clever, creative or skilled as they are.

Relational leadership: the danger of relational leadership is that there is a kind of narcissism here too. The focus becomes so much on the quality of the relationships between the leader and the led that the productive purpose of the organization is neglected. The team turns inward, and so is unprepared for external challenges. The leader has to take decisions, but concern for consensus means they take a long time to be made. The leader may be reluctant to confront people who are not doing their job properly; while the focus on the leader means that it is the leader's success, and not that of the organization, that seems to matter most. There is always the danger that closely knit teams will harden into cliques, closed to outside influence or cooperation.

The point about relational leadership is that *everyone's* relationships should be positive, communicative and nurturing, not just those with the leader. Leadership should not be the property of one person, but shared throughout the organization, as we show in the practical example that comes later.

2.8 LEADERSHIP AND POWER

You may have noticed that so far we have not talked about, or even used, the word power. That is because leadership should not be about power: it is about being able to influence other people towards achieving an agreed goal. Even the most powerful heroic leader is unable to control everything and, in practice, power is distributed, albeit unevenly, throughout a group. The recognized leader will usually have the most power, by virtue of being recognized as leader, but there will be others in the group who can exercise considerable influence over outcomes, both positively and negatively. So you need to be able to understand how power operates within an organization, so that you can locate yourself in relationship to it.

The trick is to be able read the patterns of power, to know where power lies and to be aware of the way that the people who take – or influence – decisions exercise power, so that you know how to respond. It is also very important to

33

be aware of your own position within the pattern of power – and the way you exercise your power over other people.

As with much leadership theory, a lot of this is no more than common sense, but it helps to have a conceptual vocabulary of the different ways in which people exercise power.

In their classic essay 'The Bases of Social Power' (French and Raven 1959), the social psychologists John French and Bertram Raven identified six categories of social or organizational power.

Reward power: this is based on the ability to reward others through positive outcomes (for example, by paying people more money or giving them promotion) or through the removal of negative aspects of the job (such as not giving them irksome tasks – or the sack). One way of looking at reward power is to think of it in terms of the power to allocate – or withhold – resources, including personal attention.

Coercive power: this is based on the ability to punish. People will do things because they have to, not because they want to, and so it is very different from reward power.

Legitimate power: is based on the belief that someone has the right to tell others to do things simply because of their job title – they have been appointed to a position, or elected to an office. An officer commanding soldiers is an obvious example, but the title Chief Executive gives the same kind of legitimate power. Your attitude to legitimate power will have a lot to do with your social and cultural formation. The army trains people rigorously to obey the chain of command, and so do other organizations where hierarchy is a strong element in the organizational ideology. Traditionally, older people will have more authority simply because they are older, whereas what they do tend to have is more experience.

The important thing to remember is that while someone's positional authority may quite unconsciously influence the way you relate to them, your own positional authority may equally be influencing other people's responses to you.

Referent power: this is a very social form of power, because it is based on personality. People will give consent to someone with whom they can identify, because they feel they are the same sort of person, or because that person has qualities that they admire. They are attracted to someone's charisma, or they wish to associate with someone who appears to have power.

Transformational leaders have referent power in abundance, but you can exercise power quite simply by being liked.

Expert power: this is a form of power that features strongly – and often quite negatively – in the museum world. It has little to do with administrative hierarchies, but is based on having a distinctive expertise, ability and/or knowledge. Like reward power and coercive power, expert power is exercised by the giving or withholding of expertise.

Information power: this is a variation of expert power, except that it can be exercised by anyone in an organization, at whatever level, because it is based on having *control* over information needed by others. This knowledge can be formal (for instance, information held by IT or finance officers), or it can be informal. Knowledge is power – and gossip can be a particularly poisonous form of power.

Exercise

Within your working environment, who has social power, and what form(s) does it take?

1. Make a map of your organization – but one that is not a simple organizational chart.

 − Take a sheet of paper and put your own name at the centre, and then think about the people or groups who influence you, and the decisions you are able to make.
 − Try to think of all the people who are really important in your working life.
 − Put their names in the upper part of the sheet, and try to express their closeness to you in terms of their power to influence you.
 − Similarly, think of those people or groups that you influence, and the decisions they are able to make. These are the people to whom you are important in their working lives. Put their names in the lower part of the paper.
 − As you locate each individual or group, think about your own reaction to them.
 − Ask yourself what the power base is of each individual or group – they may exercise more than one type of power, and they may exercise it weakly or strongly.
 − Once you have done that, check to see if there are people who you know are important, but you are not sure why.

And don't forget to ask yourself what is your own base of power.

2. Once you have done that, look at the people you have decided are the most important in the organization. Link them by lines, and ask yourself how they relate to each other, how they exercise their power and what is the quality of the relationship – record this along the line that links them. And don't forget to include yourself.

3. Ask yourself the following questions:

 – Are there areas of the organization where you don't know or are not sure how the power relationships work?
 – To what extent does this social map correspond to the formal organizational chart? Are there, for instance, people who are nominally equal – or even junior – who exercise more power than their colleagues. If so, how and why?
 – What do you feel about your own position within this social map?
 – Are you in a position to influence the people who appear to have the power?
 – And what would you do to have more influence?

2.10 CONSENT

If we look at these different kinds of social power, it is obvious that even if you have Legitimate Power, which gives you both Coercive Power and Reward Power, this does *not* give you absolute control over an organization. You will need to use other ways of exercising influence to achieve your aims and, regardless of their formal status, there will be other people in the organization who will have expertise or information, or may be able to access levels of Referent Power so that they can support – or thwart – whatever it is that you want to achieve.

This brings us to another way of looking at power – through the other end of the telescope, as it were. The reason for exercising power, in whatever form, is to achieve a desired outcome, and to do that you need to have people's consent. It sounds blindingly obvious, but a leader cannot be a leader without followers. Leadership is only held by the consent of the group. Thus leadership is the responsibility of followers, and will depend on their consent or dissent. Both consent and dissent can be exercised responsibly, or irresponsibly.

In *Leadership: Limits and Possibilities* (Grint 2005), the leadership theorist Keith Grint has argued that leadership will be conditioned by four kinds of follower-response.

Destructive Consent: consent can be destructive when it is uncritical consent given to a narcissistic leader, irresponsibly given by yes-people; it is the kind of consent that allows bad leaders to get away with bad things, a fascist model that, when things do go wrong, destroys both the leader and the organization.

Destructive Dissent: this is the irresponsible refusal to cooperate in any way that makes leadership of any kind impossible, and so leads to anarchy and the collapse of the organization.

Constructive Consent: this is the responsible agreement to accept the leadership of an individual or an elite, in exchange for the security of order and control, as happens in transactional leadership: it is a hierarchical model that depends on the leader to deliver the goods – and the follower has to be ready to give up a certain amount of personal autonomy to make it work.

Constructive Dissent: here, followers exercise responsible control by being willing to criticize the leadership and recognize its limitations; it is a pluralist model, where power and responsibility is distributed throughout the organization.

Exercise

Within your immediate working environment, which forms of consent/dissent do you see in operation, and in what proportion?

- In what ways do you respond to the people who shape your working environment?

- Revisit the map you made of your organization, and consider how consent and dissent operates in the power relationships that you have.

2.11 DISTRIBUTED LEADERSHIP: THE ROYAL SHAKESPEARE COMPANY

So far we have been discussing leadership, power and followership at a theoretical level. In practice, things are never as neat as that. Leadership styles go in and out of fashion because the cultural context changes, and organizations have to adapt to new circumstances. For instance, the transformational, 'heroic' style of leadership that got a lot of new arts buildings built in Britain in the 1990s is giving way to the relational form of leadership that is needed to keep organizations going in difficult times. One organization that has changed from the former, very hierarchical style of leadership to a more 'distributed' form of leadership is the Royal Shakespeare Company (RSC).

At the beginning of the 21st century the RSC, which is not only the biggest theatre company in Britain, employing some 800 staff and freelancers, but one of the best-known theatre companies in the world, was in crisis. The work on stage was not very good, audiences were in decline and a big deficit was looming. Morale within the organization was low. They also had the problem that their plans to rebuild their main theatre in Stratford-upon-Avon had been badly received, and they had to raise funds to pay for the work that needed to be done. An attempt to solve all these problems by adopting a plan developed by outside management consultants failed.

Part of the problem was that the RSC was a very hierarchical organization, with Coercive, Reward and Information Power concentrated at the top. It relied on a very close working relationship between the Artistic Director, the Chief Executive (who called himself Managing Director) and the Chairman of the Board. A small clique of people around the Artistic Director took all the decisions about artistic policy. Senior management was remote from the rest of the organization. Even their offices reflected this: they were all on their own floor, known as 'The Corridor of Power'. The rest of the organization – stage staff, props, wardrobe, front of house, marketing, education, IT – tended to work in 'silos', thinking of themselves as separate, even competing teams. Orders came down from the top, and all information was channelled through the Chief Executive's office, which was the one place where decisions were made.

Change began in 2002 when the Artistic Director resigned, and Michael Boyd, who was already a Theatre Director with the RSC, was appointed to take his place. A new Chairman took over, Sir Christopher Bland (a former Chairman of the BBC, among other things); the former Managing Director left, and a new Finance Director was appointed. Instead of installing a new

Managing Director, however, Boyd created a new post, Executive Director, and appointed Vikki Heywood, who had once been a lowly stage manager at the RSC but had recently been working on the successful refurbishment of the Royal Court Theatre in London. Although Boyd made it clear that he was the leader of the RSC, his idea was that he and Heywood would work as equals (as at the National Theatre where there is also an Artistic Director and an Executive Director), with Heywood looking to the management side of the operation, and Boyd giving artistic leadership and, of course, directing plays.

Boyd and Heywood wanted to open up the RSC. One of the first things done under Boyd's leadership was to stop having virtually all financial decisions taken by one person, and to give each of the departments their own budgets. That immediately gave many people more responsibility and involvement – and because it felt as though it was *their* money that they were spending, the budget deficit began to disappear.

Another key decision was to change the operation of the Human Resources Department, responsible for hiring and firing and general company welfare. Previously, as in too many organizations, Human Resources kept themselves very separate from the rest of the organization, and it was almost as if they were working *against* the rest of the RSC. As with budgets, HR responsibilities were now spread throughout the RSC. Heads of departments had to work with HR to sort out problems and deal with hiring and firing. When it came to having to lose staff, instead of redundancies being announced at a mass meeting, as though the RSC was some old-fashioned factory, great care was taken to prepare and explain; and because information was much more freely available, when job losses were necessary the reasons for them were much better understood.

Communication was the name of the game. Boyd opened up the formerly secretive business of planning the artistic programme to many more people. That meant that departments like education and marketing were better prepared for the decisions that were taken, and could influence them before misguided plans were set in stone. The old hierarchy of senior management became much flatter, with weekly meetings for senior staff and monthly meetings involving heads of department and middle managers. They in turn were expected to pass on information to everyone in their departments. There were big meetings three times a year that everyone could attend, and during the change process a whole series of discussions and workshops took place to prepare people and bring them on side. At these meetings Boyd and Heywood listened carefully to what was said, and changed and shaped the process accordingly. The layout of offices was changed to make them open plan, with Boyd and Heywood accessible at opposite ends of the main floor.

Although Boyd and Heywood did use an outside consultant – an expert in organizational development, Dr Mee-Yan Cheung-Judge – to advise them and work with the senior team, they quickly realized that if the changes they wanted to achieve were to stick, they and the whole of the RSC would have to lead the process for themselves. They would have to *own* the process, not have it directed from outside.

The RSC did have one advantage, a means of describing what they wanted to achieve that made sense in theatre terms. This was the idea that a theatre company is an *ensemble*. Being an ensemble can mean no more than the actors working together in more than one production, and usually for quite a long time. But something happens when the sense of ensemble is built up: people know each other, trust each other and are better prepared to take creative risks. In the rehearsal room the director will ultimately take decisions, but these decisions will have been worked through with the cast, and arrived at collectively. It is not just the director telling actors where and how to stand: the whole performance is a shared creation, arrived at together. Just as in music, where a sense of ensemble enhances the playing, an ensemble performance in the theatre is a stronger and more satisfying production.

The RSC had been founded in 1960 as an ensemble theatre company, but the tradition of keeping actors together for more than a production or a season had withered away. Boyd brought back long-term contracts for actors, and that helped to restore the artistic reputation of the company. But he and Heywood did something more. Through the process of delegation of responsibilities, of opening up communication, of listening as well as leading, they gradually managed to take the spirit of ensemble that existed in the rehearsal room and on the stage, and spread it throughout the organization, even into departments like IT and Finance. As the change-process set in (and in a sense, the process never ends) the RSC imagined its internal organization completely differently to that of a hierarchically arranged organization with separate, vertical, power blocks that act as 'silos' incapable of communicating with each other:

This is a much more free-form, organic way of thinking about the organization. The key figures are still there, working closely together and giving leadership, but now they are at the centre, not hovering above. Information and decision-taking are shared, and because they are shared, so is leadership. Boyd and Heywood had a vision, and transformed the RSC, but they did it in a relational way. And in practical terms, this worked. The RSC rediscovered its creativity, restored its finances *and* rebuilt its main theatre, on time and on budget. This diagram illustrates precisely what is meant by 'distributed leadership', and the RSC has successfully turned a theoretical model into a working example.

RSC Senior
Management
Diagram 2008

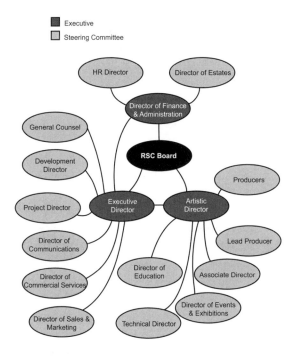

Executive

Steering Committee

Figure 2.1 RSC management diagram 2009

2.12 TOOLBOX

The whole of this book is intended to equip you as a creative leader and cultural entrepreneur. Here are some useful conclusions to draw from what has been discussed so far:

- Think of leadership as a relationship. Yes, you have to take the lead, but you can't do that without getting people to follow.

- Your leadership will be more effective if it is shared – responsibility has to be everybody's, and everybody should be able to contribute creatively.

- Build networks of trust – by empowering other people you are strengthening the whole organization, because individuals gain confidence and resilience from the group.

- Acknowledge your need for the support of other people.

- Acknowledge your emotions, and the emotions of other people. Leadership is about being sensitive to people's feelings, and emotions drive creativity and expression.

- Communicate: don't keep information and decisions that have been taken to yourself.

- Be visible: you must try to embody the values of the organization, and lead by example.

- Create a space where the values of the organization can be reviewed and discussed. Acknowledge the need for self-reflection and group-reflection. Try to develop a language in which these values can be expressed, but however complex the organization or the task in hand, try to keep your headline messages clear and simple.

- Listen.

- Observe the shifting geography of power. Stop 'silos' developing by reconfiguring groups and setting up short-term teams for specific projects. The way people behave towards one another is more important than job titles.

- Think in terms of networks, not hierarchies.

- Think of yourself at the centre, not the top, of the organization.

- Try to employ a diverse range of people. It helps avoid the conformity of 'groupthink'. Diversity is one of the keys to creativity.

- Tolerate a certain amount of ambiguity, and stay flexible. No plan entirely survives the process of implementation, nor should it. Having a clear idea of your goal is what matters.

- Remember that you are leading the organization, not just running it, so think about leadership issues first, and management issues second.

- Always be ready for change: a crisis is always an opportunity.

- Keep learning.

And finally: keep some time for yourself, to think and recharge your batteries. What you need to think about is the subject of the next challenge.

2.13 CASE STUDY

Here is a chance to think about what you would do in a tricky leadership situation.

You are the leader of a small but successful cultural enterprise. You have a team of 20 who have been with you for between 1 and 7 years, and their ages range from between 21 to 55. You have no financial deficit, but only a small operating surplus. You earn approximately 50 per cent of your income from your own enterprise, but depend on external funding for the rest, of which 40 per cent comes from a single public source. You have been told that in six month's time half of that 40 per cent funding will cease. You have a range of options, including cutting back on activity and cutting back on staff.

As the leader:

- List your options.

- Decide on a preferred option.

- Decide how you will set about implementing it.

2.14 SUMMARY

Challenge 2 has been about the challenge of leadership itself. The formal distinction between leadership and management is just that: leaders have to manage, and managers have to lead. It is how you lead that matters, and that depends on knowledge and skill, but above all, on behaviour. Different styles of leadership will be appropriate for different situations, but the best kind of leadership is where responsibility and decision-taking is distributed throughout the organization, and the leader is seen as being at the centre of a network, not the top of a hierarchy. We have shown how different people have different kinds of power. No single individual will have absolute power: leaders are ultimately only as good as their followers.

Creative organizations are driven by values. To be a leader, you need to know yourself. The following challenge is to discover what your own values are.

2.15 RESOURCES AND READING

There are literally thousands of books and online sources that will tell you about leadership in general, usually with business models in mind. The same is true of academic approaches to leadership, where all business schools will offer leadership training as part of their courses. But resources for learning about the sort of cultural leadership we are talking about are much scarcer, though they seem to be increasing all the time. Here is a selection of what is on offer.

In Britain, the best-known cultural leadership course is run by the independent Clore Leadership Programme (which, as it happens, we helped to devise, and with which we are still involved). This was launched in 2004 and is aimed at people who have had at least five years' professional experience in an arts or heritage organization. Between 20 and 30 Clore Fellows are appointed each year. Full-time fellows get enough to live on while they are on the programme, which begins and ends with an intensive two-week course with the other fellows. In between, each fellow is funded to take courses to develop specific skills, will spend time on a placement with a cultural organization, and may write a piece of academically supervised research. It is sometimes possible to spread the programme part-time over two years. There is no academic qualification. To complete the course is thought to be good enough. The Clore Leadership Programme also runs two-week 'Short Courses', with the support of Arts Council England. More information is available from www.cloreleadership.org.

There are many university courses teaching aspects of cultural policy and management. One of the longest running is at City University London, which offers a one-year full-time or two-year part-time MA in Cultural Policy and Management. (Again we have to declare an interest: we are both involved in this course.) More information is available from www.city.ac.uk/cpm.

At the University of East Anglia, the Sainsbury Centre for Visual Arts runs an annual, two-week Museum Leaders course, with one week in early autumn and the other in the following spring. This is a well-established course for senior people in the museum sector. More information is available from www.uea.ac.uk.

You should also look for other university courses, which are changing all the time.

In the United States of America, the Getty Center in Los Angeles runs the Museum Leadership Institute, which delivers an annual three-week residential

museum leadership course at the Berkeley campus of the University of California. There are about 30 participants, with an age range of 30 to 50; all are museum directors or senior division heads. A small number of non-Americans attend each year. This is one of the most respected cultural leadership courses in the world, but it only addresses museum leadership, and in an American cultural and institutional context.

There is also the Kennedy Center Arts Management Institute Fellowship Program, Washington, DC. In 2001 Michael Kaiser, former CEO of the Royal Opera House, London, set up this in-house training programme when he became President of the John F. Kennedy Center for the Performing Arts. A dozen fellowships are available each year, and are advertised internationally. Fellowships last for ten months, and fellows are drawn from a wide range of disciplines, and some come from overseas. The emphasis is on practical experience working for two months at a time in the various departments of the Center, not as observers but with full responsibilities. Teaching leadership as such is not the primary concern, although the improvement in skills and experience may produce future leaders. More information is available from www.kennedy-center.org

As we said, business schools will all offer aspects of leadership, but there are a number of centres at American universities where the focus is on public service rather the bottom line. Among them are:

- Center for Public Leadership, J.F. Kennedy School of Government, Harvard University.

- Center for Values in Public Life, Harvard Divinity School, Harvard University.

- University of Buffalo, Arts Management Program, College of Arts and Sciences.

- Jepson School of Leadership Studies, University of Richmond, Virginia.

- Hess Center for Leadership Studies, Birmingham-Southern College, Alabama.

- Gannon Center for Women and Leadership, Loyola University, Chicago.

- The Leadership Institute, Marshall School of Business, University of Southern California.

- The James MacGregor Burns Academy of Leadership, University of Maryland.

- Columbia College Leadership Institute (for women), Columbia College, South Carolina.

- Center for Leadership in Nonprofits, Hubert H. Humphrey Institute of Public Affairs, University of Minnesota.

- 21st Century Leadership Center, St Mary's University, San Antonio, Texas.

National Arts Strategies is a not-for-profit organization that has developed an interesting model for leadership training. It is based in Washington, DC but it operates peripatetically and concentrates on group-based leadership development. Intense short courses are designed specifically to address the needs of a town or community that wishes to develop its arts organizations. The courses are delivered in cooperation with leading teachers from business schools such as Yale, Harvard, MIT and Stanford. Teaching is by case study on the business school model. More information is available from www.artstrategies.org.

In Canada, the Banff Centre for Continuing Education, Alberta, is a designated National Arts Training Institution by the Department of Canadian Heritage, and has a well-established leadership training programme offering generic or customized short courses for not-for-profit organizations. Of particular interest is its development of programmes specifically addressing aboriginal leadership and management. More information is available from www.banffcentre.ca.

In Europe, the Berlin School of Creative Leadership is based at Steinbeis University. For the Berlin School, 'creative' means that it is aimed at leading executives from the fields of entertainment, the media industry, advertising and marketing, and also design and architecture. It offers an 18-month (80-day) global executive MBA in Creative Leadership, and is also a centre for research and mounts symposia, conferences and workshops. More information is available from www.berlin-school.com.

The International Executive Development Center (IEDC) at Bled, Slovenia, is an important institution for management training in Central and Eastern

Europe. It is mentioned here because it has a particular interest in stimulating 'creative leadership' and links with the arts. It uses artists as speakers, and has its own art gallery and collection. IEDC is associated with the annual Forum for the Arts and Leadership in Dubrovnik. More information is available from www.iedc.si.

ENCATC (European Network of Cultural Administration Training Centres) was founded in Poland in 1992, and currently has 125 members from 36 countries. It is an important forum for debate, partnerships and exchange, has an annual conference and mounts subject-specific workshops. More information is available from www.encatc.org.

The literature on leadership is almost infinite, but because leadership theory was first developed in the United States, there is a strong American emphasis. It is also mainly about leadership in a business context, and writing on cultural leadership is rare. Among the studies that have acquired 'classic' status is Henry Mintzberg's *The Nature of Managerial Work* (Mintzberg 1973); J.P. Kotter's *A Force for Change: How Leadership Differs from Management* (Kotter 1990); W. Bennis's *On Becoming a Leader* (Bennis 1989) and James Kouzes and Barry Posner's *The Leadership Challenge* (Kouzes and Posner 2007). Jeffrey Sonnenfeld's *Concepts of Leadership* (Sonnenfeld 1995) brings together a number of key articles, including work by Kotter, Bennis and Mintzberg.

When it comes to describing what arts managers have to do Giep Hagoort's *Arts Management Entrepreneurial Style* (Hagoort 2000) is a useful round-up, with the emphasis more on management than leadership. Murray Belbin's *Team Roles at Work* (Belbin 1993) explores how people respond to each other in work situations.

Jonathan Gosling is one of the most thoughtful British writers on leadership. He and the Italian Antonio Marturano have co-edited *Leadership, The Key Concepts* (Marturano and Gosling 2007), which will take you through the core concepts of leadership and introduce you to more recently developed concepts.

John French and Bertram Raven's essay 'The Bases of Social Power' was first published in a book edited by D. Cartwright, *Studies in Social Power* (French and Raven 1959). Keith Grint is an English leadership theorist who writes about followership in *Leadership: Limits and Possibilities* (Grint 2005).

The material on the Royal Shakespeare Company comes for our report, commissioned by the RSC: Robert Hewison, John Holden, Samuel Jones, *All Together: A Creative Approach to Organisational Change* (Hewison *et al.* 2010).

There are some useful resources available in the UK from organizations, such as the Charity Commission, the National Council for Voluntary Organisations (NCVO), the Association of Chief Executives of Voluntary Organisations (ACEVO) and the Directory of Social Change, that support the third sector. It is worth keeping an eye on their websites as they update their publications on a regular basis. Two books that are particularly relevant to the issues that we have looked at in this chapter are Mike Hudson's *Managing at the Leading Edge* (Hudson 2003) and Brian Rothwell's *Leadership 101* (Rothwell 2007).

3 Challenge: Values

'If we use our values to make decisions, our decisions will align with the future we want to experience.'

Richard Barrett (Barrett 2009: 1)

3.1 INTRODUCTION

In this challenge we look at values. It is your job as a leader to articulate and communicate the values of your organization. You have to be able to reflect the reality of the organization's values back to it, and be ready to expose any gaps between the way it talks about its values and the reality of what it does. But in order to be able to do that, you also have to understand your own values, and be able to demonstrate what they are.

Different people will value your organization for different reasons. An audience member, an artist and a funder will see the organization differently, and may well want different things from it. The leader must be able to translate between these different interests – what in artspeak are called stakeholders.

In the arts and heritage, the primary value that people are trying to create and experience is what this book calls Cultural Value. The creation of financial value, together with the values that the organization adopts, such as valuing creativity and imagination, respecting the local community, dealing fairly with staff and so on, are all means to an end: the ultimate aim is the production of Cultural Value.

We will be looking at the concept of Cultural Value in detail in Challenge 4, but this challenge looks first of all at your values, and at how a leader's

beliefs and behaviour affect the organization as a whole. It then looks at how organizational values help to create the circumstances from which Cultural Value can emerge.

3.2 KNOWING YOURSELF: UNDERSTANDING WHAT DRIVES YOU

Have you ever stopped to ask yourself why you want to have a successful career in the arts or heritage? You see yourself as a creative leader; as someone who can make a difference as a cultural entrepreneur. But why culture? It can't be the money, even though the financial rewards can sometimes be great. Some people are driven by the need to prove themselves, or by a kind of vanity – the urge to show their superiority over others. Then there are people at the opposite end of the scale who want to devote themselves – and sometimes sacrifice themselves – to the pursuit of a high ideal.

Wherever you come on the scale – and we assume you have a passion for culture, that you want to make a positive input and, above all, that you do indeed want to make a difference (in short, that you want to do something of value) – then running a cultural organization in a creative and enterprising way is one of the most satisfying and useful things you can do.

You will have to pay attention to the financial success of the organization, because without financial sustainability there can be no continuing achievement. You will have to be able to provide value for money in order to be able to create or maintain an organization that will have a life beyond your own time as leader. But unlike in the commercial world, financial performance will not be the only measure of your success.

On the contrary, financial success will be a means to an end, and a precondition of something much more valuable: the creation or presentation, the distribution or sharing, the conservation or development, of works of art – in whatever form – that will be understood to have cultural importance and meaning. That won't necessarily stop them having commercial value but, because culture and commerce have different purposes – the creation of meaning and the making of money – they are not the same things, however much they may overlap and feed on each other.

So while you will need to provide value for money, the money will be there to provide a different kind of value: the Cultural Value that drives the thinking in this book. And before setting out to address that, it helps to know what kind of a person you are, and what values you hold: *your values* feed

organizational values, which create *financial value*, enabling the creation of *Cultural Value*.

3.3 UNDERSTANDING YOUR VALUES: BEING AWARE OF YOUR PERSONALITY

There are all sorts of methods that have been developed to help someone work out what kind of a person he or she is and what kind of work would suit them. They should all be taken with a pinch of salt, but there are a number of techniques that have become well established (and profitable for those who own the copyright on them).

Myers-Briggs: based on the work of the psychologist Carl Jung, the Myers-Briggs assessment is a questionnaire designed to measure psychological preferences in how people perceive the world and how they make decisions. The point of taking the assessment (which can be done online or by purchasing a hard copy) is to determine which of 16 possible personality types you are. The test assesses your preferences in terms of four key opposing modes of being, each represented by a capital letter: E and I; S and N; T and F; J and P. Thus:

51

- your attitude will be defined by a choice between Extraversion and Introversion, depending on whether you prefer to get your validation from within or from the external world;

- the way you see the world will depend on whether your preference is for Sensing or iNtuition;

- the way you assess and respond to situations will depend on whether your preference is for Thinking or Feeling;

- the final choice, which is about how you interact with the world, depends on your preference for Judging, that is to say, making your mind up about a situation and closing your response down, or Perceiving, which means you prefer to observe, and keep your options open.

Everyone who takes the test is able to assemble their individual set of preferences, such as ENTJ or ISTP – there are 16 possible combinations – which tells you about your distinctive character.

None of these character types is seen as better or worse – Myers-Briggs is simply an explanatory tool. But knowing what 'type' you are can help you to understand how you are likely to approach problem-solving and how you are likely to react to other personality types. It is often used in a team context in order to ensure that all the necessary attitudes and approaches are represented in the group to counteract the dominance of any one particular personality type. For example, a team that is comprised solely of people who tend to prefer theory to practice, or gathering data to taking decisions, is likely to be dysfunctional – just as their opposites would be.

If you want to find out more, details of this and other methods of self-evaluation can be found at the end of this challenge.

360 degrees: 360-degree feedback, which is sometimes called 'multisource assessment', is, as its name suggests, feedback that comes from all around you: a circle of commentators with you at the centre. This means that you have to seek views and opinions about your performance from your peers, your manager, your board and the people who work with and for you. It also includes a self-assessment, and can include feedback from people outside your own workplace such as funders, suppliers, customers or other stakeholders. It can be quite a shock to see yourself as others see you.

DISC assessment: invented by the American psychologist William Moulton Marston in the first half of the 20th century, DISC assessment is a four-quadrant behavioural model that, like Myers-Briggs, also likes to play with capital letters. It looks at leadership styles and preferences in specific contexts, where each of the four letters stands for a different leadership style, and you score yourself strong or weak in each category.

The D of DISC is for *dominance*: if you are a high D, then you are very proactive when it comes to addressing problems and meeting challenges. If you are a low D, it suggests that you like to stop, think and find out more before acting. As this suggests, high Ds tend to be domineering, ask a lot of other people and are not backward in coming forward. Low Ds are careful, unaggressive, low profile and a lot easier to get on with – but that doesn't always produce results.

I is for *influence*: a high I shows that you are influential because you are positive, charismatic, emotionally engaged and able to talk people round to your point of view through the warmth of your personality and the way you communicate and create a sense of trust. A low I goes for the facts, not the feelings. You will be a bit sceptical, even pessimistic, and certainly critical – which may help you to take a decision based on the realities of the situation.

S is for *steadiness*: as the word suggests, those with a high S go for an even pace and a sense of security. Consistency is important, along with stability and deliberation: you will be patient with people, and calm about outcomes. A low S means you are more emotional, volatile and restless. A love of change and variety leads to a certain impulsiveness.

C is for *conscientious*: high Cs are cautious, they follow the rules, stick to the system, and work and think in a way that is neat and exact. They understand the arts of diplomacy and tact – and are possibly a bit inflexible. Low Cs are all about challenging the system, thinking outside the box and not worrying too much about the details. They can also be stubborn and wilful, contrary and uneven.

You may notice some of the differences between people who want to be leaders and people who want to be managers in the distribution of characteristics.

FIRO-B: this is yet another acronym, where FIRO means 'Fundamental Interpersonal Relations Orientation' and the B stands for behaviour. FIRO-B is a theory put forward by William Schultz in 1958. It assesses leadership in a different way to the psychological profiles by focusing on the relationships that the leader has with others, and it can help leaders understand how they establish, build and maintain relationships. The technique uses three 'relationship scales' – inclusion, control and emotion – and highlights the strengths and pitfalls of each leader's approach. The proposition is that different people have preferences for types of interaction in the areas of socialization, leadership and intimacy – with a difference noted between expressed and wanted behaviour. Yet again, a matrix of 'types' results, based on preferences for inclusion, control and affection. In the Challenge 2 we talked about social power and how it operates; this is another approach to the subject.

3.4 THE IMPORTANCE OF SELF-REFLECTION

It may be that you think these and other techniques are just sophisticated party games, or that they are updated versions of the ancient theory of the four humours – choleric, phlegmatic, sanguine and melancholic. But do not underestimate the power of self-reflection. A few years ago, when undertaking research for a study of leadership (Horne and Stedman Jones 2001), we interviewed the chief executives of many organizations in the public, private and third sectors, including the people running some of the biggest corporations in Britain. A common feature of their leadership development

was that they had nearly all spent some time away from their daily lives having a period of reflection that made them question and understand their own values. Sometimes this happened during a period of study, sometimes on a retreat or on a journey, but all stressed the importance of both knowing and being able to explain the values that they held.

A second common feature of those interviews was that many leaders had learnt their values by observing and talking to – or sometimes just reading about – a significant and inspirational person, whether that was a boss, a teacher, a world leader or a spiritual guide. Bookshops are crammed with titles such as *The Leadership Secrets of Genghis Khan* (we didn't make that up – see Man 2010), so chose your potential role model with some care.

3.5 DISCOVERING YOUR VALUES: MENTORS AND COACHES

Leadership can be lonely, even with the most supportive team around, for there will be times when you will have to take a decision that no one else can take. That is why it is so important to know your own strengths and weaknesses. It is also why it is important to be ready to seek advice from people outside the organization. This can be no more formal than talking in confidence to your friends, but there are two very useful ways of getting more professional advice – by having a mentor or a coach. (To distinguish this kind of coach from sports coaches, they are often referred to as a life-coach.)

Some people use the terms mentor and coach interchangeably, but in our view there is an important difference: coaches help you to get better at what you already do, whereas mentors use their own experience to enable you to develop into something new. A tennis coach helps a player to be better at the game, but if the tennis player has a mentor, that person might help the player to develop the skills and confidence to become a sports writer or to open a chain of health clubs – or get better at handling the pressures of the press.

There are more than a hundred definitions of mentoring. Here is one of them quoted in a public hospital's mentoring policy:

> *A mentor is a wise and trusted advisor and helper to an inexperienced person, guiding the person on a journey at the end of which the person is a different and more accomplished person. In a formal learning situation, mentoring functions can be understood as providing support, challenge, and vision. (National Health Service 2007: 1)*

And another from an educational context:

> *Mentoring is a term generally used to describe a relationship between a less experienced individual, called a mentee or protégé, and a more experienced individual known as a mentor. Traditionally, mentoring is viewed as a dyadic, face-to-face, long-term relationship between a supervisory adult and a novice student that fosters the mentee's professional, academic, or personal development. (Wai-Packard 2009: 1)*

In fact, many experienced people also find it helpful to have a mentor. The relationship between a mentor and a mentee is one where the mentor encourages wisdom and self-reliance on the part of the mentee. A good mentor can be a real help if the relationship is honest, open and trustworthy. In practice, developing such a relationship usually takes time, and it works best when both the mentor and mentee understand their roles and have both made an explicit commitment to the venture. It helps to draw up an informal contract, in which you agree how often you will meet, decide if there are any no-go areas, and where the mentee agrees to follow up the suggestions, or undertake the tasks, that the mentor thinks would be helpful to the mentee. It is often useful for the mentor to suggest to the mentee at the end of the session that certain things should be done by the time they next meet.

The key to the relationship is that the mentor is (usually) a senior person who (usually) works in the same field as the mentee, who uses their experience to help the learner develop their knowledge and skills, and keeps an eye on their career. A good mentor will be someone who is willing to write you a reference in support of a job application and whose opinions are valued by others. To be successful there has to be a degree of mutual appreciation as well as respect, where the mentor is giving something back in return for their professional success. It should be a long-term friendship, and it can be very satisfying for both parties.

The role of a coach is very different. It is usually a professional relationship, and coaches sometimes charge high fees. They come in all shapes and sizes, but quite often have a background in industrial psychology. It is unlikely that they will have a particular expertise in your field of work – especially as you work in the arts – but their job is to act more like a counsellor or analyst and centres on helping to give you a better understanding of yourself and how you relate to others. Although they don't usually advertise the fact, many senior managers employ coaches – in business, in the public sector and in the British Broadcasting Corporation, for instance. Some people make it a condition that they have a coach when they take on a chief executive role. It is a solitary business being at the top and they need someone to talk to about their colleagues – if only to let off steam. Coaches usually work with

their clients for a fixed time, at a moment of transition or particular difficulty. Lynne Brindley, the tough and effective chief executive of the British Library, one of the biggest cultural organizations in the UK, has talked to us about the help she got from a coach when taking the library through a large-scale change programme.

In terms of self-knowledge, the role of both mentor and coach is to reflect back to the leader their true state of being – and to help the leader to improve and to change. In the end, though, it is up to you to get to know your own strengths – and your weaknesses.

Exercise

Interrogate yourself. Obviously we all have our strong and our weak sides. The important thing is to be able to recognize them, and know yourself well enough to be able to work as part of a team – especially when you are leading one. Whatever way you choose to go about discovering your best – and worst – features, you need to ask yourself some questions:

About you:

- Can you cope with complexity?

- Can you handle criticism?

- Can you take the blame?

- Are you good at keeping confidences?

- How do you deal with disappointment?

- Can you keep your temper?

- How punctual are you?

- Are you honest?

- How consistent are you?

- Are you prepared to argue your case?

- Are you confident about speaking in public?

- How good are you at expressing yourself on paper?

Relate your answers back to the 'desirable characteristics of a leader' in the previous challenge, at 2.3.

About you and others:

- Do you like people?

- Do you need people to like you?

- Can you mobilize others?

- Do you see other people as potential partners or as possible rivals?

- Are you comfortable telling others what to do?

- Can other people trust you?

- Would you be able to sack someone?

- Can you stand up to bullies?

About your future:

- Are you ready to work long and often irregular hours?

- Do you recognize that the rewards of working in a cultural organization are rarely financial?

- Do you realize that one of the hardest things to do will be to keep a proper work/life balance?

- Are you ready to take risks?

- Can you shoulder responsibility?

3.6 THE LEADER AND THE VALUES OF THE ORGANIZATION

As a leader, it is your responsibility not only to embody the values that you hold personally, but to communicate them in such a way that your organization adopts them as a whole. This involves:

- constantly reaffirming the organization's working values;

- ensuring that the organization's practices, procedures and behaviours reflect those values;

- personally adopting those values so that you are a living example of the organization's values;

- creating and continually refreshing a vision for the organization.

3.7 WHY DO VALUES HELP AN ORGANIZATION?

Organizational performance is enhanced through having a set of clearly understood and commonly held values, because they encourage:

Consistency: if everyone in the organization holds, or conforms to, shared values there is likely to be consistent behaviour and responses. This means that staff can anticipate reactions, and have a reasonable expectation of what others in the organization will do. This in turn leads to greater efficiency. It also gives everyone in the organization not only a common set of goals, but a shared means of achieving them.

Clarity: when everyone is clear about the values of the organization less time is spent on debating the right course of action, and people will be more confident about acting on their own initiative.

Decision-making: it is a fact of organizational life that decisions often need to be taken at all levels in the organization and are frequently based on imperfect information. In today's world of high customer expectations, with the demand that comes with it for speedy responses, old hierarchical models, where the request for a decision would be passed upwards and decisions handed down from on high, no longer work. As we saw in the case of the RSC, in today's flatter organizations, where there is less hierarchy and fewer levels of management between the bottom and the top, values help people to make good judgements about the decisions they should take.

Autonomy: by enabling people to make decisions in the knowledge that they can justify them with reference to a set of values, in turn they are given more autonomy, leading to greater job satisfaction and better morale.

Nonetheless, an organization with shared values also needs to be aware of the dangers of conformity and groupthink. Values can be consistent, but they need to be continuously tested both against competing values and against changing contexts.

3.8 VALUES AND VISION

In order to achieve their mission, leaders need to organize others and put together all of the elements of a package that will make whatever-it-is happen. It necessarily involves ideas of change: doing new things, or old things in better ways. Those new things, and the way they are done, are expressions of your and the organization's values. In other words, leaders need to have a vision. Fundamentally, a vision simply means having a clear idea of where you want to take the organization.

The leader must find others who are able and willing to join this enterprise. There, in a collective or organizational setting, the vision has to be articulated and communicated so that it becomes shared by everyone who is involved in making the vision a reality. There is a famous story that when President Kennedy visited the headquarters of NASA, the US space agency, he asked one of the cleaners what his job was. The cleaner replied: 'To put a man on the moon.' That was a classic demonstration of the unifying power of a clear and bold vision in action.

Articulating a compelling vision is an important part of what leaders do, and it is what people working in organizations want from their leaders – a survey of employees across all sectors in Britain clearly demonstrated that an inspiring vision was what the managers surveyed wanted most of all. The trouble was that only 11 per cent of them thought they were getting it (Horne and Stedman Jones 2001: 8).

A shared vision provides a simple and comprehensible reason for what the organization does and how it does it. But this should not degenerate into a situation where the leader is expected to know all the answers. In today's world of specialist expertise and rapid developments in knowledge, leaders cannot know everything. When people in an organization look to their leader for all the answers they become infantilized and incapable of taking autonomous decisions. That does nothing for them or for the organization.

59

What a vision does is set out the space within which those employees can act: as the Chinese philosopher of war Sun Tzu put it, 'The good leader is the one people adore, the wicked leader is the one people despise, and the great leader is the one where people say "we did it ourselves".'

3.9 ORGANIZATIONAL VALUES IN PRACTICE

When Anthony Sargent became General Director of the Sage, Gateshead, his first task was to make sure that everyone understood and adopted a set of shared values. As he puts it:

> *The very first thing was the core values because until we all had confidence that we were aiming in the same direction, we couldn't put the car into gear. So all thinking about what we will and won't do is, at the end of the day, tested against those – whether it's conscious and explicit, or in some cases unconscious. And now they are so deep in the bloodstream of the people who work there that it's like Brighton Rock lettering. (Whitaker 2008: 15)*

It is not difficult to write a list of values to which organizations should aspire. But, as Sargent stresses, those values have to be real and not mere platitudes. Few things damage an organization more than the exposure of a gap between what leaders say and what they do. When politicians say that they are public servants and then are seen to enrich themselves at our expense, or when there appears to be a difference between a religion's teachings and the practices of its adherents, there is a damaging loss of trust.

Leaders need to reflect, to look inside themselves, to be sure that the values they expect others in the organization to embrace are true to their own innermost ways of being. It is no good saying that people in your organization should treat each other with respect unless you truly believe it, and unless you yourself live up to that ideal consistently. When Michael Boyd became Artistic Director of the RSC he did not use hire cars, he took the train, and he did not fly business class. Without any instruction being issued, everyone else in the RSC began to follow his example. It saved the RSC money but, more importantly, it showed how everyone was willing to put the organization first.

Values need to be expressed and reiterated by leaders, and the practices of the organization should be constructed so that the values are made real. Take as an example the principle of 'fairness'. First, the organization would need to develop a common understanding of what the term means. Fairness to one

individual might conflict with fairness to another, or to the group. What is fair and reasonable to one person may appear unreasonable to someone else. There is, therefore, a need to discuss and debate what the value of fairness means.

Next, the organization's way of doing things must reflect that value of fairness. Fairness might be enshrined in employment procedures (for example, in providing equality for men and women in childcare benefits); in job descriptions (such as describing how a member of staff will treat the public); and in communications (making sure as much information as possible is available to everyone).

If the values have been truly adopted, they will be observable in the behaviour of everyone working at the organization. If the leader preaches fairness but does not practise it, fairness will not take root. If the organizational procedures say one thing, but something else routinely happens, fairness will not be a reality.

Exercise

Organizational values: just as we invited you to interrogate your own values, what are the values of the organization that you know best? Using the following table:

- List the values that the organization espouses and write down how those values are either fulfilled or contradicted in practice. Some of those values may be clearly expressed – in a mission statement or in the terms of a job description, for example. Others may be tacit or hidden, and shown through people's words or actions without being written down.

- Think about where the gaps are between what the organization says it does and what it actually does.

- Comment on where the organization is doing well and where you think it needs to improve.

Explicit values	Where do they appear?	Examples of where they are made real	Hidden values	Where do they appear?	Do they match explicit values?

3.10 TOOLBOX: HOW TO ANSWER THE CHALLENGE OF USING VALUES TO IMPROVE ORGANIZATIONAL PERFORMANCE

Here are some suggestions of ways in which to get the best value out of yourself, and your organization:

- look at yourself from the outside;

- begin, not with what you do, but what you can do for your audience;

- acknowledge your dependence on other people and other organizations;

- share your knowledge – and accept that you don't know everything;

- approach leadership not as a command, but as a conversation;

- use the conversation to create a set of common values;

- create a sense of trust that makes a space for others to be able to act on their own responsibility;

- empower others;

- don't be captured by routine;

- challenge conventions;

- have the courage to allow others to disagree – and also to stick to your principles.

We will be looking at how these ways of behaving are applied to managing creative people and leading organizations in more detail in the challenges to come, but bear them in mind when you tackle the questions posed in the following test case.

63

3.11 CASE STUDY

You are the leader of a large, multi-arts venue that has the following mission statement:

> *We value music, theatre and dance of all kinds and we are committed to enabling everyone to experience and enjoy them through watching, listening, learning and participating.*

Your organization has recently moved to a brand new building and there has been a significant increase in the numbers of staff, visiting artists and freelance education and learning professionals, all of whom need to become committed to the organization's values. This is your chance – and also your responsibility as a leader – to shape the organization's values, and to see those values become real through the rhetoric, practices and behaviours that develop as the organization grows.

Question 1: What set of *organizational* values will ensure that the organization fulfils the aspirations of the mission statement?

Question 2: What practical steps would you take to make these organizational values real?

There are many ways to approach these questions, but here are some suggested answers:

1. Your organizational values will be defined by big ideas such as:

 - Quality
 - Equity
 - Justice
 - Creativity
 - Sustainability.

2. These values become meaningful when you put them into practice.

Quality: ensure that you get an explicit commitment from your board to the value of quality in your artistic and learning programmes. Address the issue of board representation. Both your internal communications and your external public relations underline your commitment to quality.

To monitor quality, you set up a group of staff, board members, freelancers and outside experts. They are asked to review the programme and the learning activities – and you listen to what they say.

Equity: you make sure that there is a fair distribution of resources between all the parts of the organization and all the activities that deliver the mission statement. This is backed up by having equitable and fair pay scales for staff and making sure that the management structures supporting different activities are properly resourced.

Justice: the freelance professionals serving the programme are treated with the same respect as full-time members of staff, and are similarly supported and resourced. They are treated as stakeholders in the programme. The public, whether audience members, visitors, those engaged in schools and outreach programmes or members of the local community, are treated with respect at all times.

65

Creativity: your public-facing activities, your learning programme and your performance programme are fully integrated. The learning programme is designed to support the performances; the performances feed the learning. The creativity of audiences and the public are valued as much as the artistic creativity that the venue presents.

Sustainability: you ensure that the organization is sustainable in three ways:

- Financially – by building a strong box office and allied streams of earned income; establishing good relations with public funders, and with trusts and foundations; the same goes for businesses and individual donors, both large and small.

- Environmentally – by investing in the right equipment (What sort of lighting do you have? What sort of heating?); by introducing the right practices and behaviour among staff and audiences (Do you recycle? Are staff encouraged to walk and bicycle instead of driving? What proportion of your audience drive to events – and could you help them to use public transport?); by getting tough with your suppliers (Does the franchisee running your café use local ingredients? Do your cleaners use toxic chemicals? Do you use recycled paper?).

- Regeneratively – in terms of building and growing the audiences, artists and participants of the future by integrating learning and growth into your activities; by giving new artists a chance; by being imaginative about how you use the spaces that are under your

control to bring in as many people as you can; by adopting ticketing strategies and free events that encourage new audiences.

3.12 SUMMARY

In this challenge we have argued that before you can become a creative leader or cultural entrepreneur you need to understand yourself and your values, and we have suggested ways in which you can explore this. In order to be effective, a leader has to be able to relate personal values to the values of the organization and, as our closing case study shows, put them into practice. In Challenge 4, we show how personal and organizational values help to create Cultural Value.

3.13 RESOURCES AND READING

Here are some sources for the self-assessment and personality-testing techniques we mention:

- *Myers-Briggs*: the website of the Myers and Briggs Foundation is at www.myersbriggs.org.

- *360 degrees*: there are plenty of firms, together with organizations like the Work Foundation, who can set up 360-degree surveys.

- *DISC Assessment*: as with Myers-Briggs and 360-degree feedback, there are plenty of firms ready to sell you the means to carry out a DISC Assessment, which can be done online. Just two of several companies who provide this service are www.4sight4business.co.uk and www.eDISCprofile.com.

- *FIRO-B*: there are plenty of consultants ready to give the test, for instance www.YourLifesPath.com and www.advancedpeoplestrategies.co.uk.

- *Finding a mentor*: this is a very personal relationship, so it is up to you to find someone you admire who will be willing to take you on. If you want to read up on mentoring, Laurent Daloz's *Effective Teaching and Mentoring – Realising the Transformational Power of Adult Learning Experiences* (Daloz 1986) is a good place to start. There is also Becky Wai-Packard's *Definitions of Mentoring* (Wai-Packard 2009).

- *Finding a coach*: coaching involves a professional relationship, and there are many commercial organizations offering coaching. In 1995 the International Coach Federation (www.coachfederation.org) was formed to establish professional standards for the profession. There are also a number of do-it-yourself books, such as Angus McLeod's *Performance Coaching – The Handbook for Managers, H.R. Professionals and Coaches* (McLeod 2003).

4 Challenge: Cultural Value

'No culture can live if it attempts to be exclusive.'

Mahatma Gandhi

4.1 INTRODUCTION

Everything we said in Challenge 3 about the importance of knowing yourself, of understanding your values, and of making sure as a leader that your organization embodies and communicates its values, can be applied to any kind of organization that wants to succeed. But this is a book about working in an entrepreneurial way in a field where values combine to create something that we have called Cultural Value. As culture carries a different set of values to purely monetary ones, in this challenge we show how the leader has to be able to handle the complex relationship between individual ideas of aesthetic value and the economic and social values to be derived from collective cultural activity.

4.2 THE 'MEANING', 'VALUE' AND 'BENEFITS' OF CULTURE

Culture is important because it does something to our lives. It makes meaning, we value it and it has the capacity to bring benefits both to individuals and communities. It does, indeed, 'do you good' – but then, what do we mean by 'good'?

The words 'meaning' and 'value' are unavoidably linked. When someone finds meaning in a work of culture, they value it. If there is no meaning for them in a work of art or a performance or a place they will not value it, economically or culturally. Value, in this sense, is therefore subjective: we

cannot tell you, and you cannot tell us, to value something; value has to come from within each of us. When we listen to a concert or read a poem or stand in front of an art installation, each of us will value it differently, depending on our own histories and preferences.

'Benefits', by contrast, are objective. If creating paintings helps a group of hospital patients to get better more quickly, we can say that they benefit from the experience because we can measure the difference between their recovery times and those of some other patients who recovered less quickly. That is a positive social outcome; similarly, a successful arts venue can help to regenerate a town centre, and the economic benefits are measurable.

A lot has been written and spoken about the value of the arts and culture because they have value to individuals, and because they benefit individuals, communities and society. Value is the reason why people choose to engage with culture; benefit is the reason why government, local authorities and other funders support it. In order to get the best for you and your organization, you need to understand the many types of value and benefit that culture has – in other words, you need to understand Cultural Value.

4.3 EXPRESSING CULTURAL VALUE

A useful approach to thinking about Cultural Value is to look at the value of culture in three ways, using different sorts of language and measurement in each case. These three viewpoints arrange themselves into a triangle, and are not mutually exclusive; on the contrary they are complementary, but, depending on who you are, each aspect will be more, or less, important.

Here is a diagram of the Cultural Value triangle:

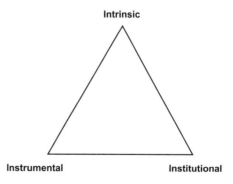

Figure 4.1 Cultural Value triangle

4.4 INTRINSIC VALUE

At the top of the triangle is Intrinsic Value. Intrinsic means integral to, or an essential part of, something. An obvious example is the particular beauty of the colours and forms in a painting. But museums, dance, theatre and so on also have a value unique to themselves. Intrinsic Value suggests that the arts are good in their own right: we should value dance because it is dance and poetry because it is poetry, and so on, and not only for other reasons, such as their economic and social consequences. Over the last decade there has been a running theme in writing about culture on both sides of the Atlantic, arguing that more attention needs to be paid to valuing culture for its own sake, and addressing what Intrinsic Value means and how it can be described and accounted for. The British think-tank Demos published a series of conference papers called *Valuing Culture* (Demos 2003) and the first of series of pamphlets on Cultural Value, *Capturing Cultural Value* (Holden 2004). In the US a think-tank called the Rand Corporation published *Gifts of the Muse* (McCarthy *et al.* 2004).

As well as suggesting that every art form has something about it that is unique to itself, the term Intrinsic Value is also used to describe the way that art forms have subjective effects on each of us individually. Intrinsic Value is what people are talking about when they say 'I love to dance' or 'that painting's rubbish' or 'I need to write poems to express myself.'

Intrinsic Value is notoriously difficult to describe, let alone measure, and the rational econometrics of government find it difficult to cope with, because this aspect of culture deals in abstract concepts like fun, beauty and the sublime. It affects our emotions individually and differently, and it involves making judgements about quality. Nonetheless, it is possible to separate out the different ways in which works of art – and indeed places, objects and buildings – have an effect on us because of what they are. These effects are dynamic and interrelated, and they too can be expressed, very schematically, in the shape of a triangle.

Body, mind and spirit, the psychologists would argue, are all one and indeed they are, but, as with other aspects of Cultural Value, we have separated them out in order to better express how they interact.

Body: art can give us pleasure or pain. This can be experienced and expressed intellectually, but that experience begins in bodily sensations: sight, hearing, touch, smell. 'Aesthetics' are defined as 'the appreciation of the beautiful'; this appreciation begins with physical feelings that produce emotions – fear and horror as well as delight.

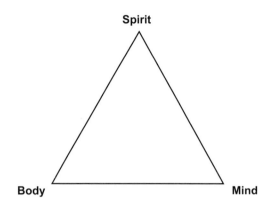

Figure 4.2 Body, mind, spirit

Mind: art is sensed through the body, but it affects the intellect – when we see or hear something we think about it. We relate it to other things we are aware of. It may be integrated with some other piece of information or experience to become new knowledge. Art can thus encourage our minds to learn and to grow, and the intellectual stimulus of art becomes a pleasure in itself. Aesthetic sensation, whether pleasant or painful, begins with the body, and produces an emotional reaction. But it is also a source of information that becomes a piece of knowledge. And because its source is first physical, then emotional, it constitutes a different form of knowledge to that gained by rational, intellectual effort alone. We can know the world better, and know it in a different way.

Spirit: the aesthetic experience is fundamentally emotional. Art moves us, and not always pleasantly: the emotional response can be one of fear or disgust. But the emotions give us access to a world beyond the rational mind and sometimes take us to places that can only be described as 'spiritual'. Because the feeling is so individual, and often so hard to describe in words – rather than by gestures of joy or sorrow, by laughter or fear – the emotional and spiritual dimension can be regarded with suspicion, especially because it cannot be measured. Yet we have all experienced it at some time in our lives, and if we are lucky, we have done so more than once. This sensation is itself a form of knowledge, and it is knowledge that is not accessed by the rational mind. It is what Keats meant when he wrote: 'Beauty is truth, truth beauty'.

Exercise

Write down five things that you think are most important for their Intrinsic Value.

4.5 INSTRUMENTAL VALUE

When we turn to the second type of value, Instrumental Value, we are dealing with an objective concept – that there is a benefit – so here we have to think about value differently. Instrumental Value is used to describe instances where culture is used as a tool or instrument to accomplish some other aim: economic improvement, such as urban regeneration, or social improvement, such as better exam results or lower incidences of reoffending among prisoners. These are the knock-on effects of culture, looking to achieve things that might well be achieved in other ways as well. This type of value has been of tremendous interest to politicians and funders over the last 30 years or so, and at some points it has become so overwhelmingly important that the other values of culture have been forgotten.

There are perfectly understandable reasons why that has been the case. As we have said, from the point of view of an individual what matters is their own experience of culture: whether they like the play or whether they enjoy the music. But an individual's pleasure is not really something of much interest to politicians. They are much more concerned about whether cultural experiences will have some kind of measurable effect on masses of people, whether that is better exam results or the regeneration of city centres or integrating refugees into society – all of which are, of course, perfectly worthy and sensible aims, but of a different order, and relate to a different way of thinking.

Politicians will always tend to look at culture in this way, and that means that politics will always have a highly ambivalent relationship with the arts and heritage, pulled in two directions at the same time. On the one hand, politicians want to keep their distance from culture for lots of reasons: because the arts can be oppositional and troublesome; because – at least in free societies – they don't want art to reflect state ideologies; and because they don't want to have to defend artistic experimentation that upsets the status quo.

But, on the other hand, the politicians control the use of public money, so they feel obliged to interfere in the arts to try to make sure that the arts are achieving their wider goals for society, and to make sure that public funding is properly accountable. They want their policies to be seen to contribute to the quality of life.

Local government has always been, and continues to be, interested in what the arts can do to help the people for whom they are responsible. In Britain, with the exception of public libraries, local authorities are not required by law

to provide any cultural facilities at all. Getting the arts and culture embedded into the thinking and practice of local authorities, by making sure culture is included in formal local authority plans such as Local Area Agreements and Local Strategic Partnerships, has become essential to securing support for the arts at a local level. Advocacy – putting forward arguments in favour of public spending on culture – also has a role. One example worth looking at is a 2007 report from the Society of Local Authority Chief Executives (SOLACE) that set out the benefits of the arts and culture (and sport) in terms of learning, regeneration, community building and health (Anderson and Allison 2007).

Governments, whether at national or local level, have to make decisions about how to spend their money to best effect. They can't rely on hunches or simply say that 'the arts are wonderful'. They need to be able to compare competing claims on their resources, and so they need to measure the outcomes that flow from what they spend.

Exercise

Write down five cultural activities that have Instrumental Value.

4.6 INSTITUTIONAL VALUE

The third type of value shown on the Cultural Value triangle is Institutional Value. This is all about the *way* that cultural organizations act. They are part of the public realm, and *how* they do things creates value as much as *what* they do. Through their relationship with the public, cultural organizations are in a position to increase – or, indeed, decrease – such things as our trust in each other, our idea of whether we live in a fair and equitable society, our mutual conviviality and civility, and a whole host of other public goods. So the way in which our institutions go about their business is important. Things like opening hours, meeting and greeting, and providing opportunities to grow and to learn are not simply about customer care, as they would be in the commercial world. They are much more important than that, because they can act to strengthen our sense of a collective society and our attachment to our locality and community.

After all, culture is one of very few instances where citizens interact voluntarily with the public realm: people are obliged to send their children to school and they have to go to court if they get a summons, but people go to a theatre, a museum or a library because they *want* to go. Institutional Value should therefore be counted as part of the contribution of culture to producing a democratic and well-functioning society.

In Challenge 1, in our discussion of what culture means, we said that culture should no longer be thought of as something that is provided by an arts organization to the public, but rather, as we put it in *Democratic Culture*, 'Culture should be something that we all own and make, not something that is "given", "offered" or "delivered" by one section of "us" to another' (Holden 2008: 32). This view of culture has radical implications for the way that organizations interact with their public and their communities, and for the Institutional Value that they thereby create.

In *The Art of With*, the social thinker Charles Leadbeater has written about the way in which organizations have traditionally done things *to* and *for* us, but how increasingly in the commercial world and in public services the organization and the individual collaborate in order to satisfy needs. He sees this development becoming more widespread because of the logic of collaboration that pervades the internet, but stresses that:

> *Openness is a matter of degree, just as participation is. There are*
> *many different ways for people to collaborate, in many different*
> *kinds of activities, from fundraising, to feedback, to participation in*
> *a work. Organizations should engage in a portfolio of experiments*
> *each testing different ways to engage participants in different kinds of*
> *projects. (Leadbeater 2009: 17)*

In our view one of the great challenges of creative leadership is to get the relationship right between the cultural expert, the artist, and the arts organization on the one hand, and members of the public on the other.

The following chart (Figure 4.3) sets out different organizational approaches. The closed organization thinks of itself as controlling/being in charge/having complete authority to make judgements. The mediating organization sees itself as an enabling resource that works in a collaborative endeavour. The open organization is simply there to be a neutral canvas for others. In practice many organizations occupy all three categories. For example, a receiving venue (that is, one that brings in work from outside, rather than producing its own) will put on a programme that is decided upon by the staff, but will probably have a learning and education department and some means of entering into a dialogue with its audience. On occasion it may just hire its premises to someone who wants to use it, like a local amateur choir.

It is worth thinking about where you stand in relation to the closed/ mediating/open configuration. Can you justify where you are, and if you wanted to move in any direction, how would you do it?

Closed CONTROLS	Mediating HELPS	Open EXISTS
Dictates programme	Co-programming	Available for hire
Content	Input from others	User-defined
Timing	Influenced by needs	User-defined
Price	Influenced by needs	User defined/free
Decides quality	Discusses quality	No role
Expert-only	Expert-led	Neutral resource
Owns IP	Creative Commons	Open source
Controls distribution	Creative Commons	No role

Figure 4.3 Closed/mediating/open organizations

We will be saying more about how Institutional Value is generated and judged in our our final challenge, at 8.3.

Exercise

Write down two cultural institutions that have a positive relationship with their public, and two that have a negative one.

4.7 MEASURING CULTURAL VALUE

It is all very well to be able to 'express' Cultural Value, to show that you understand the complex way the arts and heritage affect us as individuals and communities. But in the world of arts administration there will always be pressure, from national and local government, from public and private funders, to *measure* the benefits of what you do, in order to justify them giving you support. We argue that there is no single 'bottom line', but that past attempts to say that culture has nothing to do with economics, or that culture is only worth supporting for its economic and social effects, are equally simplistic. That is why the Cultural Value triangle was devised. But the problem of turning arguments for the value of culture into hard evidence remains. Here are some approaches to evaluating the three aspects of Cultural Value, each in its own terms.

4.8 MEASURING INTRINSIC VALUE

It might be argued that the various elements that constitute the Intrinsic Value of a performance, a work of art or a place – pleasure, emotion, insight – are so individual and subjective that there is no way that they can be brought together into some kind of collective judgement of their overall worth, let alone measure that total worth. Professional critics, who admittedly form a rather peculiar kind of audience, do try to evaluate the Intrinsic Value of the works they see, and will even give them a crude measurement in the form of a star rating. You could say that the box office returns were the only valid measure of an audience's response, but that is a very crude translation into financial terms of the much more subtle responses that people have, and it brings into play all sorts of external factors – such as availability, price and disposable income – that are separate from those that are essential to the autonomous nature of the work itself, and how these affect us as individuals or as members of an audience.

Over the past few years, attempts have been made to measure Intrinsic Value, and a lot of careful thought has gone into working out what happens when, for instance, an audience watches a show. Although it is unlikely to be the last word on the subject, and people will continue to try to find different ways of measuring Intrinsic Value, one of the most ingenious experiments was carried out in 2006 in the United States, where a team of consultants, WolfBrown, were commissioned by a consortium of 14 university performing arts presenters to find out what they called 'the intrinsic impacts' on their audiences of the live performances they were programming. The results were written up by Alan S. Brown and Jennifer L. Novak (Brown and Novak 2007).

The methodology used was relatively straightforward and familiar to anyone who has done any marketing: the audience survey. A preliminary questionnaire was handed out to audience members, who filled it in just before the performance that they were about to see. This was followed up by a second questionnaire that the audience took home with them and completed after the show.

So far, so simple, but what was interesting was the questions that were put. Before the performance audience members were asked:

- How much they knew about the performance and the performers they were about to see.

- How comfortable they felt about the place they were in, in order to see how familiar they were with it socially and culturally.

- How excited they were about what they were going to see – was their anticipation high or low?

This gave the researchers a baseline from which to judge the audiences' responses that came in after the show. It is also worth noting they took into account people's cultural comfort zones. Feeling that you are in a socially hostile environment, where you don't know your way around, or feeling that you are wearing the wrong clothes, can have a damaging effect on your enjoyment of what is on offer, be it a rock concert or grand opera.

After the performance, people were asked to rate it according to a set of categories that, while they do not exactly match the three divisions of body/mind/spirit, can be read across to them. We will use WolfBrown's own terms for what the researchers called their 'Impact Constructs':

- 'Captivation Index': how engrossed was the audience member in the performance?

- 'Intellectual Stimulation Index': how engaged were audience members in terms of ideas about themselves and society?

- 'Emotional Resonance Index': how intense were the emotions felt – and did they have a therapeutic effect?

- 'Spiritual Value Index': to what extent did the audience member have a 'transcendent, inspiring or empowering experience'?

- 'Aesthetic Growth Index': how stretched did the audience member feel when introduced to new styles or types of art?

- 'Social Bonding Index': to what extent did people feel connected with other members of the audience, to what extent did they feel able to celebrate aspects of a common cultural heritage or learn about unfamiliar ones, and did they feel they had fresh insight into human relations?

You can read the results of the survey in WolfBrown's report (Brown and Novak 2007); the important point here is that not only is it possible – provided you have developed the right technique and have sufficient time and resources – to assess the impact of a performance on body, mind and spirit, but that the arts organizations that paid for the survey were ready to adjust their programming in the light of the greater knowledge they had.

Exercise

We don't expect you to rush out and set up an audience survey immediately, but next time you go to a live performance, why not try assessing your enjoyment, and that of the people you were with, in terms of the 'impact constructs' suggested by WolfBrown? It will sharpen your critical insights, and help you to articulate what you liked – or didn't like – about the event.

But what if the work of art is not a performance, but an object such as a painting, or even a landscape that people feel should be preserved? You might wish to express the subdivisions of Intrinsic Value differently, but many of the same categories apply. A painting – and here we assume it is in public ownership – or a building or landscape that has similarly been protected will have:

- aesthetic value: it will give visual pleasure;

- symbolic value: it will have a particular meaning, in a painting because of its content, in a building or landscape because of its context;

- spiritual value: it has the capacity to give us a sense of the sublime;

- social value: it offers an experience that can be shared;

- historical value: even a modern painting or a new building has a relationship between the present and the past;

- bequest value: the fact of its protection means that it will be passed on for the enjoyment of future generations – and you cannot put a price on that, since you won't be there to see it happen.

This way of looking at the value of culture has been articulated by the Australian economist David Throsby in a number of works (Throsby 2003; Hutter and Throsby 2008) and has been used by other writers, including ourselves (Hewison and Holden 2004; Holden 2004).

Exercise

Again, next time you go to a gallery, or visit a place, try asking yourself if these different ways of thinking about your response to what you have experienced are helpful. Try making a case for the public ownership of the

work of art or protection of the landscape in terms of these non-monetary values.

4.9 INTRINSIC VALUE AND 'EXCELLENCE'

The examples we have given have concentrated on finding ways in which to express Intrinsic Value in accessible forms. It would be fatal to suggest that measuring their 'impacts' is an exact science, nonetheless there are a number of ways in which, once you have agreed your categories, you can accumulate evidence. WolfBrown used audience surveys, but you could commission sample interviews or hold focus groups. You could even assemble all the critics' responses – provided you don't leave the bad ones out.

In spite of what has been said, aspects of Intrinsic Value such as that slippery term 'quality' will always be hard to measure, and it is important that as a leader you have confidence in what you understand by such terms and are able make your own understanding clear. This is important for its own sake, but it is also significant that discussions of quality and 'excellence' have been reintroduced into the policy debate and into the practical workings of the public arts funding system. In January 2008 the British arts funding system was presented with a new challenge (and something of a policy volte-face) when the Department for Culture, Media and Sport (DCMS) published a report by the distinguished arts leader Sir Brian McMaster, *Supporting Excellence in the Arts – From Measurement to Judgement* (McMaster 2008).

McMaster's definition of excellence, 'excellence in culture occurs when an experience affects and changes an individual', may not tell us much about what excellence *is*, or how one thing is more excellent than another, but it sends an important signal (McMaster 2008: 9). Official support for his report showed a recognition that the arts and heritage do have Intrinsic Value, a value that is mainly experienced at a personal level, and that this has tended to be overshadowed by the policy emphasis on the Instrumental Value that the arts and heritage can also produce. The shift from 'measurement' to 'judgement' implies that cultural leaders will have to be better prepared to explain the Intrinsic Value of what they do than they have been in the past.

The point is, as McMaster says, that works of art can have effects and can change people. All along we have been speaking, in general, as though these effects were always beneficial. They also have the power to disturb, to offend and to challenge the status quo – indeed, that is one of the things they should always do. If culture had no effect, censorship would not have been invented. We assume, however, that the effects you are trying to achieve are benign, in

fact uplifting, and that you are ready to fight censorship for the sake of your beliefs.

And because of the Intrinsic Value of the work you do, you will find yourself becoming responsible for other kinds of effect as well, beginning with the instrumental.

4.10 MEASURING INSTRUMENTAL VALUE

If we want to *count* Instrumental Value – the contribution that culture makes to specific economic and social policy goals – then we have a number of hard and soft tools at our disposal. Here we are looking to capture objective benefit – did children's behaviour improve, did re-offending decrease, did businesses move into an area when we built an art gallery? The counting can take place at the level of an individual project, or in relation to a specific arts organization, or at some aggregated level – a town, a region, an art form or so on. Many writers have pointed out there are considerable practical difficulties inherent in measuring Instrumental Value and numerous problems in trying to prove cause and effect between an artistic intervention and a particular later outcome (Selwood 2002; Holden 2004; Carey 2005; Belfiore and Bennett 2008).

Having said that, there are also many studies and research papers that witness the Instrumental Value of culture across a whole range of areas. Published in 1997, the writer François Matarasso's report *Use or Ornament* (Matarasso 1997) catalogues the many benefits that participation in the arts can bring to individuals, communities and society as a whole. Since then, a host of individual reports have described the efficacy of the arts and culture in particular areas. The literature on arts and health is so well developed that an academic journal, *Arts and Health*, was launched in March 2009 to support growth in this field.

In the area of urban regeneration, writers including Charles Landry (Landry and Matarasso 1999) and Richard Florida (Florida 2002) have been highly influential (though not uncontested) in arguing that the arts and culture can play a significant role in improving the public realm, creating economic growth and attracting businesses.

As with health, explanations of the economic impact of the arts have generated a considerable body of work, starting with John Myerscough's report *The Economic Importance of the Arts in Britain* (Myerscough 1988). You can even find an online calculator which makes this ambitious claim:

81

the Arts & Economic Prosperity III Calculator is a free and simple tool that makes it possible for you to estimate the economic impact of your nonprofits arts and culture organization – or even your entire nonprofits arts community – on your local economy. (Americans for the Arts 2009)

Be warned, though, that economists love to argue about how precisely you can calculate the economic benefits of cultural projects. After all, money spent on an arts centre might have been much better spent building a factory. David Throsby's *The Economics of Cultural Policy* (Throsby 2010) is an excellent introduction to the way governments approach the problem of the difference between economic and cultural investment.

In terms of the wider social and educational benefits of cultural investment, the English Museums, Libraries and Archives Council (MLA) developed a framework called 'Inspiring Learning for All' – or ILFA for short – that has been widely adopted and that claims to help organizations: 'Provide evidence of the impact of your activities through…generic learning and generic social outcomes' (Museums, Libraries and Archives Council 2008). While focusing on learning, these 'outcomes' cover a range of health, wellbeing and social cohesion benefits ascribed to culture. The ILFA toolkit contains helpful guidance on how to assess projects. It suggests research questions and methodologies, gives information on how to run focus groups, provides definitions of terms and shows how to analyze the results of the inquiry.

At a macro level, in Britain in 2009 a consortium of DCMS, Arts Council England, English Heritage and the MLA got together to set up the Culture and Sport Evidence Programme (CASE). This initiative is trying to produce an agreed, consistent and coherent evidence base for why people participate in culture, and what effects culture has on society. As its website says: 'One major evidence issue which underpins the case for investing in culture and sport is understanding what "value" it adds to society' (CASE 2009).

The fundamental thing we should be looking for in judging these exercises in terms of measuring Instrumental Value is their objectivity, because research sometimes get confused with advocacy, where the facts are presented so as to make the best case for whatever it is that you want to do. There is also a question about the transferability of research from one situation to another; the circumstances and context of one arts project often do not translate into different circumstances. But that does not mean that, provided your methods are rigorously and systematically applied, the social and economic benefits of cultural activity cannot be measured, and articulately expressed.

Exercise

Write down all the ways that you think your organization benefits your local community. Then consider how those benefits can be measured. Do you have a set of starting points so that you can show how things have improved? For example, if you think you have added to the turnover of nearby businesses such as hotels and restaurants, can you show how much extra trade they have had because of what you do?

4.11 MEASURING INSTITUTIONAL VALUE

The question is how can Institutional Value be assessed? Well here, in contrast to Instrumental Value (where researchers are trying to find out the objective, measurable benefits of culture), what is looked for is the value that people collectively place on culture. It is very difficult to turn that calculation back into a monetary figure of the kind that might persuade politicians, or arts funders, of the economic value of what you are trying to do, but there are techniques available.

One way is to ask people how much they would be prepared to pay for a service that is currently free, or how much they would want to be paid in compensation for the withdrawal of a service. Known as 'contingent valuation' – or more simply Willingness To Pay – these surveys can produce surprising results, showing that people value services such as a free public library more highly than they are in fact paying for them indirectly through their taxes. A contingent valuation study of the town of Bolton's libraries and museums, for example, discovered that the citizens of that town placed a combined value on those cultural services that was more than one-and-a-half times what Bolton Council spent on them (Jura Consultants 2005). Some experts in the field argue that arts organizations should be less afraid of trying to put to find a monetary expression for the value of what they do: 'the solution is not to exempt arts spending from economic criteria, but to improve the economic practice used to judge such spending' (Bakshi *et al.* 2009: 2).

We provide an 'Institutional Value scorecard' in the final challenge, section 8.4.

Exercise

How well do you know your public? Do you really know what your public thinks of you, and what they want from you?

- Make a list of the ways in which your audiences, supporters and members of the community who never visit you are heard by your organization.

- What channels of communication are open between you?

- Is all your communication one-way?

- Is it static or dynamic?

- In what ways could you improve the organization's relationships with the people it serves?

4.12 CULTURAL VALUE: PUTTING IT ALL TOGETHER

Intrinsic, Instrumental and Institutional values are not three distinct boxes where we put different experiences or art forms. Contemporary dance is not all about Intrinsic Values and theatre is not all about Institutional Values. The point is that all these three values are viewpoints or perspectives of equal validity, and they should be considered together. When a schoolchild is taken on a school visit to a museum, they may well have a moving emotional experience that can be talked about using the language of Intrinsic Value; they may be taught about an artist, and reproduce their learning in the exam room, and that becomes a measurable instrumental benefit, just as what they spend from their pocket money in the shop contributes to economic activity. And they may get a sense of civic pride from this local museum, feel part of their community and see the museum as a public place that they are entitled to share with others – and that would be an example of Institutional Value.

4.13 CULTURAL VALUE: A PRACTICAL EXAMPLE

In 2004 the National Gallery in London had an opportunity to buy Raphael's painting, *The Madonna of the Pinks*, from its owner, the Duke of Northumberland. The final price was nearly £35 million, a huge sum that had to be raised by a national appeal, by applying for money from the private charity, the Art Fund, and by applying to the public body, the Heritage Lottery Fund (HLF), financed through the National Lottery. The HLF came up with £11.5 million.

There were those who thought this a ridiculous amount of money to pay for a single, quite small, picture. A think-tank, the Institute for Public Policy

Research, came up with what might be called an 'instrumental' analysis of what could have been done with the Heritage Lottery Fund's £11.5 million instead. They calculated that it could have funded:

- 695 newly qualified nurses for one year, or

- 635 newly qualified teachers for one year, or

- 687 newly qualified prison officers for one year, or

- kept 318 prisoners in jail for one year (Cowling 2004).

A calculation based on the principles of that we have been discussing in this challenge, however, suggests that the Heritage Lottery Fund's £11.5 million was money for Cultural Value, because *The Madonna of the Pinks* has:

Use value: it will make an economic contribution. In the National Gallery (as opposed to a private house) it will attract visitors whose expenditure will support jobs and economic activity generally. This is Instrumental Value.

Existence value: even though some people may never visit the National Gallery, it is being preserved in case one day they might wish to do so. This is an example of Institutional Value.

Bequest value: the existence and the availability of the painting have been guaranteed for future generations. Again, this is Institutional Value.

Historical value: the painting represents a link between the past and the present that helps people understand their relationship to the past, which is a form of educational – and therefore instrumental – value.

Social value: the National Gallery is a freely accessible space; the painting can be enjoyed individually and collectively. It is now 'owned' by the nation: by bringing people together, it has Instrumental Value and, because the National Gallery makes it freely available, Institutional Value.

Symbolic value: the painting is an expression of ideas about motherhood. This has social and educational value, which relates to the instrumental vector of the cultural value triangle, but is also intrinsic to the painting itself.

Spiritual value: the painting was conceived as a religious icon, which could be thought of in terms of educational and social value, but since spiritual

feelings are the inspiration for the painting, we see this as an aspect of its immeasurable Intrinsic Value.

Aesthetic value: however subjective the experience may be, most people find that the painting is beautiful, with a harmony of colour, proportion and poise. This comes only from the painting itself and so is the clearest example of Intrinsic Value.

As you will see from this practical example, the three vectors of Cultural Value are sometimes hard to separate out into hard-cut categories. But that is the point: there is always a dynamic relationship between the three aspects. It is your job to be able to bring them together, so that these different aspects make a coherent case for what it is that you want to achieve.

4.14 TOOLBOX: HOW TO ANSWER THE CHALLENGE OF CREATING CULTURAL VALUE

In order to know whether you are making a difference to the public realm, you need to be able to articulate what values your organization creates. It is certain that it will be aiming to create many different sorts of value for different people, as our practical example demonstrates. The people who work with you will get financial value when they are paid; funders will want their funding criteria to be met; audience members or visitors will be looking for something from their expenditure of time or money.

- Ask yourself who your organization is serving, and make a list of people and groups who have an interest in what you do – your stakeholders.

- What value do those people and groups want from you? (You may have to ask them in order to find out.)

- Decide how you are going to measure or judge the different types of value involved and ask yourself:

 - How do we judge the artistic or cultural quality of what we do?
 - Do we know what our audiences experience?
 - What effects do our activities have on people and how can we explain those effects to others?
 - What value are we creating for our communities? (These might be local, regional, national and international, as well as special interest groups and virtual communities.)

4.15 CASE STUDY

You are the leader of a regional museum in a town that is funded by both the town and the county local government. The museum has collections of local archaeology, natural history and some modest paintings. It also houses a world-class collection of clocks, the gift of a local clock manufacturer who supports the museum financially. In common with most museums of this type, you host visits from schools, have a friends' scheme, run a café and lend objects to other museums.

Question 1: the county authority that supports you is questioning whether you offer value for money. How will you justify your receipt of funds from them?

Question 2: how would you set out to be more valued by your local community? How do you think that value could be best expressed?

4.16 SUMMARY

A cultural organization has to be concerned with much more than profit and loss: it has to create Cultural Value. Cultural Value is created in three principal ways: firstly through the intrinsic qualities of the activity, secondly through the instrumental benefits – social and/or economic – that the activity generates, and thirdly through the way the institution connected with the activity behaves both to its own people and the public at large. Brought together, the interdependent intrinsic, instrumental and institutional aspects of Cultural Value provide a means by which a leader can articulate the significance and meaning of what a cultural organization does.

4.17 RESOURCES AND READING

To follow up ideas on the concept of Cultural Value, John Holden's pamphlets *Democratic Culture* (Holden 2008), *Capturing Cultural Value* (Holden 2004) and *Cultural Value and the Crisis of Legitimacy* (Holden 2006) are all available from Demos as free downloads at www.demos.co.uk/publications. An American approach to the question of Cultural Value can be found in the Rand Corporation's *Gifts of the Muse* (McCarthy *et al.* 2004). To explore the relationship between economic and cultural values, Michael Hutter and David Throsby's *Beyond Price: Value in Culture, Economics and the Arts* (Hutter and Throsby 2008) is a very useful collection of essays by philosophers, economists and art historians. David Throsby explores the way economic and

cultural values relate to official policy-making in *The Economics of Cultural Policy* (Throsby 2010).

The classic text on Instrumental Value is, for economic impacts, John Myerscough's *The Economic Importance of the Arts in Britain* (Myerscough 1988), even if the figures are now out of date and the methodology challenged. For social impacts, François Matarasso's *Use or Ornament* (Matarasso 1997) defined an approach to articulating the benefits of taking part. For a critique of the way cultural impacts are measured and used in official policy, read Sara Selwood's article 'The Politics of Data Collection' (Selwood 2002). In education, the organization Creativity, Culture and Education (CCE) has produced a steady stream of findings since it was set up originally as Creative Partnerships; all of its reports can be downloaded from www.creativitycultureeducation.org/research-impact. The International Federation of Arts Councils and Cultural Agencies has made a study of the contribution of culture to regeneration, *Art and Culture in Regeneration* (IFACCA 2006).

The idea that institutions (of any kind) can create or destroy what the Harvard professor of government Mark H. Moore called 'Public Value' was developed in his study *Creating Public Value: Strategic Management in Government* (Moore 1995). You will find out more about Institutional Value in the context of the cultural sector in Robert Hewison's pamphlet, *Not a Sideshow: Leadership and Cultural Value* (Hewison 2006), available from Demos as a free download.

Ways of measuring Intrinsic Value are suggested in Alan Brown and Jennifer Novak's *Assessing the Intrinsic Impacts of a Live Performance* (Brown and Novak 2007), available at www.wolfbrown.com/index.php?page=mups.

In the UK the Independent Theatre Council, the Society of London Theatre and Theatrical Management Association have jointly launched *Capturing the Audience Experience: A Handbook for the Theatre* (Independent Theatre Council, Society of London Theatre, Theatrical Management Association 2005), which shows you how to assess audience response to performances, and has sample questionnaires and surveys. It is available for download at www.itc-arts.org/page204.aspx.

For economic impacts, the Arts & Economic Prosperity III Calculator (*Americans for the Arts* 2009), devised by Americans for the Arts, is available at www.artsusa.org/information_services/research/services/economic_impact/005.asp.

For educational and social impacts, the Museums, Libraries and Archive Council's 2008 'Inspiring Learning For All' toolkit can be found at www. inspiringlearningforall.gov.uk. You can find out more about the British government's Culture and Sport Evidence Programme (CASE 2009) at www. culture.gov.uk/case/case.html.

For contingent valuation, or Willingness To Pay, David Throsby's *Economics and Culture* (Throsby 2002) is an excellent introduction to the topic. He discusses the topic further in an article for the *Journal of Cultural Economics* (Throsby 2003).

The example of *The Madonna of the Pinks* is based on our report on the cultural value of heritage for the Heritage Lottery Fund, *Challenge and Change* (Hewison and Holden 2004).

5 Challenge: Creativity

'The realisation of creativity rests on collaboration.'
R. Hewison, J. Holden and S. Jones (Hewison et al. 2010: 20)

5.1 INTRODUCTION

It goes without saying that creativity should be at the heart of everything you do – but there, we have just said it. Whether you see yourself as a leader at the service of an organization or an entrepreneur striking out on your own, the one constant is change, and what drives that change is the creativity of yourself and those with whom you work. Most discussions of this topic begin with the abstract, philosophical question of what really constitutes creativity. We will come to that, but from your perspective, the most important idea you have to grasp is that you are not dealing so much with creativity in the form of self-expression, as with the work of creative people, including yourself. But the idea of 'dealing' with creative people, whether they actually call themselves 'artists' or not, is to step off on the wrong foot. In this challenge we look at what makes creative people tick, what that tells us about the way creativity works in collaborative situations and how best to manage that process, and the risks involved, within an organizational framework.

5.2 CREATIVE PEOPLE

There is no doubt that creative people are special people. In her study of the academic writing on cultural labour, an expert in this field, Kate Oakley, has pointed out that artists are seen as:

Part of a select group of people – including academics, researchers and scientists – for whom the standard economic model does not work, and for whom satisfaction or a desire to work in their chosen field generally motivates them more than financial reward. (Oakley 2009: 41)

That satisfaction comes from the encouragement to think and act creatively, and the sense of achievement when things go right. Oakley reminds us that 'creativity' is not confined to artists. We all have the potential to be creative – even if for some of us it is only creative accounting.

Everyone in your organization should be treated as having the capacity to be creative, but it stands to reason that visual artists, actors, choreographers, curators, dancers, designers, directors, musicians and writers will be more comfortable with the 'creative' label than box office staff, front-of-house personnel or gallery attendants. (One note of caution: sometimes creative people take 'uncreative' jobs to get a foot in the door – make sure their creative ambitions don't lead to frustration in the job you have hired them to do.) With the exception of some senior people – an artistic director, if you have one, or musical director in the case of an orchestra – for the most part the recognized 'creatives' in your team will have a distinct relationship with your organization because they will be there for a relatively short time – for a production, a season, a project – and that will affect the way they see you, 'a member of staff'. Usually they will be self-employed – freelance – and the economic conditions of their working lives have a profound effect on their attitudes and behaviours. It is important to understand what shapes their approach to working with you, so that you can give them the best support possible, while being prepared for some of the challenging aspects of the creative life.

One such aspect, which anyone working in the cultural field will recognize, is insecurity. The idea of the 'portfolio career', where people have more than one job and constantly move from temporary project to temporary project, has long been familiar in the arts. The rest of the world is beginning to catch up, as industrialized employment, along with an industrial economy, becomes a thing of the past for many in the West. With creative people, however, some of the insecurity that they manifest comes from the very commitment that they show – that passion and drive which makes you want to work with them in the first place. Because they identify themselves so closely with the work they do or make, when their work does not go well they suffer deeply, for there is so little distance between themselves as people and their work as artists.

Because they are so keen to work, creative people are not just open to exploitation by others; they are far too ready to exploit themselves. In his study of the 'no-collar' workers who enjoyed the free and easy days of IT start-ups in the 1990s, the American sociologist Andrew Ross describes their eagerness as 'sacrificial labour', which he defined as: 'A willingness to work in low-grade office environments, solving creative problems for long and often unsocial hours in return for deferred rewards' (Ross 2003: 10).

Sounds familiar? But, as Ross quotes one of his interviewees 'it was work you couldn't help doing' (Ross 2003: 10). Artists, says Ross:

> *are predisposed to accept non-monetary rewards – the gratification of producing art – as partial compensation for their work, thereby discounting the cash price of their labour. Indeed it is fair to say that the largest subsidy to the arts has always come from arts workers themselves. (Ross 2003: 142)*

93

The downside to the upside of job satisfaction is that not only are the financial rewards low, there are always people ready to take the job if someone else won't. The worst case concerns interns, who are so desperate for work experience that they will work for nothing. Interns and volunteers, who we will be discussing more in Challenge 6, when properly looked after can be a vital part of your organization, bringing enthusiasm and new ideas. But if they are simply treated as cheap labour, you will be destroying the institutional value we talked about in the last challenge – as well as harming both the intern and yourself.

It should also be understood that creative people in your organization are not only often providing 'sacrificial labour', but also what the sociologists call 'emotional labour'. That is obviously the case with an actor in a tragedy or a dancer in a ballet, but you need to appreciate that the emotional identification between the artist and the work, in whatever form, is so close that the person becomes the product. Here, there is an interesting crossover into the work that is done by many people who would not consider themselves 'creatives', but have just as important a role because they 'interpret' your organization to the public. We are talking about people like box office staff, receptionists, catering staff, front-of-house ushers and gallery attendants. They too are involved in a 'performance' – and hopefully a sincerely motivated one – sympathizing, responding, smiling, engaging. It is worth remembering the extent to which everyone in your organization is part of what your creatives offer to the public.

The upside of the insecurity of the creative professions is independence. A freelancer is precisely that: she or he can go and work for whomever they please. They are hired for their distinctive contribution, and they hold on to that and the creative satisfaction that they derive from making it. For their study of people working in the so-called cultural and creative industries, *The Independents: Britain's New Cultural Entrepreneurs* (Leadbeater and Oakley 1999), Charles Leadbeater and Kate Oakley talked to web designers, video-games makers, and dance and music promoters, who were in the main self-employed:

> *Most people who are self-employed in the cultural sector want to stay that way. They do not want to work for large organizations: they recognise that employment has become more insecure and unstable; they do not want to be told what to do; they do not want to be part of a corporate culture or formal career structure; they prize their small scale as the basis for the intimate and creative character of their work. They opt for self-employment or micro-entrepreneurship because independence will give them a sense of authorship and ownership: it is the best way for them to develop their own work. (Leadbeater and Oakley 1999: 22)*

As with the traditional visual and performing arts, and to an increasing extent in the world of museums and galleries, the trade-off is between insecurity and independence. When it comes to creativity, you will have to learn to manage contradiction and, let's face it, sometimes contradictory people.

5.3 CREATIVE PEOPLE: THE PROS AND CONS

Creative people are your most vital asset, so you need to understand them. Often their virtues are their vices – and vice versa. Here are some characteristics of creative people, set out in pairs that look like positives and negatives, but which are in fact closely related consequences of each other.

Creative people:

- are often playful/ but not always reliable;

- hate isolation/but like to work alone;

- are highly cooperative/ but also fiercely competitive;

- are good at multi-tasking/ and like to cultivate specialist skills;

- are good at managing their tasks/and don't like being given deadlines;

- are ready to take risks/but have a short-term perspective;

- are good at motivating themselves/but are often insecure about success;

- are capable of deep commitment to a project/but will be manipulative in order to get what they think is right;

- are tolerant of ambiguity/but need to be able to work within a secure framework;

- like to cooperate on projects/ but dislike long-term engagement;

- are open and tolerant/ yet like to work with people they know;

- are quick to build trust/but also quick to move on;

- are ready to experiment/and are resistant to routine;

- like networks/dislike bureaucracies;

- are hugely enthusiastic/and can burn themselves out.

Doubtless you can think of some more pairings, which are kinder, or harsher, about creative people. But if you look more closely at this list, you will see that the left hand of each pair is more concerned with working in groups and the right hand more to do with individualism. This reflects another apparent contradiction within the idea of creativity – that, on the left hand, it comes from people coming together to collaborate and, on the right hand, that it depends on some kind of lonely genius. We say that this is an *apparent* contradiction because, just like the paired characteristics listed above, these ideas are so closely linked, that they exist in tension – and a creative one at that

Exercise

Write a profile of a creative person who you know and respect. Analyze your own practice in relation to the list of characteristics – which side do you mainly fall?

5.4 CREATIVITY

So what is creativity? We have deliberately approached it through the characteristics of creative people because we want to emphasize that this is above all a dynamic process, and that the sort of contradictions that we have been hinting at generate energy. There is a large amount of theoretical literature on creativity, but one way of looking at it is to say that it is a process that is dialectical. Put simply, an idea – a thesis – meets its opposite – its antithesis – and out of this encounter there emerges a new idea – a synthesis. What makes this a dynamic process is that the synthesis becomes a new thesis, which meets its antithesis, which ... etc., etc. The dialectical process involves a fair amount of tension and struggle, which is why it appealed to Karl Marx. The skill you have to master is to turn 'the dialectic' from potential conflict into a positive outcome.

At its simplest, creativity is do with making something new, be it the work of the hands or of the imagination. But we have to be careful about the word 'new', and recognize the difference between creating something that is new to you and new to the world in general. Similarly, we have to acknowledge that there is a distinction between something that is merely novel and something that is truly original. In the last century the Austrian economist Joseph Schumpeter established an important distinction between 'invention' – that is to say the discovery of genuinely new ideas – and 'innovation', which took those ideas and turned them into practical applications. Crudely, the work of invention is the business of artists and scientists, while the work of innovation is that of technocrats, producers, and indeed businessmen and women who find ways to turn creativity into cash. Schumpeter's distinction has become broadly accepted, so that a recent report on the creative and cultural industries by the British think-tank the Work Foundation argues that creativity:

> is about the origination of new ideas – either new ways of looking at existing problems, or of seeing new opportunities, while innovation is the successful exploitation of new ideas. (Work Foundation 2007: 16)

Innovation often comes about by successfully putting things together in new combinations; creativity is about achieving a genuine transformation. There are systems and techniques that you can use to produce something novel, but an original idea can come from breaking all the rules in the book, which is why creativity involves risk.

5.5 THE ACT OF CREATION

So how do you originate new ideas? It seems to be a mysterious process – but it is a process, and the truth is that a flash of inspiration may come by accident, but the mind has been preparing itself to receive that flash and then goes on to give shape to the idea that has appeared. In his study *The Act of Creation*, the novelist and thinker Arthur Koestler argued that creation happened when two completely different systems of thought – he called them 'matrixes' – crashed into each other, as it were, at right angles to create a new idea. Koestler called this 'bisociation' and argued that the more extreme the difference between the two matrixes, the more creative the collision would be (Koestler 1975: 121). In his study *Management and Creativity*, the English academic Chris Bilton suggests that to be creative we need to be prepared to think logically and illogically at the same time, a classic case of bisociation:

> *Creativity requires that we think irrationally and rationally, that we cross boundaries between different ways of thinking, that we not only have the ideas but the resources and inclinations to do something with them. (Bilton 2006: xiv)*

97

Two of the matrixes that most frequently crash into each other in the cultural sector are, on the one hand, the ambitions of those who want to run a project and, on the other, the resources that are available to carry it out. Handled well, this can be a very creative process, handled badly ...

Another explanation of creativity comes from the 19th-century French physicist Henri Poincaré, who came up with a simple way to describe the process by which individual creativity comes about. First there was:

- *Preparation*: the mind starts to gather information, to tease at a question, to speculate. Then comes a period of:

- *Incubation*: the material is digested, half forgotten, literally slept on. And then comes:

- *Illumination*: the sudden moment when the flash of inspiration happens, when the matrixes clash, when the solution appears. But this is then followed by a longer period of:

- *Verification*: when the new idea is subject to thorough testing, to see if it is truly original and not a mere novelty, and, above all, to make sure that it *works*.

Poincaré was thinking as a scientist, but it is easy to see how this translates into creativity in the arts. He was writing at a time when the predominant image of the artist was that of the lonely creator, the tormented genius: Beethoven, Wagner, Keats, Baudelaire, Rodin. But this Romantic image is a long way from how creativity is seen today, when the emphasis is much more on creativity as a process of experiment rather than on a single flash of inspiration, and as something that depends increasingly on mutual collaboration, not artistic isolation. As a leader or entrepreneur, this latter description will be much closer to the conditions you will be working in. That does not mean that creativity is not concerned with self-expression – that is where the imagination and drive will come from – but it will be best achieved when the conditions surrounding self-expression are understood.

The reasons why a more collaborative model of creativity is emerging are entertainingly discussed by the American author Malcolm Gladwell in a video available at www.newyorker.com/online/video/conference/2007/gladwell. And the gradual dropping of the idea that creativity depends on a lonely genius matches the move away from the idea that leaders are charismatic heroes who bear the whole weight of decision-taking on their shoulders, as we argued in Challenge 2. But that does not mean that leaders do not have a responsibility to lead – or to come up with new ideas.

Exercise:

• When did you last have a new idea?

• What were the circumstances that brought it about?

• Do you see it as an original idea, or an adaptation?

• How are you going to set about putting the idea into practice?

5.6 THE CONDITIONS FOR CREATIVITY

Although the best way to translate an idea into action is through collaboration, there is no harm in a certain amount of conflict along the way. Indeed, the language we have been using to describe creativity implies tension, clashes, struggle. But these clashes are not necessarily between people. The tension is caused by the conditions within which the act of creation takes place.

To begin with, creativity will always have a *context*. As Margaret Boden, who writes about creativity in terms of what can be learned from computers about artificial intelligence, argues: 'To be appreciated as creative, a work of art or a scientific theory has to be understood in a specific relation to what preceded it' (Boden 1990: 61). That relationship with pre-existing ideas will be, as we have suggested, dialectical, partly in opposition to earlier ideas, partly derived from them.

- Creativity almost always has a specific *purpose*: something needs to be said, done or made, and a way has to be found to do that.

- Creativity is built on the act of *making*: it is not enough to say that something has to be done: something has to be made to happen.

- Creativity is built on *expert knowledge and experience*: you need to know how to make things, how to say and do things in the most effective way. That means that creativity will depend on professional 'craft' as well as imaginative 'art'. The great thing about working with creative people is that they tend to have a set of 'hard skills' that relate to their particular craft, and a set of 'soft skills' – innovation, networking, communication, risk-taking – that are transferable to many situations. Both types of skill need to be backed up by business skills such as financial planning, IT and management.

- Creativity is built on *tradition*: that may sound odd when we are talking about making something new, but tradition is part of the context from which new ideas spring. It is the repository of expert knowledge and experience – and it is there precisely to be challenged. Cultural conventions give you a language in which to express ideas – and something to oppose.

- Creativity is built on *discipline*: inspiration only comes when the mind is well prepared and the subject properly researched. Inspiration will only be effective if the idea is fully tested.

- Creativity benefits from *constraints*. As Margaret Boden writes: 'Far from being the antithesis of creativity, constraints on thinking are what make it possible' (Boden 1990: 82). In the cultural field these constraints can be internal or external. Internal constraints can be the form the idea has to take, the genre you are working in, indeed the traditions and conventions that we have already mentioned. External constraints are more physical: time and deadlines, budget, human and material resources, the location you are working in, even

99

geography. Other stimulating constraints include competition with your peers. Even uncertainty about the future can lead to new ideas.

To sum up, because creativity flourishes in conflict and benefits from constraints, it can be approached as a process of problem solving. That is what makes a creative solution different from merely thinking up a novel idea. Just as a start, a lot of hard work has to go into identifying precisely what the problem is to be solved. Asking the right question is often more difficult than finding the right answer.

Exercise:

- Think about an organization you know well.

- What are the things it does best?

- What are the things it does worst?

- What are its traditional ways of working?

- What resources does it lack?

- What is holding it back?

- What is the solution?

5.7 CREATIVITY IN CULTURAL ORGANIZATIONS

If you agree that creativity is a process of problem solving, then leadership is the most creative thing you could possibly do. There will be lots of problems to be solved in your working day. But you will not be able to solve them on your own, and you will have to respect the creativity of others, especially if you are the facilitator of the event, or the host or commissioner of the production. At the same time, do not neglect your responsibility to contribute to the process by reminding people of the constraints on your organization. As we have argued, constraint can lead to creative solutions, whereas if you indulge artists because they have 'genius' you will not merely infantilize them, they will behave accordingly. There may be times when you will have to step in to protect staff from the demands of artists, though we would not agree with the American arts administrator Marilyn Taft Thomas, who writes of the business of handling artists: 'Someone who has raised a two-year-old may actually be better qualified for the job than the more likely candidates

with lots of professional credentials' (Thomas 2008: 11). Often, it is the lack of respect shown to creative people that makes them behave in childish ways.

So where does responsibility for creativity within an arts organization lie? We are not talking about the work itself – the play, the ballet, the opera, the concert piece, the sculptures or paintings – or the people who perform or make the work. We are talking about the people who have the responsibility of solving all the problems that can be thrown up while getting these things and these artists in front of the public – and solving them creatively. These people have similar overall responsibilities, but tend to fall into one of two different roles.

5.8 DIRECTOR OR PRODUCER?

In the 20th century a fundamental – but, on a day-to-day basis, very fluid – distinction grew up between the people who were responsible for getting the show on the road and those who were responsible for making sure there was a show, and by extension, a road to go on. This is the sharing out of responsibility between the *director* and the *producer*. These roles grew up in the theatre, and were transferred to and formalized in film, radio and television. In the 19th century what became the responsibilities of the theatre director were undertaken either by the stage manager or the leading actor, but as technical specialization grew, someone was needed not only to oversee things like scenery and lighting, but also to have an overall vision of what the play was to look like, say and mean. As the title suggests, the director's creative focus is on pointing everything in the direction of making the work actually work.

The forerunner of the producer was the impresario, the organizer of events, and that word remains in use, often in association with opera. The producer's creative role is to organize the circumstances that will allow the production to happen – beginning with finding the money. Controlling the money means that the producer will be in a position to control the resources that go into a production, and that can mean the choice of director, as well as hiring the theatre, actors and technical team. But the producer's job also faces outwards – towards the investors in the production, the press and the public.

So far, so obvious, but the question is, where does the creative responsibility lie? Is it with the director, who decides what happens in a production, or the producer, who puts it on in the first place? Rows between producers and directors are legendary. When we think about the conditions of creativity, we can see why: the producer will generate the context, purpose and the

constraints (especially financial constraints) within which the director's creativity has to operate. Some directors manage to act as their own producer, but the stress of combining these roles is such that most do not – which is why the distinction grew up in the first place.

The reason for stressing the opportunities for tension between producer and director (and between choreographer, designer, conductor and all those other creatives who make a show happen), as well as the creative possibilities in the producer's function, is that these possibilities and tensions can be at their most extreme when the producer/director relationship is not concerned with a single production, but the long-term running of a theatre, opera or dance company that has not just a programme of shows, but a building to maintain.

In most building-based operations there will be a hierarchy of functions on the administrative side and a hierarchy of functions on the creative side, and they will have to meet somewhere. In small organizations the meeting point will be the *artistic director*, who is also preoccupied with setting the long-term vision of the organization, not to mention putting on shows. The larger the organization, the more likely it is that the two sides will meet just below the artistic director, and the responsibilities of holding them together fall on the shoulders of someone who used to be called *general manager*, but who nowadays is more likely to enjoy the more elevated title of *executive director* – there must always be someone who can represent the administrative, technical and, most important of all, financial aspects of the operation to the artistic leadership. Responsibility for running the building on a daily basis will fall to someone reporting to the executive director, rather than the executive director in person.

Michael Kaiser, *president* (that is to say, in effect, *chief executive*) of the Kennedy Center for the Performing Arts in Washington, DC (and before that chief executive of the Royal Opera House in London), likes to raise a laugh when he discusses the artistic director/executive director roles:

> *I always compare the relationship between these two staff heads to that between a naughty child (artistic director) and an angry parent (executive director). The naughty child is always asking for 'more, more, more!' and the angry parent says 'No! No! No! We can't afford it.*

But the laugh has a serious point: 'The lack of trust that develops between the two people who are meant to act as a team is ineffective at best and crippling at worst' (Kaiser 2009).

So how do you solve the problem?

In business, the chief executive is king, but in the arts the watchword should be collaboration. To be successful, the artistic director and the executive director need to share power and responsibility in what is sometimes informally called a 'duumvirate'. There is still a distinction between their roles: Vikki Heywood has described her job as executive director at the RSC as to 'head up the strategy and delivery of the business side of the RSC, making sure that all the creative plans can be turned into reality' (Heywood 2010), which shows her producer role, and of course she does not direct plays, as an artistic director would. In spite of his powerful position, Michael Kaiser says:

> *The truth is that the only reason the executive director has a job is to fulfil the wishes of the artistic director. And good artistic directors always have a wish list because they want to expand the boundaries of the organization and consistently produce good art. (Kaiser 2009)*

Kaiser's point is that in the arts creativity is a necessary aspect of leadership and, by making sure that the artistic director is the head of the team (as at the National Theatre and the RSC), creativity is acknowledged as the most important virtue, because that way the whole organization will thrive.

It is not the only virtue, however, and it takes more than two people to turn creative plans into reality; the principle of collaboration at the top has to be spread throughout the organization. The third most important person will be the *finance director*, definitely *not* a creative role, but which has a great deal of influence in terms of what we have called context and constraints. The key is to build a team where the difference between the 'creative' and 'non-creative' roles are respected, but people are not polarized in the process. We will talk more about team building in Challenge 6, and the responsibilities of the finance director in Challenge 7.

So far we have been talking about creative roles in the leadership of the performing arts, but there is just as much need for creativity in museums and art galleries, historic houses and archaeological sites. Partly because they will usually have been around for a long time, public museums and art galleries tend to be organized on hierarchical lines, with different departments – conservation, education, registration of collections, collection management and the usual business, customer-service and communication departments – having different organizational cultures, and even different pay grades. But the need for team building and collaboration is just as great as in the performing arts.

The most obviously creative role in this context is the *curator* – the person who has care of the collections. Nowadays, curators are usually outnumbered by the rest of the staff, but they remain the key people, and it is very unusual for someone who has not been a curator to become a *museum director* or *gallery director*. The curator's primary responsibility is towards the objects in the collection, but art and artefacts only come to life when they are displayed and explained. Creativity comes in the research into the object that is to be displayed and even more in the way that the object is interpreted to the public by how it is displayed. In some ways, a curator's role is similar to that of an *editor*, in that the curator selects and assembles objects or images that have already been created, putting them together in a creative way, just as an editor decides what will be published. In art galleries this editorial role can extend into commissioning work, as well as presenting it.

The creative role of curators in a museum or art gallery context – especially with the development of mixed media and installation art – is such that they have begun to be seen in much the same way as producers, and some are sufficiently independent-minded and successful to work as freelancers, outside the hierarchy of an established organization. It is now fashionable to talk not just of curating exhibitions, but seasons of dance and other performances, treating them like a collection where the different parts come together in a creative whole. At the dance theatre Sadler's Wells, some of this work is undertaken by the Head of Research, Emma Gladstone. She may not be called curator, but it is a similar process, working with ideas and people. As she colourfully put it to us: 'A lot of what I do is like a dating agency.'

When we find that cultural events are being credited with having a *creative producer*, we seem to have come full circle, back to that tension between producer and director, but now emphasizing the creative aspects of the producer's function. As we have argued, there is no harm in a little tension, but mutual respect and collaboration will get the best results. And as we also said, the distinction between producer and director is in practice a fluid one. A series of interviews with 14 contemporary creatives, *The Producers: Alchemists of the Impossible* (Tyndall 2007) shows just how rich and varied the job can be.

Exercise:

- You have been asked to direct a new play. Write down, in order, your ten top priorities.

- You have been asked to produce a new play. Write down, in order, your ten top priorities.

- Where do the two lists differ?

- Where are they the same?

5.9 KEEPING A CREATIVE ORGANIZATION CREATIVE

The Poincaré paradigm for individual creativity that we discussed earlier – preparation, incubation, illumination, verification – applies equally to the process by which an organization develops a project. The conditions for creativity outlined in section 5.6 similarly apply. And, as with an individual, there is the problem not just of being creative, but staying that way. Working in a particular artistic tradition, keeping your audiences happy by respecting the conventions of form and genre, may feel satisfying and creative – but how often is a production just a reproduction?

Overall, only a small proportion of cultural activity at any one time is genuinely new work – and even then we must distinguish between the new and the novel. The proportion will vary from art form to art form. Opera houses, classical ballet companies and orchestras do relatively little new work, often presenting a well-established repertoire, albeit in new performances or productions. Theatres invest in new writing, but their staple diet is often the classics and revivals of established plays. The majority of art exhibitions are retrospective, even when a living artist is involved. The leading opera producer Sir Peter Jonas, who was very successful in the 1980s running English National Opera as general director in a 'triumvirate' with the conductor Mark Elder (music director) and David Pountney (artistic director), has argued that the solution to this problem is to make sure that, whatever the chosen art form, the emphasis must be not on 'representation' of the work, but on its 'interpretation'. As we pointed out in connection with museum displays, it is in the interpretation that creativity is to be found (Jonas 2006).

105

The problem, however, is not just staying creative within each individual piece of work, but staying creative as an organization as a whole. Arguably, many cultural institutions are not creative at all. They present creative interpretations of the cultural canon and add to it with new work. But too often they are content to work with a fixed idea of the audience they are trying to reach, and a conventional and well-established way of delivering their work. That is often unconsciously determined for them by the kind of building in which they operate.

There are organizations that make a virtue out of having no fixed abode. The London-based organization Artangel manages to avoid commitment to any particular cultural medium by not having a permanent performing or exhibition space. It is free to commission genuinely new work in theatre, film, music, sculpture, radio and even has a project that will run continuously until 31 December 2999 (van Noord 2002). Very little of Artangel's work is intended to be permanent, which is creatively liberating. Similarly, it constantly renews its relationship with its audience by never performing in the same place twice, and by using unconventional locations and 'found' public spaces.

Although Artangel was actually started in 1985, it has so far managed to stay ahead, in the avant-garde. Long term, it is possible to see a pattern in the life of an organization, from being cutting-edge, leading the way with the development of new forms of expression and new ways of seeing the world, to becoming devoted to the conservation of a body of work and the policing of 'standards'. This is the journey from the avant-garde to the academy.

The academy has its uses as a form of collective memory, as an archive of repertoire and practice, but it is not a crucible of innovation. What we have described is a long-term process, but every organization has to watch out for the way that its original creative, entrepreneurial approach is gradually supplanted by self-repetition, formalization and, eventually, bureaucracy. People begin by looking forwards and outwards towards future goals, and finding new ways to achieve them. But as they become established they start to look inwards and end up looking backwards, and are therefore increasingly resistant to change.

The kind of gradual atrophy that we are describing doesn't just apply to the work that an organization does, it applies to the way it goes about its business. One of the effects of public funding can be that a necessary financial cushion actually stifles creative thinking. Organizations don't have to consider competitive advantage over their rivals, or work out new ways of financing their operations. Similarly, as we will be discussing in Challenge 6, the way an organization is managed and led can fall into a routine, when there may be a good reason to change its structure, its patterns of governance, even the title used by the leader. The way to overcome this is always to look forwards, since decisions about policy must always be about the future, not the past. That is one way of keeping your organization creative.

Exercise

Identify six organizations that you know well and whose work you respect. Which would you classify as part of the avant-garde and which as belonging to the academy?

5.10 THE CREATIVE INDUSTRIES

It would be impossible to discuss creativity without mentioning that very 21st century phenomenon, 'the creative industries'. There has always been a blending between 'pure' art forms and the business of making money from ideas. Until the Renaissance, painters and sculptors were considered merely to be highly specialist craftsmen. The technology of industrialization brought individual creations to a mass market, but the special importance to the economy of creativity in terms of ideas and images was formally recognized in the United Kingdom in 1998, when the (itself newly named) Department for Culture, Media and Sport set up a 'Creative Industries Task Force'. The idea that there can be such a thing as a creative *industry* has since been taken up around the world.

The Creative Industries Task Force was given the job of working out the extent of the field in a 'Mapping Document', so as to be able to devise ways in which government policy could support its economic development. But before that, they had to decide what it was they were dealing with.

The answer was that the creative industries were those that had their origins in individual creativity, skill and talent, and which had a potential for wealth and job creation through the generation and exploitation of Intellectual Property. This makes the essential link between individual creativity and wealth creation, but this definition could equally apply to scientific research, which similarly turns new ideas into new products. But whereas scientific ideas become exploitable when they become trademarks or patents, the creative industries are distinguished as those that exploit Intellectual Property in the form of legal copyright. The field was defined by certain forms of economic activity: advertising, architecture, the art and antique markets, crafts, design, designer fashion, film and video, interactive leisure software, music, the performing arts, publishing software and computer services, and television and radio.

Although this list excludes individual visual artists, and some not-for-profit activities like running museums, it is clear that in the broadest sense all these activities are *cultural* – that is to say they have something to do with meaning

and expression, with emotions as well as ideas – and that they are covered by both the commercial and public-funded spheres that we set out in Challenge 1. As thinking about the creative industries has developed, it has become usual to recognize this by talking about 'the cultural and creative industries' as opposed to just the creative industries. You could say that the 'cultural' part corresponds to the 'individual creativity' in the official definition, and the 'creative industries' part to 'the exploitation of intellectual property'. Although the journey from one to the other is by no means straightforward, it is possible to see how an inner core of 'pure' creativity in the visual, writing and performing arts provides the material for commercial development, and the talent to exploit it.

As far as creativity is concerned, it doesn't matter whether the initial creative act takes places in a commercially funded, publicly funded or homemade context and, as we have said, a cultural entrepreneur will be constantly moving between the three spheres. Little work has been done to probe how the relationship between publicly funded culture and the creative industries functions, but the good news is that as the creative industries have matured and offered a sustainable income to a greater number of people, there is a new situation in which individual expression, less structured work patterns and more varied social values are no longer such obstacles to the possibility of earning a living. (Think rock 'n' roll.)

As a result, in a digitized and globalized world the relationship between culture and creativity has become more complex, and potentially more economically as well as culturally fruitful. More and more people are engaging with the *content* and *spaces* of publicly funded culture, while the working lives of greater numbers of people are taking on the *characteristics* and *processes* of cultural practitioners. As we argued in Challenge 1, more and more people are working in ways that have long been common in the arts, meaning flexible, freelance and part-time work, but also working within conventional organizations in new ways, such as being part of ad-hoc teams and temporary associations to achieve particular aims or projects. The interesting thing is not that artists are having to learn to behave like businesspeople, but that businesspeople are becoming interested in learning how to behave like artists.

But many in the creative industries, as we saw in the quotation from *The Independents* in section 5.2, prefer to live and think like artists, which frustrates policy-makers and bureaucrats who want to institutionalize the creative process.

Although they have grown much faster than other parts of the UK economy, the creative industries are regularly criticized for failing to conform to

traditional business models. They lack the strategic skills to work out how to achieve high and sustained growth by having specific financial goals, and too few have such a thing as a formal business plan. To be a successful cultural entrepreneur, you will need these skills, and must abandon the snobbery about book-keeping and business-thinking that can come with being 'creative'.

It may be that this snobbery helps to explain why, in the mixed economy of the creative industries, the financial benefits have flowed for the most part from the publicly funded to the commercially funded sphere, and from individual artists towards corporations. In a very real sense public funding is a form of investment. Creative people get their education and develop their skills in the publicly funded sector, which then pays off for the commercial sector. As the classical actress and Oscar-winning film star Judi Dench has said: 'being trained in the theatre is a necessity. The health of our film industry depends on the health of our theatre' (Knell and Oakley 2007: 20). Public funds provide the training and the seed-money and the spaces for emerging talent. The story goes that the rock star Sting was able to buy his first equipment because of a local authority grant and first played in a local authority venue. The financial return on that tiny investment must represent one of the highest reward-to-risk ratios in history.

Even people who spend much of their working lives in publicly funded culture are employed ad hoc in the wider creative industries. Orchestral players, for instance, play on film and advertising soundtracks and with pop and rock musicians. Cultural organizations create markets for the creative industries. On a modest (but for the producers important) scale, shops inside arts centres and museums act as retail outlets for craftwork and publishing. On a much larger stage, whole industries benefit: the Victoria and Albert Museum in London is a constant resource for fashion designers and craftspeople looking for ideas. Publicly funded cultural organizations act as brokers, bringing together practitioners from different sectors, so helping to develop their networks and their practice. Spaces, places and conditions for networking are vital for the development of the creative industries, just as they for keeping cultural organizations creative.

A lot of that networking takes place in the third sphere – homemade culture – where ideas are generated that can transfer to either of the two other spheres, or ideally both. Whether you offer the idea to a publicly funded organization or to the commercial sector, you will have to be ready to deal with the gatekeepers who control access to the means to developing your ideas. The public sector will be looking for profit in terms of sustainability and social benefit; the commercial sector will be looking for straightforward profit.

Be prepared for the brutal fact that the generation of ideas tends to be less profitable than their exploitation. The training, research and development that goes into ideas and creative people tends to be a cost that falls on the public sector and on the people who, as we said earlier, are not really in it for the money, but for creative satisfaction. It may not pay the rent, but there is some satisfaction to be gained from knowing that the term 'creative industries' is not an oxymoron, because creative people are at the centre of the 'industrial' process.

Exercise

Take a publicly funded organization that you know well, and work out the ways in which it contributes to, or is exploited by, the commercial sector.

5.11 TOOLBOX: MANAGING CREATIVITY

> *'You need to have a strong chief executive who can make sure that creative people have high morale and are well motivated. You have to put your arm round their shoulders and tell them they are good.'*
>
> *Leslie Hill, former chairman of the UK's Independent Television Network*
> *(Hill 2009)*

Creativity is a complex process, and this challenge has concentrated on trying to understand the context in which creativity takes place. However unknowable the *process* of producing something original may be, the *results* of that process will be knowable and it will be clear whether they are useful or not. We have suggested that a lot of creativity is to do with problem solving. To maximize your own creativity, you will need:

- to be on the lookout for new problems and challenges, and not wait for other people to bring them to you;

- to be willing to share the process of solving those problems and meeting those challenges, in an open and collaborative way;

- to be able to apply the lessons you have learned from one situation to another;

- to know where to concentrate your efforts at any one time;

- to be open to learning, and always learning.

As a leader or cultural entrepreneur you are going to be working with creative people, and here are some tools to help you.

Creative listening. It is essential that you genuinely listen to what your team has to say, because:

- Sensitivity secures confidence

- Respect builds relationships

- Listening helps leadership.

Creative looking. It is essential that you also observe people's body language, because it can sometimes say something different to their words:

- Are they looking you in the eye?

- Is their expression open – are their arms or hands closed?

- Are *you* looking them in the eye?

Creative collaboration. Creativity is a shared process, so you have a contribution to make. Listen to artists, and when you speak, mean what you say:

- Negotiate, don't negate

- Transparency creates trust

- Flexibility fosters friendship.

To which it is worth adding:

- Optimism oils operations

- Courage conquers doubt

- Drive defeats defeat.

5.12 CASE STUDY

As a leader and entrepreneur, your creativity will be often expressed by
facilitating the creativity of others, which will depend on the particular art
form in which you are working. This case study invites you to imagine that
you are in charge of a large organization that actually exists, for instance a big
producing theatre, a major orchestra or a significant museum. Get hold of its
latest programme of activities or season's brochure and take a long hard look.

- How much of the work on offer is new?

- How much is novel?

- How much is 'reproduction', in the sense that it is familiar or
 conventional?

- How would you change the programme to make it more appealing
 to the public?

- Are there ways you could exploit the programme more commercially?

- Are there ways in which the organization could be more creative, in
 the sense that we have been using the word in this challenge?

- How would you put those into practice?

5.13 SUMMARY

Creativity is the key to a successful cultural organization and to being a
cultural entrepreneur. We haven't told you how to be creative yourself, but we
have shown how creative people work, and how important it is to understand
the balance between individualism and working as a team. It is also important
to recognize the difference between a genuinely original idea and something
that is merely novel. The conditions for creativity show that it is not a sudden
and solitary process, but a matter of preparation, of context, of practising
skills, and that it may actually benefit from being bounded by constraints.

Creativity is a process of problem solving. In the arts and heritage sectors one
of the major problems is often resources, and we have shown how in general
two kinds of creative problem-solvers have emerged: the producer and the
director. The producer essentially is a finder of resources, the director a user
of resources. The actual title used for these roles may vary from cultural form

to cultural form, but the creative tension between producer and director is a useful way to think about creating partnerships and teams. But creativity is the key, and it is essential not only to stay creative individually, but also to make sure that the organization itself stays creative in what it does and how it does it. The emergence of the 'creative industries' demonstrates how important creativity is to the economy as a whole, and you need to think of ways in which you can contribute to that process, while protecting your interests. Because you are trying to do something new, however, there is always the possibility of failure, but assessing risk is just another form of problem solving. You must know how to manage risk, as we will discuss in Challenge 7, but you mustn't be afraid of it – otherwise you won't be able to act creatively.

5.14 RESOURCES AND READING

In addition to Margaret Boden's *The Creative Mind: Myths and Mechanisms* (Boden 1990), which looks at the mechanics of creativity, there is Keith Negus and Michael Pickering's *Creativity, Communication and Cultural Value* (Negus and Pickering 2004), which explores creativity as something that everybody uses to communicate, how it works in terms of research and cultural policy, and the value judgements involved. For a more theoretical and wider-reaching approach that takes in science and philosophy as well as the arts, there is Rob Pope's *Creativity: Theory, History, Practice* (Pope 2005), which makes a point of not having to be read continuously, and allows you to pick and choose. Chris Bilton's *Management and Creativity: From Creative Industries to Creative Management* (Bilton 2006) suggests ways in which individual creativity can be built into management structures.

The way to find out about the titles and roles of creative people in large cultural organizations is to look at their annual reports. Kate Tyndall's *The Producers: Alchemists of the Impossible* (Tyndall 2007) is full of good stories about what it is like to be a producer in a wide variety of fields. ResCen, the Centre for Research into Creation in the Performing Arts at Middlesex University, has published a study of the practical experience of performing artists in making new work, *Navigating the Unknown: The Creative Process in Contemporary Performing Arts* (Bannerman *et al.* 2007). There are some useful 'how-to' guides to putting on productions, such as *From Option to Opening: A Guide to Producing Plays Off Broadway* (Farber 2005) and the equivalent for London's West End, *So You Wanna Be a Producer?* (Stage One, n.d.) and *So You Want to Be a Theatre Producer?* (Seabright 2008). There is also *Creative Producing: A User's Guide* (Lavender 2001).

There is a growing literature on aspects of the creative industries, with surveys and reports being regularly produced by the London-based National Endowment for Science, Technology and the Arts (NESTA, www.nesta.org. uk). John Howkins' *The Creative Economy: How People Make Money from Ideas* (Howkins 2001) has an interesting chapter on managing creativity in the sector. Among academic studies, John Hartley has edited a wide-ranging collection of essays, *Creative Industries* (Hartley 2005). David Hesmondhalgh takes a critical view in *The Cultural Industries* (Hesmondhalgh 2007). Charles Leadbeater and Kate Oakley *The Independents: Britain's New Cultural Entrepreneurs* (Leadbeater and Oakley 1999) gives a good feel of what it is like to work in the sector.

6 Challenge: Resources

> 'There is a need to develop more appropriate definitions for entrepreneurship, including an understanding that in all situations entrepreneurs require business, financial, legal and technical skills and knowledge.'
>
> Higher Education Academy Art Design Media Subject Centre and NESTA (Higher Education Academy et al. 2007: 14)

6.1 INTRODUCTION

In Challenge 5 we looked at the heart of artistic and cultural endeavour: creativity. But creativity on its own does nothing: art needs a way of getting out into the world, and 'getting out there' usually involves the use of some kind of formal organization – as well as a less formal network. You may be starting up a new venture to get your own work on to the stage or on to the wall, or perhaps you aspire to lead a long-established and large Institution with a capital 'I'. Either way, a common factor will be your need to marshal resources: to bring together the people, buildings, money and other elements that will combine to turn your vision into a reality. It's likely that you will give a great deal of your time and your gifts to this venture, perhaps even your whole being. You might agree with the great impresario Sergei Diaghilev when he said: 'Why should I waste my imagination on myself?' (James 2008: 170). And if you do want to share your imagination with everyone else, then, just like him, you need to know about the practical aspects of running an organization.

We deal with that in this challenge and the next by looking first at resources, and then the skills needed. Our aim is not to go into a level of detail that turns you into a specialist finance manager or an HR professional. Instead,

we want to give you sufficient knowledge to allow you to lead in these areas. There are plenty of publications that provide as much detail on the areas we are about to address as you could wish – though you will need to make sure that the ones you consult are up-to-date because the rules and regulations change all the time.

6.2 PEOPLE

'People are our greatest asset.' How often have corporate CEOs chanted that mantra – and then downsized the company? It's a phrase whose abuse invites cynicism, and yet it is true: people are the greatest asset of any organization. Moreover, it is not 'institutions' that change things, it is the people within them. That is why the Harvard professor and author Mark Moore argues in his book, *Creating Public Value: Strategic Management in Government*, that it is important to concentrate on people: 'the primary change being recommended is *in the thoughts and actions of managers*, not in the existing institutional arrangements that hold them accountable' (Moore 1995: 76, his italics).

It is instructive to compare and contrast the fortunes of two airlines. One of them has always put their customers first, and moulded the staff to suit the customer's preferences; as their former Chief Executive put it: '[we] design our people and their service attitude, just as we design an aircraft seat, an in-flight entertainment programme, or an airport lounge' (Marshall *et al.* 1995). The other believes that staff are the more important priority. As their Chief Operating Officer argues:

> to ensure the best customer service, you have to put the customers second … I don't understand why an employee should have one personality at work and another outside of work … We hire you for your individuality, and we aren't going to try to spend six months moulding you into our corporate culture. (Taylor 2005)

The two airlines have radically different records in employee relations. The first is British Airways and the second is the US carrier Southwest Airlines, who have posted a profit every year in their 38-year history up to 2010.

So how do you get the best out of people? We think that this question needs looking at in two ways: first, from the point of view of motivating individual members of staff, and then at the level of the team and the whole organization, because people are most effective when they are able work together in the right way. One of the most important tasks for a leader is

to create the conditions for people to combine their talents. In turn that involves creating networks with rich, frequent and high-quality interactions.

6.3 MOTIVATING INDIVIDUALS

The American author Dan Pink has come up with some extraordinary facts about what makes people do a good job, and we recommend that you read his recent book, *Drive: The Surprising Truth about What Motivates Us* (Pink 2010). The basic findings are that for purely mechanical tasks, where you as a leader need compliance and repetition, financial rewards act as an incentive to perform well, as we saw with 'transactional leadership' in Challenge 2. But in areas of work where you want people to engage their conceptual and cognitive skills, high financial rewards are actually counter-productive, sometimes to a catastrophic degree – just look at the banking crisis of 2007–8. Working in the cultural world, you are unlikely to be faced with the issue of overpaying your staff, but still the question arises – if money doesn't work, what does?

For those employees whose job it is to take decisions, who have to be inventive and apply their intelligence (which, when you think about it, is more or less everyone), the issue of money is quite subtle. A wise employer would pay them enough so that they don't have to worry about their bills, in other words enough to make sure they are thinking about work not money. Beyond that, high performance is best achieved by making sure employees get three things: autonomy, mastery and purpose.

Autonomy means the ability to exercise control over your own work, or to be self-directed. We all know that this matters – how many of us have been angered when we've had a boss breathing down our neck or felt demeaned when forced to fill in forms checking up on how we have spent our time? Liberating people to do their best does, in fact, work – as long as they know and understand what they are supposed to be doing. Your job as a creative leader is to set the terms, not to micromanage. You should be telling your finance and marketing staff what you and the organization need, but not how to do their jobs.

Mastery is the sense of being able to do something well, the feeling that we are good at whatever task we are engaged in. This usually comes about from long application. The author Richard Sennett, in his book *The Craftsman* (Sennett 2007), says that it takes 10,000 hours of practice to achieve really good results when it comes to things like playing a musical instruments or being able to make furniture. When you see adolescent boys skateboarding, endlessly

repeating moves where they fall off time and again, they are trying to achieve mastery. Mastery exists in a space between terror and boredom. You can feel frightened in a job when you feel unable to do it; and you can feel bored when you do it too often, repeating the same thing. The art of mastery is to invest whatever you are doing with meaning – even the smallest things. This is one of the insights of Zen Buddhism, which insists on bringing mindfulness to the most mundane tasks. As a Zen monk, who was also a cook in a famous restaurant, once said: 'When you are chopping a carrot, chop the carrot. It is as simple and as difficult as that.'

The third great motivator is a sense of *purpose*. We all need to feel that what we are doing is worth doing, and that it has some point to it. When people don't understand why they are doing something – if, for example, they have to fill in a form but have no idea what the information that they are providing is used for – they will become demotivated. That is why applications for funding that demand seemingly pointless details can be so tiresome. By contrast, work that is full of purpose is satisfying and even joyful, especially when there is a common, shared purpose. In modern organizations where people do specialized tasks, that sense of purpose can be lost when the task becomes isolated and disconnected from the greater whole. It is one of the leader's duties to keep on telling people how their role fits into a bigger picture of organizational achievement; how for example, the web-manager's role makes it possible to sell more tickets, which in turn enables the theatre to put on more plays.

6.4 BUILDING TEAMS

A sense of purpose can also be achieved by encouraging people to be part of a social group. This is why leaders need to pay attention to helping people interact. Edgar Schein of MIT Sloan School of Management says that organizational cultures are created 'in between' people more than 'in' people (Hewison *et al.* 2010: 140).

In our own study of organizational change at the Royal Shakespeare Company, we observed many ways in which the RSC's leaders created opportunities for the staff to get together in working, informal and social ways:

- The configuration and design of buildings can act to promote or inhibit contact between people. Better to spread the organization's leaders throughout the office than to have them huddled in a corner or, worse, given separate offices on another floor. Better to have

the kitchen in the middle of the floor where everyone has to pass someone else's desk to get to it.

- Informal social and learning groups share knowledge and skills beyond the working day. Why not lay on some lunchtime or after-hours activities such as yoga or dance classes, or whatever people want to get involved in?

- Celebrations help bring people together. When the organization has pulled off a great performance, or overcome some difficulty, throw a party.

- Within formal working meetings, make sure everyone who needs to be there is there – and people who don't need to be there aren't.

- So that people understand what's going on in the rest of the organization, encourage job-shadowing and show-and-tell sessions where one department visits another to explain what they do.

In all this, though, you have to make sure that the interactions are genuine. Nothing is worse than the artificially created, one-off, team-building exercise that stands apart from everyday life. Team-building days can be helpful, but only within a context where the team is real.

The point of creating well-functioning working and social groups, beyond providing a sense of shared purpose, is to create a more effective organization. The strength, number and frequency of contacts and interactions – in other words, the strength of networks – within an organization are crucial to its efficiency and also to its morale.

Encouraging listening and talking can build a virtuous circle. When people are listened to, they open up more. When they talk more they must be listened to – and their views and ideas should be respected even if they cannot be acted upon. In this way the rationale for all decisions – the unwelcome ones as well as the welcome – can be understood by everyone. People who communicate a lot and know each other well are more likely to be honest and open, and more likely to trust each other, even when they disagree.

Trust is one of those things that is difficult to build but easy to destroy. We know of one organization that abolished its holiday calendar when a member of staff pointed out that it sent out a message that people could not be trusted. On reflection, the leaders decided he was right. The holiday calendar

was not an essential planning tool because the organization was quite small and different teams managed their own time in an effective way. The organization had simply imported a way of doing things from big business without thinking it through.

Exercise

You have recently joined a medium-sized gallery in a medium-sized town. There are 14 members of staff doing things as varied as running the finances, curating the programme, running an education programme and managing the café-bar. In addition there are 20 part-time front-of-house gallery attendants. You notice that there is little communication between the different roles and most people have a sense of isolation – almost of achieving what they do in spite of everyone else. Make a plan of the short-, medium- and long-term things that can be done to improve the situation, and make a list of the people who need to help you achieve change. Remember what you learnt in Challenge 2 about power and authority, and remember the importance of autonomy, mastery and purpose.

6.5 EMPLOYING PEOPLE

Employment law is a specialist discipline, and the recruitment, employment and dismissal of staff is an industry in its own right. Employment regulations are constantly evolving, and the non-expert should seek advice when it comes to drawing up job contracts, putting disciplinary procedures in place and so on. As a leader, you will be very much involved in the formal, as well as the informal, aspects of employment; it essential to know the legalities of what you can and cannot do, and the practicalities of what you should and should not do. For the United Kingdom the National Council for Voluntary Organisations produces a helpful guide to all aspects of employing people, in the form of *The Good Guide to Employment* (National Council for Voluntary Organisations 2010a), and further advice is available on their website, www. ncvo-vol.org.uk.

Be very careful about employing someone in the first place. It is easy for wishful thinking to take over at the interview stage, followed by immense difficulty when later on you have to let the person go. Always take up references, always test rigorously for the skills that you are looking for and always think about how the personal style of the potential recruit will fit in with the organization's culture.

When a new recruit arrives it is important that they know where they stand. They must, of course, have a contract of employment that sets out all the conditions of their employment, and you will probably want to agree their job description – although we do know of some places where job descriptions are thought to inhibit flexibility and the employee's own development and initiative.

Regular, and formalized, reviews should take place – on a two-way and a peer-to-peer basis, so that you get feedback from your people just as you give them feedback on their performance. Just how far you want to go with workplace openness and democracy is up to you. A few companies – such as the famous example of Semco in Brazil, which is a medium-sized manufacturing company making things like industrial equipment, not a whizzy design agency – are going the whole way and letting everyone know what everyone else is paid. You might want to check how you rate as a 'democratic company'. If so, take a look at www.worldblu.com.

Most arts organizations are too small to have 'in house' trades union branches, but many of the people you employ, as staff or freelancers, will belong to unions that have negotiated standard contracts that may well apply to the kind of work you do: in Britain the Broadcasting, Entertainment, Cinematograph and Theatre Union (BECTU) covers many technicians working in broadcasting, film, theatre, entertainment, leisure, interactive media and similar areas. The Musicians Union and the actors' union, Equity, have established minimum contracts and conditions for the artists they represent. A group of actors in a production usually chooses one of their own number, who is an Equity member, to act as 'Equity Rep'. The Writers' Guild has established minimum terms contracts for its members in the theatre. Trade union law is tricky, and it is up to you to make sure you are up to speed and know what agreements are in place. If in doubt, get legal advice. To be a member of a trade union means that you are a recognized professional in your field, and should be treated with professional respect. No leader or entrepreneur will needlessly antagonize the people working for them.

One of the toughest jobs that a leader has is to fire people. It is rarely easy, and can be traumatic for all concerned, but there are ways of doing it well. There are three main reasons why people have to go. Sometimes it is because they cannot do their job, and the root of that problem can lie in poor recruitment, inadequate training and support, or an inability on their part to change and learn. Another reason why people have to leave is when the organization can longer afford them, or has changed to such a degree that what they did is no longer relevant. And the third reason people leave is when they have broken the terms of their employment through some kind

of bad behaviour. Often, the person who has to go knows in their heart the reason why. If they can be helped to realize the inevitable, and to come to terms with it, so much the better. If not, you will need to get involved in formal procedures with legal and financial consequences. This will be hard on everyone, because these situations are never just about a job; they are about people's lives and their deepest emotional states. In such circumstances, you need to look after not just the departing employee, not just the people who remain, and not just the organization – you also need to look after yourself. Never be slow in taking legal advice – it saves money in the end.

6.6 INTERNS AND VOLUNTEERS

Almost all cultural organizations depend on the involvement of interns and/ or volunteers. There are many reasons for this. Some of them are financial – obviously, from the organization's point of view, unpaid labour is attractive, though don't make the mistake of thinking it is cost-free. Interns are prepared to work for little or nothing because they want to gain experience and contacts. It is up to you to ensure that you keep your side of the bargain by giving them proper opportunities to learn. Longer, healthy lives mean more older people want to stay active and involved through volunteering, while the trend for ever-increasing pre-employment qualifications and experience is driving the trend towards more internships at the other end of the age range. There is something of a tendency to meet in the middle as well – there are plenty of younger volunteers, and some older interns looking to gain experience because they are trying to change careers. As we said in Challenge 5 (section 5.2), interns should not be exploited and their needs should be treated seriously – but if you are the type of leader that this book encourages then you will already know that you must treat everyone with due respect and humanity.

In the UK there is now a specifically political drive to encourage more volunteering through the idea of the Big Society. We are all being encouraged to volunteer more, and also being encouraged to rely on the third sector – charities – rather the State to provide the building blocks of civil society. It is therefore likely that arts organizations will become more, rather than less, reliant on interns and volunteers in the immediate future – always assuming there are enough volunteers to go around.

The National Council for Voluntary Organisations (NCVO) runs many courses and produces many publications on all aspects of recruiting, managing and motivating volunteers (www.ncvo-vol.org.uk), but as a leader, your responsibilities to volunteers and interns extend beyond the

legal requirements and minimums. Some commercial and third-sector organizations exploit interns in particular as a source of cheap or unpaid labour. The deal with interns should be that if you cannot afford to pay them, they should at least be learning something. The NCVO says: 'the possibility of receiving training is a strong motivating force for many volunteers. Many value it more highly than cash payments', while stressing that 'Agreements must not characterise training as a right for volunteers' because they might then become contracts of employment (National Council for Voluntary Organisations 2010b).

Exercise

You are the director of a small touring theatre company. There is a permanent staff of five, helped by a series of interns on three-monthly contracts. You recruit actors on a seasonal basis twice a year. In other words, although the company name has been kept alive for 15 years, there is little in the way of continuity when it comes to the people who are involved. Write down how you think a healthy organizational culture can be maintained in these circumstances.

6.7 MONEY – WHERE TO GET IT

Your second most precious resource, after you have harnessed the creativity, energy, commitment and skills of your people, is money.

As we outlined in Challenge 1, over the past 70 years the UK has developed a mixed economy model of funding the arts and culture, where individual organizations get income from a variety of sources. The exact proportion of income from different public and private sources varies between organizations and there is no overall norm, although there may be sub-sectoral norms: theatres have often been run on a model of one-third box office/one-third grant/one-third sponsorship, while contemporary galleries that do not charge for entry may rely much more heavily on either public funding or private patronage. The other reason why there is no norm is that at different times both government and the private sector are more, or less, generous.

Audiences and users: this is the source of what is generally called 'earned income' and comes from the sale of tickets at the box office, the operation of commercial services such as a bookshop or a café, and the provision of services to other organizations, such as providing training courses to corporations, hiring out space to amateur groups and delivering education programmes in schools.

If you are set up as a charity – there is more about charities later – you can generate income from carrying out the charitable activities themselves but you can only 'trade', that is, sell goods and services that are not charitable activities (up to a certain limit: currently £50,000 of sales for a charity with a total turnover of £200,000 or more, but the level changes so beware). What this means in practice is that you can sell tickets and do all the things that you are set up to do as a charity, but you cannot undertake non-charitable activities like running a bar or a shop if they go beyond the limit. At that point, charity law requires you to set up a separate trading subsidiary, the rationale being that a charity must not subsidize commercial activities. The usual course of action is therefore to establish a 100 per cent owned subsidiary trading company to run the bar, shop, restaurant or whatever it is, and for that subsidiary to covenant its income back to the charity. That puts all the trading profits back into the charity, thus avoiding corporation tax, and ensures that the trading company is supporting the charity and not the other way around.

Earned income is becoming increasingly important for most cultural organizations and some now trade on a large scale – for example, many national museums exploit the potential of their ownership of copyright and intellectual property through the sale of images and publications. As a leader your job is to maximize earned income and to put together a team that spots opportunities and turns ideas into income.

The public sector: the cultural sector, and its surrounding penumbra, the creative industries, operate in a market economy and can be highly entrepreneurial, but when we look at the operation of the economics of the arts it is obvious that conditions are often determined not by the invisible hand of the market, but by its opposite, 'market failure'.

Market failure occurs when it proves impossible to produce certain goods in sufficient quantity and/or at an acceptable price to justify their existence in purely monetary terms. In particular the market fails to produce, or under-produces, cultural goods such as dance, symphony orchestras and new political plays. The other side of the coin is that culture sometimes needs to be protected from the market, for example by conserving desirable landscapes or historic properties from the depredations of developers. The arts are particularly susceptible to market failure because they are unable – outside books, film and recordings – to reproduce their creations in sufficient numbers to exploit their success beyond a certain level. Nor can the arts easily achieve economies of scale. You cannot downsize an orchestra or reduce the number of notes in a concerto, and nor can you build a bigger auditorium

without radically altering the audience experience. A symphony on a synthesizer is not 'an efficiency gain'.

A cold-hearted answer to this problem would be to say that the market cannot supply these things because there is insufficient demand for them. But that is not the case. There is demand of a different kind: national or local prestige, a belief in the educational value of the arts and heritage, and a belief in the morally redemptive power of culture are implicit or explicit reasons for wanting to have these things. So the visible hand of public support for public goods reaches in – but this is not without its problems.

Recently the question of public subsidy in the UK has come into sharp focus because of deep cuts in overall public expenditure. Making the case for the arts to get funding when other budgets such as welfare benefits and medical care are being cut is not easy, and the arts have taken more than their fair share of the pain. But public investment in culture continues, and will probably maintain the erratic course of increases and cuts that have characterized it since the present funding system began in 1946.

Cultural life, in its broadest sense, is not defined by the existence of public subsidy, although it is conditioned by it. It is obvious that some kind of cultural activity will take place whether there is public intervention or not, and it is also true that public and private patronage will happen whether or not there is market failure because culture is believed to be desirable regardless of market forces. But the fact that, in general, cultural goods are judged to be socially necessary, as opposed to widgets, which are economically necessary, plays into the fundamental difference between the business of culture and the culture of business. Although private commercial enterprises have an important role in the cultural sector, particularly in the field of entertainment – the term is used non-pejoratively – a key difference between culture and business is that businesses have shareholders, and cultural organizations have stakeholders.

One major stakeholder is central government. Although some cultural organizations, such as the national museums, get public funding direct from the Department for Culture, Media and Sport, most receive central government funding, if at all, via an arm's-length funding body, such as one of the Northern Irish, Welsh or English Arts Councils, or Creative Scotland. Arm's-length bodies also distribute funding – historically mostly for building or maintaining cultural infrastructure – from the National Lottery.

Alongside Arts Councils, the other important public sector stakeholder in culture is local government. As a cultural leader, it is to these two sources of funding that you will probably turn.

In terms of your organization, your attractiveness to public funders will vary depending on where you are and what you do. In the United Kingdom individual local authorities are under no legal obligation to fund culture (apart from public libraries), and their ability and willingness to do so varies widely. It varies depending on the council's own resources and budgetary position, and according to the political leanings and individual prejudices of elected members. If you are starting up, one of things you need to consider is where you are most likely to receive support for your work.

Local and regional advocacy to public-sector funders is a vital aspect of leading an organization. Many arts leaders express frustration at having to repeat the messages about the benefits that the arts provide as local government councillors come and go and funder priorities change, but as a leader it is your job to be out there talking to funders on a continuous basis, making contacts, giving formal presentations and socializing.

You will also have to be adept at filling in grant applications and understanding the jargon that funders use. Unfortunately, Arts Councils and local authorities all require different information in different formats; there is no uniform way of presenting your case and asking for a grant. It would make life a lot easier and more efficient for all concerned if public funders would adopt a system such as one that is growing in the United States, where private-sector funders have started to adopt a common format for grant applications.

Exercise: finding the (public) money

You have set up a children's theatre group that has no premises of its own but works by hiring spaces and also performing in schools. You have recently obtained charitable status and want to move to the next level of stability by obtaining funding from your regional Arts Council office and from two local authority areas that you work in. Write down your strategy for obtaining public funding. This will include addressing who you need to contact, setting out the rationale for why you should be funded, and a timetable.

The private sector: private-sector support for the arts happens in three ways. First there are individual donations, which may come from wealthy private patrons or from more modest enthusiasts. Next are companies and corporations who very occasionally donate, but more often sponsor – in other

words they want something (and it may be a very expensive something) in return. Last, but by no means least, there are trusts and foundations, who over the years have not only provided the money to build a lot of the UK's and almost all of the US's arts infrastructure, but have also been at the forefront of funding experimental, community and educational work.

Private-sector funding for the arts, like government funding, fluctuates and has been on a downward path since the recession. According to Arts & Business, the organization set up to encourage business support to the arts, in the United Kingdom in 2009–10 it stood at £658 million, made up of £144 million from business, £359 million from individuals, and £155 million from trusts and foundations (Arts & Business 2011). In 2009–10 organizations that had 'regularly funded' status with Arts Council England got on average 9 per cent of their income from these sources (Arts Council England 2011: 24). These statistics come with a number of cautionary notes: UK private-sector support is heavily concentrated in London (68 per cent), and many organizations around the country get no support at all (38 per cent). It is the same with major cities in the United States. Like public subsidy, private-sector support has its ups and downs, but there has been a distinct trend for individual donations to increase and corporate sponsorship to decrease as a proportion of the overall cake. It is the policy of the British coalition government that took over in 2010 to encourage private philanthropy to help fill the gap created by its own reduced financial commitment to culture, and a scheme is being put in place to encourage this by matching money raised by cultural organizations from the private sector with public money.

If you are at a large organization (especially if it is a heritage organization) in London or another big city you will probably have a team of fundraisers talking to wealthy patrons and major global corporations, but if you are a touring theatre in a small town you may struggle to get much in the way of private funding. As a leader you will have to be involved in fundraising, whatever the scale of your enterprise. Even if you have a specialist fundraiser or a whole department devoted to it, sponsors and donors will want to meet you to find out how your aims fit with their own. You will almost certainly need to be involved in a certain amount of entertaining and 'schmoozing'. And you should be out there in your community making sure that potential supporters know why you need funding and what they can expect in return.

In the UK, Arts & Business runs courses and produces literature on fundraising from the private sector, so have a look at their website: www.artsandbusiness. org.uk. Advice will also be available from your regional or national Arts Council office, and from professional associations such as the Arts Marketing

Association (www.a-m-a.org.uk) and the Museums Association (www.
museumsassociation.org).

The three types of private fundraising demand different approaches. If you are
trying to get money from individuals there are a number of things to realize.
First, you need to have a clear 'ask', an easily communicated reason why
you want the money, such as fixing the roof or commissioning a new ballet.
Americans have the excellent term, 'the elevator pitch', meaning a description
of what you want to do that is so short and so clear that you can pitch the
whole idea during an elevator ride.

Second, you need to think about the psychology of giving: why would
potential donors give? Donors need to know how their generosity will be
used, and they usually don't like to see it going to meet general running costs.
They may want anything from a warm glow to the achievement of some
very specific purpose, like remembering a loved one (but they can't receive
something that could be interpreted as an actual benefit – if they do then it's
no longer a donation).

Third, recognize that sometimes people give to other people rather than to
causes. You may be able to raise money for that ballet from someone who
has no interest at all in ballet, but they give because they have an interest in
doing a favour for, or impressing, an existing donor. And finally, remember
that it is usually much easier to get one cheque for £100,000 than 100,000
cheques for £1. In fact, there seems to be a mysterious rule that when you
raise some money, roughly half will come from one donor, the next quarter
from a handful, the next eighth from about four times that handful and
the remainder will arrive in the form of small donations. It is a good idea to
follow that order because the small donors will be encouraged by the success
you have already achieved and will dig in their pockets to find that last little
bit.

Funding from corporate organizations demands an equally rigorous approach,
thinking through what you have to offer and what your potential partner
needs. It's worth knowing, for example, whether the company's partnerships
with the arts are located in the marketing department, or with the corporate
social responsibility team, or are an aspect of its community involvement.
That will give you a clue about what the company might want from you.

Getting to know a company takes time, but while sustained relationships
between arts and corporate organizations are not unknown, they are unusual.
Most companies these days are driven by short-termism, and corporate
priorities can change overnight – taking your sponsorship with them. So treat

your corporate relationships as a meeting of equals. It has to be something that works as well for you as it does for them.

Trusts and foundations are completely different. Historically they have acted as seed-funders for new ideas, taking imaginative risks in areas where public funders have been reluctant to venture. For example, the Gulbenkian Foundation funded the Arts Council's first Education Officer, because it was such a radical step. Trusts and foundations build relationships and can be tremendously supportive, but they often see their role as helping experimentation which, once established, should be funded by others. It is important to remember that trusts and foundations are not public funders (even though they get special tax treatment), and they have issues of their own. When their investments fluctuate they can suddenly find themselves unable to fund projects that they would like to fund. Many of them are run on a shoestring and they can be overwhelmed by grant applications, requests for help and unrealistic demands for feedback. So again, the watchword is mutuality: try to understand them as they develop a relationship with you.

Fundraising and the board: we will be talking about boards in more detail later, but start a discussion amongst any group of arts leaders in the UK about the people who serve on their organization's board, and it won't be long before the vexed question of fundraising comes up. Why is it that British board members are so reluctant to use their connections or dig into their own pockets? In the United States, of course, it is completely different, and the rule of 'give, get, or get off the board' applies. But in the US different tax rules and social norms come into play.

British boards are often so poor at fundraising (and there are notable exceptions to that sweeping generalization) because of a failure of communication – they are not told when they join the board what will be expected of them. On top of that, they are rarely given either the training or support that they need to do the job properly. As a leader, you must make sure that neither of those two factors inhibits the performance of your board. That is not to say that all board members should also be fundraisers – there are many other reasons why you might want someone to be on your board. But if you do expect them to help in this way then make sure they are able and willing to do so. There should be a semi-formal induction process for board members: they need to know something of the history and purposes of the organization they are joining, and there should be the equivalent of a job description so that they understand what is expected of them.

Exercise: fundraising and the board

You are the leader of a chamber orchestra and next year will mark the 50th anniversary of your foundation. You have suggested to the board that to mark the occasion you will commission a new work from a leading composer, which will give you the opportunity to perform the piece in a notable concert hall. Moreover, the premiere will be broadcast on BBC Radio 3. The only problem is that to pay for everything you need £80,000. Make a fundraising plan involving your board members to achieve your target.

Innovation in funding: it is likely that you, as a cultural leader will be at the forefront of a new movement in the arts. During a period when conventional forms of public funding will be hard to find, in order to achieve what you want to achieve you will have to be much more inventive than your immediate predecessors in the way that you find the wherewithal to make your organization work. In particular we expect that you will need to encourage your audiences to think of themselves not just as paying customers in a series of transactions (i.e. buying tickets for the occasional show), but as collaborators in the continuation of the arts organization that you both wish to see flourishing. You will have to build strong relationships that have a financial component in order to generate more income from your base of supporters and collaborators.

Be aware of the value that you create for the people who support you. Cultural organizations have a long history of selling themselves cheap. We once heard of a community festival that put the logo of a major multinational corporation on all of its tickets, publicity materials and festival banners in return for £3,000, which barely covered the cost of printing, let alone the cost of the festival volunteers' time.

You will need to become ever more innovative in earning income, whether this is in the form of maximizing the use of your assets or identifying new streams of public- or private-sector funding. Several new ways of fundraising have recently become possible:

- Crowd-sourcing of funding may become a significant new way of funding artistic work, through websites such as the American IndieGoGo (www.indiegogo.com).

- Social investment organizations, such as Venturesome (www.venturesome.org), that provide loans to charities may be suitable funders for some cultural organizations.

- New and emergent financial instruments, such as barter and exchange mechanisms and guarantees against loss, are becoming more popular. The organization Mission Models Money is at the forefront of this move to 'expand the financial toolbox' as they put it, and their website provides examples and case studies of new developments (www.missionmodelsmoney.org.uk/money).

Recently, some cultural organizations have increased their income, and diversified their sources of funding, by turning themselves into 'Social Enterprises'. One such is the Museum of East Anglian Life (www.eastanglianlife.org.uk). Instead of only getting grants from funders, the museum now earns income from providing courses, helping with the rehabilitation of offenders, holding special events and selling produce from its gardens. Although the model is not right for every cultural organization, the museum provides a good example of a leadership thinking broadly, and originally, about how to fulfil the museum's purpose as a significant local resource.

131

Exercise

Imagine you are a local government arts officer and your council has decided that it has to cut the arts budget. It has decided – against your advice – to spread the pain equally by imposing an across-the-board cut of 5 per cent a year for the next three years on the local museum, dance company, music venue and arts centre. What advice will you give to your cultural 'clients'? How can you help them to make up for the shortfall?

6.8 GOVERNANCE

In the United Kingdom, in the 50 years following the establishment of the cultural welfare state in 1946, most cultural institutions and organizations that did not operate as for-profit businesses conformed to one of two models of governance: either they were directly run by a local government authority or they were set up in the form of a not-for-profit company limited by guarantee with charitable status. There were a few exceptions. The national museums have their own legislation and operate under agreements directly with central government, and a small number of organizations, such as the Royal Shakespeare Company, have a Royal Charter.

Over the last decade three things have changed. The first is that local authorities are increasingly divesting themselves of direct control by setting up charitable trusts to run their arts infrastructure. This takes away their direct

financial responsibility, and also means that cultural organizations can be run more cheaply – one reason being, for example, that people working in a charitable trust don't have to be given the same rights to pensions as local authority employees.

The second development is that, with the introduction of 'community interest companies', a new form of constitution has become available. And third, more and more arts entrepreneurs are rejecting the 'not-for-profit' route because they believe that they can make a living out of their art, and that the 'for-profit' route gives them greater control over their own destinies. The challenge for you is to work out what is the best way to manage your affairs, and to understand the limitations and legal implications of the particular form you chose.

Company limited by guarantee with charitable status: the most commonly found form of constitution for cultural organizations in the UK is the company limited by guarantee with charitable status. What on earth does that mean? Essentially, a company limited by guarantee is governed by the Companies Act, with a board of directors taking responsibility for the actions of the company. Each member of the board of directors is appointed by the members of the company, who stand as guarantors for the debts of the company up to a limited amount (hence 'company limited by guarantee'). Like a 'company limited by shares' (the usual form of company in the business world), it has to register with Companies House, and file its annual accounts there, but in contrast to a commercial limited company, a company limited by guarantee has to use any surplus money left at the end of the year to further its aims, instead of paying it out to shareholders. In other words it is 'not-for-profit' – at least not in a financial sense.

Many – but by no means all – cultural organizations set up as companies limited by guarantee also have charitable status; that is, they are registered at Companies House and are also registered as charities with the Charity Commission, to whom they must also make annual reports. Registration is not automatic and to qualify organizations must have charitable objectives. The Charities Act 2006 changed the meaning of 'charitable objectives' to include 'the advancement of arts, culture, heritage, or science', but there are many cultural charities that still have 'education of the public' as their charitable objective as a legacy from the pre-2006 situation. Guidance on charitable registration can be found in the Charity Commission publication CC21, *Registering as a Charity* (Charity Commission 2008).

Charities are governed by trustees (they can also be called directors or governors), so in this form of a company limited by guarantee with charitable

status, the people who are on the board are simultaneously trustees (of the charity) and directors (of the company). Although they do not have shares, they are also usually the only members of the company as well, so they vote for who can join them on the board.

The main advantage of being a charity is that you don't have to pay tax on the surplus that you make, and there are other tax advantages as well (these change from time to time, so keep an eye on the websites of the Charity Commission and HM Revenue and Customs). It is also the case that some trusts and foundations can only fund charities, and that public funders often prefer to give grants to charities. But there are disadvantages to charitable status as well. One is that, in general, there is a formal separation between the people who govern the organization (that is, the trustees and directors – it doesn't matter which of the two terms you use on a daily basis) and the staff. This means that where an artist sets up an organization as a charity, they have to hand control of the venture to a group of other people – who can then sack the very person who set the whole thing up. The artistic director or chief executive cannot normally be a member of the board, because trustees and directors are not allowed to be paid for their work as board members, so, in a sense, the paid professionals who make the company work are being employed by unpaid amateurs. In addition, there are limits to any expenses that board members can claim, and the Charity Commission keeps a watchful eye on board members who are hired by the company to provide professional services, such as running a workshop for a theatre company or giving legal advice.

133

There are other downsides as well. As mentioned in section 6.7, charities are not allowed to 'trade' – that is to say, sell goods and services beyond the scope of their charitable activities – in excess of a limit of £50,000 a year, so they have to route all their trading activities, like running a shop or a café, through a separate subsidiary company, which acts and is taxed like a normal for-profit business, but which hands all its profits over the main charity.

The community interest company: since 2006 it has been possible to adopt a new form of corporate structure, the community interest company (CIC). This is essentially a hybrid, somewhere between a for-profit company and a charity. The idea behind CICs is to encourage innovation and entrepreneurialism, while enabling social benefit. They can be limited either by shares or by guarantee and, unlike charities, the board members can be paid salaries or fees, and it is even possible to issue dividends. But because they are not charities they do not have the same tax advantages. They have their own regulator, the Community Interest Company Regulator, and once their status as a CIC has been agreed, they then have to register at Companies House. The

table at the end of this challenge sets out the differences between a CIC and other forms of company. At the moment there are not that many arts and cultural organizations that have chosen to adopt this form, but the number is increasing. If you wish to have a look at the types of organization that have chosen to be CICs you can do so by visiting the website of the CIC regulator at www.cicregulator.gov.uk.

Local authority control: many cultural organizations, from museums to concert halls, operate as part of a local authority. Historically this has had some benefits – better pay and pensions for the staff, a feeling that the budget has at least some solid backing behind it, and the ability to tap into other council resources and expertise, for example. But the downsides are also clear: a tendency to be more bureaucratic, more direct political influence and less freedom of action.

Your ability to lead will be more constrained than in the context of an independent charitable trust, but nonetheless it will be up to you to take decisions and set the direction. And just as with a charity, your ability to lead effectively will depend upon the relationships that you build, and your ability to influence and persuade. In the context of some highly politicized local authorities it can be difficult to secure cross-party support, but that is what you must aim for – otherwise culture can get treated as a bargaining chip or a football. You have to build trust with the elected representatives so that, to borrow a concept from Voltaire, they will support your right to say things, even if they disagree with what's being said.

Exercise

Your local newspaper has printed a front-page article complaining about the images in a show that you have just opened in the town's gallery. The artist has been made aware of the article and has left a phone message saying that if you take the images down there will be unspecified 'trouble'. There is another message on your answerphone saying that the Leader of the Council wants to see you as soon as possible. How do you prepare for that meeting?

6.9 YOUR RELATIONSHIP WITH THE TRUSTEES

You can see from all that has been said so far in this challenge that governance is a complex and sometimes a vexed issue. Trustees and directors take on great responsibilities, and potential liabilities, when they agree to join an arts or heritage board, but they have to rely on information provided to them by the staff, and they might only meet together four times a year.

In our experience, the relationship between staff and board can easily become dysfunctional, with the staff feeling that board members don't really understand the organization, and fail to pull their weight, and the board worried that they are kept in the dark. Board members are often busy, high-powered people who may be running businesses themselves (including other arts organizations), but something seems to happen to them when they work in this voluntary capacity. It has been said that boards of charities can be 'incompetent groups of competent people'.

As the organization's leader you are the crucial bridge between the staff and the board. It is vitally important that you build a good relationship with the board, and especially with your chair. This means that you have to get the right people on your board in the first place. Recruitment is a very big issue because if you get the wrong person on your board (and they can be wrong for many reasons, ranging from being lazy to being bullies) you might have to wait a long time before you can replace them with someone better. You should take the appointment of a new member of the board as seriously as you would a new member of staff.

The ideal board provides a range of expertise and perspectives to you as a leader and to your staff. It is helpful to have legal, accounting and other skills (maybe expertise in particular art forms, marketing and PR for example). One common problem is to recruit experts in a field who don't want to use their expertise in this context – the accountant who joins a theatre board to escape accountancy for example. Another is to have a board of trustees who are embarrassed about having to fundraise. So you need to be straight with your trustees when you recruit them, setting out exactly what you expect from them – and you can give them annual reviews to check on their performance, just as they should be having an annual review of your performance.

Once you have your board in place, you have to treat them well, and you also have to be demanding – the board is there to serve the organization as well as to take ultimate responsibility for its fortunes. Information and communication are the keys that unlock a good relationship. You need to agree what information the board needs, giving the members the right amount (not too little, not too much) that enables them to fulfil their role without placing a burden on the staff who have to produce the information. What constitutes 'the right amount' will not only vary from one organization to another, but will also vary over time, as the operating context changes.

It is also your job to keep the board members focused on the needs of the organization and motivated to do their bit, whether that is fundraising or using their specialist knowledge to help staff. As we said earlier, we

recommend having a proper induction procedure for trustees to familiarize them with the organization's history, its financial position, its staff, and the other trustees. A regular 'awayday' is also a good idea to discuss issues of strategy and direction that can often be forgotten at the regular board meetings that tend to focus on more immediate issues.

Plenty of advice is available to your trustees and to you as leader. The Charity Commission website has a number of publications relating to trusteeship that are regularly updated, and some organizations run courses for boards – both Arts & Business and the Clore Leadership Programme have done so in the past, but you will need to find out who is offering what at the time when you need it.

Exercise

You have just been appointed Chief Executive of a dance company, and are about to meet the whole board for the first time. The board is made up of seven former dancers, two dancers who have worked as freelancers for the company in the past year, and a local councillor. Write down what you would like to find out at this first encounter, and what messages you need to give to the board members.

6.10 THE FOR-PROFIT ROUTE

For some cultural entrepreneurs, the traditional vehicle of a not-for-profit company with charitable status is not an attractive option. Their purpose is still to make art, but they want to make money as well. Setting your organization up as a for-profit company has many advantages – as long as you do make a profit or can face the risk of making a loss that could lead to bankruptcy.

Some of the best-run, as well as the highest achieving, cultural organizations adopt a hybrid approach to their corporate structure. Here, instead of being a charity with a commercial arm that gives all its profits to the charity, a for-profit company will have not-for-profit subsidiaries, limited by guarantee. They are not charities, but their not-for-profit status enables them to attract the sort of charitable and public funding that is available to charitable organizations. While the head, for-profit company takes all the risks, public funders dealing with the not-for-profit subsidiaries can see exactly where their money is going and how it is being used. Because the subsidiaries are being run by the professional directors who run the main company, decision-taking is faster and entrepreneurial spirit greater than a charity run on 'amateur

board' lines. The London-based music promoter Serious, which mounts the London Jazz Festival, works very successfully on these lines.

The Akram Khan Company exists to allow the contemporary dancer Akram Khan, whose training is rooted in classical kathak dance, to develop new creative projects. His critically acclaimed work has appeared at major venues all over the world, and he has worked and collaborated with many artists including Peter Brook, Hanif Kureishi, Antony Gormley and Nitin Sawhney. He has also choreographed one of Kylie Minogue's tours and danced with the film star Juliette Binoche in a production called *In-I*. The Akram Khan Company is a commercial company, set up as a profit-making company, limited by shares. But it also has a charitable sister company called AKCD – Advanced Kathak and Contemporary Dance Training. As its name suggests, AKCD exists to provide education and training, and also research and development, for artists, thus justifying its charitable status.

Akram Khan's producer, Farooq Chaudhry, has been recognized by the French government as one of the top 100 cultural actors and entrepreneurs. He sees no reason why artistic excellence and making money should be in conflict, and believes that the model they have chosen gives them freedom and flexibility. There is no compromise of artistic standards and, in this case, creative excellence is matched by organizational innovation. Cultural entrepreneurs are increasingly able to combine making art with making money, and with public-benefit purposes.

There are many ways to skin a cat, and many ways to achieve what you want to achieve, and we expect increasing hybridity when it comes to the corporate forms and the governance of cultural enterprises. When you are setting up, think long and hard about what you want to accomplish and the form that your enterprise should take. When you are taking a job as leader of an existing organization, still think about whether the corporate form suits the contemporary aims. In many cases of course you will find that the set-up is just as it should be, and many cultural organizations clearly cannot think about turning themselves from charities into commercial organizations – and nor should they.

Table 6.1 Legal structures: a comparative table

Criteria	Charity	Company Limited by Guarantee	Company Limited by Shareholders	Community Interest Company (CIC)
Classification	Not-for-profit	Not-for-profit	For-profit	Hybrid: for social benefit/ assets 'locked' but capped distribution of profit allowed
Legal Framework	Charities Act	Companies Act	Companies Act	Companies Act
Founding document	Trust deeds	Memorandum and Articles of Association	Memorandum and Articles of Association	Memorandum and Articles of Association plus Community Interest Statement
Ownership	Trustees	Members	Shareholders	CIC can take form of either Company limited by shares or by guarantee
Liability of ownership	Liable for malfeasance (misconduct) under the Charities Act	Limited to Guarantee		

Usually £1–£20 | Limited to cost of share | CIC can take form of either Company limited by shares or by guarantee |
Governance	Trustees	Board of Directors	Board of Directors	Board of Directors
Liability of governors	Liable for malfeasance (misconduct) and to perform duties under Charities Act	Liable for negligence and to perform duties under Companies Act	Liable for negligence and to perform duties under Companies Act	Liable for negligence and to perform duties under Companies Act
Trading (shop etc.)	Very limited	Yes	Yes	Yes
Borrow against assets	No	Yes	Yes	Yes, but needs approval
Distribute financial surplus	No	No	Yes	Possible, but restricted

Tax Benefits	Reclaim tax from Gift Aid, non payment of Corporation Tax on profits, 80%–100% rate relief on premises, does not attract VAT on educational activities	None	None	None to the CIC, but investors get tax benefits
Regulator	Charity Commissioners	Department for Business, and Regulatory Reform (formerly Department of Trade and Industry)	Department for Business, and Regulatory Reform (formerly Department of Trade and Industry	CIC Regulator
Annual Returns	Charity Commissioners	Companies House	Companies House	Companies House plus CIC Regulator

6.11 TOOLBOX

To meet Challenge 6, the challenge of resources, you will need to understand all the elements that you must put together in order to achieve your aims. If you are starting up as a new enterprise, think carefully about exactly what your aims are. Make detailed lists of what exactly you want to do and then think through the consequences:

- What is the best corporate structure to adopt (if in fact you need one)?

- Who can you gather round you to make it all happen?

- How much money will you need, and where will you get it from? (And do you understand what your funders want as well as what *you* want?)

- What else will you have to find – a building, a van, a website, or just a space on a pavement to set out your stall?

Don't be unrealistic about the scale of what you need. Just as many enterprises fail from lack of ambition as fail from over-ambition. If you need £1 million to make it work, then find £1 million.

There is an old adage that time spent in preparation is never wasted, and there is a lot of truth in it. But remember the other truism – that it is important to seize the day/catch the tide/go with the flow. It is your job as leader to know when the moment is right to take everything from idea and aspiration to reality.

6.12 CASE STUDY

You are running an independent museum, established a hundred years ago to house a collection of paintings by a famous local artist whose reputation as a fine watercolourist endures. The museum owns its premises – the artist's house – and an adjoining stable block that is derelict but still weatherproof. The museum is set up as a company limited by guarantee with charitable status. There are five trustees (but only four staff), including the artist's son and daughter who guard his reputation jealously. The other three trustees are representatives of the museum's 'Friends' group, a volunteer band who help man the museum and who raise a four-figure sum each year towards the operating costs, which are mainly covered by grants from the town and county local authorities. The museum's total turnover is £125,000 but the grants are now under threat, and the arts officer of the county authority has expressed concern about the governance arrangements of the museum. What is your plan of action?

6.13 SUMMARY

In this challenge we have looked at the resources you need, in terms of people and money, to help you achieve your leadership aims. We have also examined the types of corporate structure that you might want to adopt. In the next section we will come to the question of actually putting your creativity to work: now that you have the resources to back up your drive, ambition and skills, how do you turn it all into reality and make sure that once you've got the show on the road it keeps going and doesn't come to a juddering halt – or worse, run into a wall.

6.14 RESOURCES AND READING

The classic work on teams is Murray Belbin's *Team Roles at Work* (Belbin 1993). The section on Trades Associations and Entertainment Unions in the electronic edition of *So You Wanna Be a Producer* (Stage One, n.d.) is very helpful about union agreements.

For serving on and running the board of a not-for-profit, there are many guides and handbooks to help trustees understand both the technical aspects of their role, such as their responsibilities and their obligations, and the way that they should conduct themselves. These include the Association of Chief Executives of Voluntary Organisations' *A CEO's Guide to Board Development* (Association of Chief Executives of Voluntary Organisations 2007). The Office of the Third Sector, which is part of the UK government Cabinet Office, has produced *Charities Act 2006: What Trustees Need to Know* (Office of the Third Sector 2006). The Charity Commission is an obvious source of sound advice. We recommend particularly *The Essential Trustee: What You Need to Know*, publication CC3 (Charity Commission 2005); *Trustee Expenses and Payments*, publication CC11 (Charity Commission 2008); *Charities and Risk Management: a Guide for Trustees*, publication CC26 (Charity Commission 2010); and *Trustees, Trading and Tax*, publication CC35 (Charity Commission 2007).

141

You could also look at Mike Eastwood, *Charity Trustees Handbook* (Eastwood 2010); David Fishel, *Boards that Work* (Fishel 2003) and the National Council for Voluntary Organisations (NCVO), *The Good Trustee Guide* (National Council for Voluntary Organisations 2008). The organizations that produce the works listed above – the NCVO, the Charity Commission and the Directory of Social Change – are also a useful source of publications about employment law, employment practices and HR; see, for example, the NCVO's *The Good Guide to Employment* (National Council for Voluntary Organisations 2010a).

You should certainly have the websites of Mission Models Money (www.missionmodelsmoney.org.uk) and Arts & Business (www.artsandbusiness.org.uk) on the 'Favourites' bar of your browser. They are updated regularly with information and ideas about, respectively, new financial instruments and fundraising. Small arts companies can raise money for productions by advertising for backers on the website www.WeFund.co.uk.

In more general terms, a useful article and a pamphlet that look at charities and organizations are: Geoffrey Hodgson's 'What are institutions?' (Hodgson 2006), and Geoff Mulgan's *The Other Invisible Hand: Remaking Charity for the 21st Century* (Mulgan 2005).

7 Challenge: Skills

'Just do it.'

Nike

7.1 INTRODUCTION

You now have to make it happen – and to do that you are going to need some
practical skills. This is the culmination of everything that has come before.
You have a vision and a purpose, you have thought about what you want to
achieve and you have put yourself in a position where you can bring things
to fruition. But this can also feel anti-climactic. Success is not measured only
in moments; it comes about through daily grind, mastering the small and
repetitive things, keeping an eye on the detail. That special occasion when
the tape is cut to open the new building, or you step on to the stage to take
a curtain call, is the culmination of a process that involves many people over
long periods of time – and as soon as it's done there is another project to start
or another performance to put on. In this challenge we look at how you keep
on top of all the organizational issues that you need variously to understand,
control and juggle in order to realize your dream and keep the show on the
road. That takes skill. First thing: be prepared.

7.2 PLANNING

> *'A plan is a hierarchical structure of goals and sub-goals, constructed by means-end analysis.'*
>
> Margaret Boden (Boden 1990: 162)

Planning is both an art and a science. Do you remember reading about different personal styles in Challenge 2? When it comes to planning there are some people who are so keen to pin down every last piece of data and gather every bit of information that they never finish their plan – either that or the plan is out of date by the time it's ready. On the other hand there are people who never plan at all and who just blindly rush into things without thinking them through. The point of a plan is to be somewhere in the middle of those extremes so that you are aware of the implications of your decisions and forewarned of what might go wrong.

Plans come in many shapes and sizes. Effective organizations have a long-term *strategic plan* that sets out their future aspirations and how they will be achieved. Since the future is uncertain, the plan becomes less reliable the further ahead it goes, which is why it needs to be revisited regularly. One common fault with strategic plans is to get into too much detail, when that detail is in fact unpredictable. This is why many planning exercises fail: time is spent on producing something that soon becomes redundant. The plan is put in a drawer and forgotten until someone realizes it is time to write another three-year plan because a funder wants to see one and the old one won't do. To avoid this, strategic plans should be just that: strategic, dealing with the large issues and not the tiny details.

One good way to approach long-term thinking about the organization and its place in the world is to use *scenario planning*. Invented in the US military, and famously adopted by the oil giant Royal Dutch/Shell in the 1970s, scenario planning is now a commonly used methodology. The basic process involves identifying trends in the external operating environment and the most important factors that will affect the organization. Next, a number of scenarios – usually four – are constructed that represent possible futures. This avoids the problem of assuming that the future can only take one form (usually one that is based on linearity and simply projecting from the present into the future). Scenario planning has its own pitfalls, such as creating two extreme scenarios and then opting for one in the muddled middle, but used wisely it can be a powerful tool that helps you to be prepared. The exercise of looking at possible futures in itself makes the organization more adaptive and flexible as it faces up to possibilities that it had not previously considered. We recommend using a facilitator – someone from outside the organization who

knows how to run meetings – to help with the process of scenario planning so that you have someone there who can challenge your own thinking. When organizations plan by themselves they can end up in a 'conspiracy of optimism', believing something will work because you want it to work, not because it does work, and saying something will cost less than it will because you want to get it into the budget.

Business plans concentrate on the organization's operational detail and financial forecasts. We will look at budgeting and finances in the next section, but the important thing to emphasize here is that the business plan should be a well-thumbed document that sits on your desk. You should be continually monitoring whether you are achieving your aims, and acting to correct variances – or to change the plan if you think that is the better option. There are many business plan formats available for free. Your bank will be able to provide you with one, and will probably give you advice on how to fill it in (although you might find that their basic assumptions do not fit with yours, since they will be predicated on financial profits, whereas you will have broader goal of maximizing Cultural Value). You can also find business plan templates online, including on the website www.businessballs.com, which offers a wide range of free business tools.

7.3 DECISION-MAKING

Decision-making is a real test of leadership. After all, getting your decisions right is the only thing that matters, and that is your job as leader. Clearly, your decisions have to be made on the basis of the maximum amount of information available, including what the former US Defence Secretary Donald Rumsfeld called 'the known unknowns' – meaning that you have to recognize that your knowledge will never be perfect, but you should know where the gaps are. It may be so imperfect that it is best to do nothing – always an option to be considered. Be sure that the problem to be solved really is your problem and not someone else's.

The other aspect of decision-taking is timing: if you are not sure about what to do, at least be sure about how long you have before the decision is taken for you by other people or external events. Consult as widely as possible, share the decision-making process and, once you have made up your mind, explain your reasons as clearly as possible. The decision is your responsibility, but it will be more effective (and more likely to be carried through successfully) if the organization as a whole feels it owns it. And if the decision turns out to be the wrong one, don't try to shift responsibility to someone else.

Military thinkers like to point out that no plan of attack survives contact with the enemy. Similarly, decisions will have consequences that call for further decision-making. One form of planning is known as the *decision tree*. This is a way of thinking through a problem, by projecting a set of further decisions that would follow as a consequence of embarking on a course of action, and how those decisions might lead to different actions further down the line. Inevitably, there will be a point when the way you decide to go will lead down different paths. The beauty of the decision tree is that, by examining future consequences, you get a much better idea of where you are at present.

The following example is based on a real case. A small, and far from rich independent museum owns half of a set of drawings that once belonged to the man whose life and work is the focus of the museum. Unexpectedly, an eagle-eyed private collector at a country auction has bought the other half of the set of drawings, which had been thought to be lost. Although the collector is currently enjoying the drawings that he has bought, there may come a time when he decides to sell all or part of the drawings he owns, as he has every right to do.

So the museum needs to plan for that eventuality. Here is the decision tree that they came up with:

1. Does the museum have the capacity to house and display the other half of the collection? YES/NO (If NO, no further planning needed.)

2. If YES, should the two halves of the collection be brought together? YES/NO (If NO, no further planning needed.)

3. If YES, should the museum bid for the collection if it is put on sale? YES/NO

4. If YES, where will it get the money? (If NO, who else should have them?)

5. Can the museum raise the money on its own? YES/NO

6. If YES, how will it do it?

7. If NO, should the museum seek partners to share ownership? YES/NO

8. If YES, should the partner or partners be in the UK? YES/NO

9. If YES, what UK partner would be suitable?

10. If NO, what non-UK partner would be suitable?

11. In both cases, what would be the museum's contribution to the partnership?

12. In both cases, how would the partnership find the money?

Notice, each decision calls for a further decision. The answer YES, or the answer NO, maps out a different direction, but the process begins with questions of principle and leads to questions of practicality. The skill is as much about deciding what questions need to be asked as what the answers are, because in thinking through the questions, you are preparing yourself for a whole series of eventualities. For instance: if the answer to question two is YES, the collection should be brought together, then should the museum consider selling *its* half of the collection in order to re-unite the collection?

That really would be a question for the board, taking it back to first principles about what really is the mission and purpose of the organization.

Exercise: A decision tree

You are running a successful building-based cultural organization in a rented building. Your present lease will run out in three years time. The building needs work doing to it. The leaseholder is prepared to sell you the freehold. There is also the possibility of moving to another building that is available to rent, or buying a site where you could have your own purpose-built building, if you can raise the money. Construct a decision tree as to where you might be in three years time.

7.4 MEETINGS

How many times have you tried to get hold of someone, only to be told that they are 'in a meeting'? Some organizations seem to be so introverted that they spend all day talking to themselves. Yes, meetings can be maddening, but they are also essential. There is often no substitute for face-to-face contact, and sometimes talking with someone is the only way to make sure they have heard what you need to say – it's no use pleading: 'But I sent you an email...'

Meetings therefore need to be approached intelligently. The first rule is that everyone needs clarity: they need to know what the meeting is for, who will

be there and how long it will last. There will be some types of meeting that need to be held on a regular basis. It helps if there is a more or less formal calendar of meetings throughout the year, constructed around the rhythm of board meetings, the annual general meeting that every registered company has to hold and other key moments in the year. Board members, especially, are busy people and you need to get the dates in their diaries.

Most organizations have a weekly meeting to share information and bring everyone up-to-date with what's happening. These provide a good opportunity to achieve other aims, such as motivating people by reporting successes or warning of the dangers of failure. But weekly meetings can also get boring and become a source of resentment. It's a good idea to play around with the format and encourage people to join in and play different roles. Who takes part in these regular weekly meetings depends on the size of the organization. In big organizations it may be impossible to bring everyone together so regularly, and the weekly information meeting may be held at the level of a department or a team.

Regular, but less frequent, meetings are needed for other purposes: an annual awayday to look at vision and strategy, for example, or a monthly programming meeting. Social meetings fall into this category – the Christmas party or the summer sports day is an organizational get-together. It may go off brilliantly or disastrously, but either way it will affect how the organization functions.

Then there are meetings that are directed towards a specific issue. We know of one organization that solves problems by having time-limited, cross-departmental task forces where a three-meeting rule is imposed. This encourages a structured, disciplined approach and ensures that the task force doesn't become a standing committee.

Meetings can be used to achieve more than one purpose, for example, the cross-departmental task force also makes for better communication and builds trust. But the purposes must not get muddled – don't have a meeting that tries to do too much, especially when different people around the table only have an interest in certain items on the agenda. That simply wastes their time, and time is expensive. Next time you have the whole of your organization gathered together, just work out how much has been spent simply on their salaries for the time that the meeting has taken. Then work out how much money was wasted by people turning up late, so that others were hanging around waiting for them.

It's an essential discipline to have an agenda for all meetings – even a short, small meeting needs an agenda pencilled on a sheet of paper. An agenda focuses your mind on what you are there to do and what you want to achieve. You should leave the meeting knowing what is going to happen next, who is responsible for doing it and when it will be done. The way to get the best out of a board meeting is for the chair and the CEO to work out the agenda carefully beforehand – and have a 'pre-meeting' meeting.

Chairing a meeting is a skill in itself. A good chair will make people feel both relaxed and disciplined. The participants should be comfortable enough to contribute to the discussion (and the chair may need to bring people in to ensure that all voices are heard), but they should also be kept on the subject in hand and not allowed to drift off into irrelevancies. The key to good chairing is good listening and good looking: glance around the room when someone is speaking, and use eye contact to gauge reactions and see when people want to speak. As we said, the chair needs to prepare in advance and, at the end, should summarize what has happened and make sure everyone is clear about the outcomes and actions that flow from the meeting.

Consider using outside help for some types of meeting. If you as the leader are chairing a meeting, it may be difficult for you to make your own voice heard. That's why it can sometimes be helpful to have an outside facilitator to organize and structure the conversation, leaving you free to concentrate on contributing to the content.

External advisors can be useful in many ways, bringing particular expertise or knowledge to help you achieve something (see section 7.7 on peer reviews). But remember that the organization cannot outsource change; the people within it have to change themselves.

Exercise

You have recently arrived as the new leader of an arts-and-health organization with eight full-time and six part-time staff. The organization also has relationships of varying strength with about 20 freelance artists across a variety of disciplines. One problem that you face is getting everyone 'on the same page', both in the sense of understanding a shared purpose and, on a more prosaic level, simply knowing what is going on. How can you structure meetings to help solve these issues?

7.5 UNDERSTANDING AND MANAGING YOUR MONEY

Money has a mystery and a mystique about it. It sometimes feels like the
financial industry has a vested interest in making things as difficult to
understand as possible – just try making sense of your annual pension
statement or your house insurance policy. Even those who spend their lives in
finance don't seem to understand some of the products that they have created
– witness the collapse of Barings, Enron and Lehman Brothers. Small wonder,
then, that many cultural leaders – whose job is to produce *cultural* value – are
sometimes nervous when it comes to dealing with the financial aspects of
running their organizations.

But there is nothing to be frightened of. The principles of running company
finance are not difficult to grasp – in reality they are simple, straightforward
and easily learnt. There are two absolutely basic rules. Your organization must
always be solvent – otherwise it is trading illegally – and you must keep a very
close eye on your cash flow to make sure that you will be able to pay your
bills as they become due. That means that you must always be able to keep
going financially for at least six months ahead. That is why having reserves is
important.

At the very least, a leader of any organization must be able to understand
their budget and their monthly management accounts in the form of an
income and expense account, a balance sheet and a cash-flow statement.
There is a lot of help available so that you can learn about how finances
work. The NCVO, the Directory of Social Change, ACEVO and the Charity
Commission all provide useful publications about how to understand and
manage finances, covering such issues as risk management, internal financial
control systems, legal obligations, financial reporting requirements and so
on. On top of that there are dozens of 'finance for dummies'-type guides on
the commercial market, and many courses available from both the education
sector and professional associations. In other words, you really have no excuse
for not being able to gain complete confidence when it comes to running
your organization's finances. And if your organization is of any size, you will
be able to employ a specialist to deal with the nitty-gritty of the paperwork.
(But that does *not* let you off the hook.)

There are a number of interrelated elements that combine to give you a
complete picture of your finances and we will deal with each of them in turn.
The aim here is not to turn you into an accountant or an auditor – terms
that are explained later – but rather to give you the confidence and ability
to understand and probe the figures. Every one of us is familiar with our
personal finances – however disastrous they may be – so we are going to use

those familiar, everyday concepts to explain company finances, organized under their key terms.

'Income and expense'

The statement of 'income and expense' is exactly what it says it is: it shows what has been earned and spent over a period of time. That last bit is important. When you are looking at an 'I&E statement' you need to know what period it is covering.

Your own, personal and private 'I&E' might look something like this:

Period: 1 March–30 June 2011 (All figures £)

Income:

Salary	6,000
Bank Interest	200
Freelance work	800
Total Income	<u>7,000</u>

Expenses:

Mortgage/rent	3,800
Food	600
Transport	500
Clothes	100
Gas, electricity etc.	200
Other expenses	800
Total Expenses	<u>6,000</u>

Net Income/(Expense)	<u>1,000</u>

Lucky you! Your income exceeds your expenses and you are solvent. A company's I&E would look exactly the same, except that it would have a different set of descriptions for most of the income and expense lines, and the amounts would be bigger, like this:

Period: 1 March–30 June 2011 (All figures £)

Income:

Ticket sales	16,000
Bank Interest	200
Grant income	1,800
Total Income	<u>18,000</u>

Expenses:

Staff costs	13,800
Premises	1,600
Office management	1,500
Bookkeeping	100
Gas, electricity etc.	500
Other expenses	300
Total Expenses	<u>17,800</u>
Net Income/(Expense)	<u>200</u>

Yes, the company is still solvent on a day-to-day basis, just.

'Balance sheet'

Alongside the income and expense statement, you will have a balance sheet. This shows, on the one hand, what you own (your assets, including what people, who are called debtors, owe you) and, on the other, what you owe to your creditors (your liabilities). Take one away from the other and that tells you the net worth. A balance sheet is a snapshot of your financial condition at a particular moment in time and is a summation of all that has happened to you so far. Let's assume that you are 35 years old and have been working since you were 22. You are in work and own a house, but have a mortgage. Over the years you have put aside some savings. There will be long-term items on your balance sheet, like your house and pension, that you will presumably keep and that you are not going to turn into cash overnight, and there will be short-term items that fluctuate a lot, like your bank balance. Your own personal balance sheet might look something like this:

Balance Sheet as at 1 March 2011 (All figures £)

Long-term Assets:

House	200,000
Pension savings	20,000
Total Long-term Assets	<u>220,000</u>

Short-term Assets:

Bank balance	1,500
Salary due	1,500
Freelance invoice	1,000
Total Short-term Assets	<u>4,000</u>

Total Assets	<u>224,000</u>

Long-term Liabilities:

Mortgage	<u>150,000</u>

Short-term Liabilities:

Phone bill not yet paid	500
Credit card balance	500
Overdraft	<u>1,000</u>
Total Short-term Liabilities	2,000

Total Liabilities	<u>152,000</u>

Total Assets minus Total Liabilities (net worth)	<u>72,000</u>

Congratulations! At 1 March 2011 you had, over the last thirteen years, accumulated a net worth of £72,000.

Your net worth will, of course, now continue to go up and down depending on your house value, how your pension (which is invested in the stock market) performs, and how you manage your income and expenses. If you earn more than you spend that will allow you to save more and to increase your net worth, or if you spend more than you earn, you will increase your overdraft and decrease your net worth. All of those variations in income and expense, taken together with the changing values of your assets over a period

of time, will alter what your balance sheet looks like the next time you write it down.

For example, in the personal I&E that we showed you earlier, covering the period 1 March to 30 June, you had income exceeding expenditure of £1,000. Consequently, if you prepare a balance sheet on 1 March and another on 30 June, then (assuming no change in the value of your house or pension) they will show your net worth increasing by the same amount – £1,000, like this:

Income and Expense 1March–30 June 2011 (All figures £)

Total Income	7,000
Total Expense	6,000
Net Income/(Expense)	1,000

Balance Sheets	1 March 2011	30 June 2011
Total Assets	224,000	224,000
Total Liabilities	152,000	152,000
Net earnings for period		
1 March 1–30 June		1,000
Net worth	72,000	73,000

In the case of a company, just as with the I&E, the balance sheet will follow the same principles as a personal balance sheet but it will be set out slightly differently and will use different words and have different categories. A company balance sheet will look something like this:

ABC Theatre Company: Balance Sheet as at 30 June 2011 (All figures £)

Fixed Assets:

Leasehold property	800,000
Equipment (van, lighting)	35,000
Total Fixed Assets	835,000

Current Assets:

Debtors (people who owe the company money)	25,000
Cash at bank	10,000
Stock (e.g., shop contents)	5,000
Current Assets	40,000

less **Current Liabilities:**

Creditors (people who the company owes money to)	(10,000)
Total net Current Assets	<u>30,000</u>
Total net Assets (i.e., fixed assets plus net current assets)	<u>865,000</u>

Represented by:

Restricted Reserves (which we will explain later)	40,000
Unrestricted Reserves (which we will explain later)	825,000
Total Reserves	<u>865,000</u>

There are a few points to note about this balance sheet. When a company buys a fixed asset like a leasehold property or a van or a computer, it assumes that over a period of years the value of that asset will decrease as it becomes more and more used – eventually it will have to be replaced. So every year the asset is depreciated. So, for example, the van might be shown in this year's balance sheet at its cost of £20,000. But next year, it will be depreciated by 25 per cent and will be shown as having a value of £15,000.

Another thing to look at closely is the relationship between current assets and current liabilities. In this case the current assets are £40,000 and the current liabilities are £10,000. The size of one compared to the other gives you a feel for how easy or difficult it is for the company to pay the money that it owes to its creditors. In this case it looks pretty healthy, because £10,000 of that £40,000 is held in cash. If the company had no cash, and was relying on selling its stock or receiving payment from its debtors in order to cover the bills that it is due to pay, then you would have to ask questions about the quality and reliability of the stock and debtors as sources of income.

Finally, you can see that the company's net worth is expressed as 'reserves'. Many people get confused by this – they think if a company has a reserve of £x it means that the company has £x cash in the bank. But as you can see, that is not the case – this company has reserves of £865,000 but their cash in the bank is only £10,000. The reserves in fact simply represent the excess of assets over liabilities. You can think of it this way: the reserves represent the net amount that the company has invested in other things – like premises,

the van and the cash. This company has most of its reserves tied up in property.

The reason why there are 'restricted' and 'unrestricted' reserves is because of charity law. We have assumed that this company is a charity and therefore has to show separately those funds that it has received for a specific purpose (which means their use is restricted, hence 'restricted reserves') and those with which it is free to do as it likes (hence 'unrestricted reserves').

If this company was not a charity its net worth would just be shown as 'reserves', and if it was a commercial company (that is, a company limited by shares instead of a not-for-profit company limited by guarantee) its net worth would be called 'shareholders funds'.

'Cash flow'

The third type of financial statement that you need to be familiar with is the cash flow. This is particularly important for small businesses – they often fail not because they are losing money, but because they run out of cash. That sounds odd – if you are profitable surely that's what matters? Of course, it does matter but it is just as important – if not more so – that you can pay your bills when they become due. Let's take this simple case. Imagine you are a freelance producer and you get a commission to put on a show at a theatre. The run is for three months. You do your sums and see that you are being offered a fee of £50,000 plus a share of the box office which you expect will amount to a further £20,000, and you will only have to pay the actors and dancers £40,000. You calculate your other expenses, and add a bit extra as a contingency to be safe. The total costs, you think, will be £48,000, leaving you with a profit of £22,000. It looks like an attractive proposition. But what if you have to pay your actors and dancers on a monthly basis, in arrears? The theatre will only pay your fee once the run is finished, and the box office share will arrive three months after that.

So the profitability looks very good; it looks like this:

Income:	
Fee	50,000
Box office share	20,000
Total Income	70,000

Expenses:	
Actors and dancers	40,000

Other expenses	8,000
Total Expense	<u>48,000</u>

Net Income/	<u>22,000</u>
(Expense)	

But the cash flow looks like this (in accounts, brackets around figures mean minus amounts, because you are paying out):

Month:	1	2	3	4	5	6
Income	0	0	50,000	0	0	20,000
Expense	(16,000)	(16,000)	(16,000)			
Monthly cash position	(16,000)	(16,000)	34,000	0	0	20,000
Cumulative cash position	(16,000)	(32,000)	2,000	2,000	2,000	22,000

So, unless you can find £32,000 from somewhere in order to pay all the bills that are due by the end of month two, you will not be able to take on this project and you will have to wave goodbye to the £22,000 profit you could have made.

There are some types of arts companies where cash flow is rarely a problem. When your customers are paying upfront for something that they get later, such as happens with ticket sales or grants paid in advance, you might be sitting on large amounts of cash. On the other hand many central government departments and big businesses have a habit of paying people in arrears for work done, thus placing a heavy cash-flow burden on small businesses – it's unethical, but that's government and big business for you.

'Budgets'

At regular intervals you should be drawing up budgets in order to set out your anticipated income and expense for a reasonable period ahead. As the future turns into the present you can then compare what you expected to happen with what actually happened. You will have done a good job of budgeting if the variance is small. Doing much better than budget is obviously preferable to its opposite, but it actually shows that your original budget was incorrect – what you should be aiming for is a budget that accurately predicts an outcome. When you present the budget and performance to the board, or when your finance manager presents the same things to you, it should

contain an explanation of any variances between budget and 'actuals' – what really happened. In the light of events and changed circumstances you may also wish to change your predictions during a budget period. You should do this not by altering the budget (once a budget is set, it remains in place) but by providing a forecast of the newly anticipated position.

Typically, halfway through the year, your reporting will look something like this:

Table 7.1 **Budget report**

BUDGET REPORT	Full year Budget	Quarter 1 Budget	Quarter 1 Actual	Quarterly Variance (%)	Full year Forecast
Income:					
Grant	120,000	30,000	30,000	0	120,000
Sales	80,000	25,000	26,000	4	81,000
Total	200,000	55,000	56,000	1.8	201,000
Expense:					
Salaries	100,000	20,000	24,000	20	100,000
Premises	60,000	15,000	15,000	0	60,000
Utilities	20,000	8,000	1,000	(88)	20,000
Total:	180,000	43,000	40,000	(9)	180,000
Net Income/ (Expense):	20,000	12,000	16,000	25	21,000

'Management accounts'

Management accounts are what you and your board use to manage your organization. You are under no obligation to produce management accounts, though you cannot manage without them. But because they are *management* accounts, they need to be set out in way that suits you, containing information that you need, when you need it. As the leader, you may have particular bits of financial information that you think are crucial. You might want to check box office sales every day and see monthly reporting of budget

against actuals, but only need a balance sheet once every six months. There is no hard and fast rule – it's up to you. You may also want to supplement the purely financial information with other data. You can choose your own set of 'Key Performance Indicators' (KPIs), to use the management jargon, and you might want to have a 'balanced scorecard' that shows in a snapshot how well you are doing. We know of one organization that adopts this approach and every month has a report that includes sales, staff morale (people tick a smile or a frown when they leave the office), the bank balance, the average star rating given to their productions by the press and so on.

Exercise

Have another look at the budget report at the end of the previous section.

- Write down how you think it could be improved – a better layout? More information?

159

- Why have the variances occurred – can you think of a reasonable explanation for them?

- What questions would you ask of someone who presented this document to you?

- And what other information would you like in order to judge how well the organization is doing?

'Statutory accounts'

At the end of every year you will be obliged to produce 'statutory accounts'. Every UK company has to send accounts to Companies House and every charity must also send them to the Charity Commission (both Companies House and the Charity Commission also require an annual return to be completed). Her Majesty's Revenue and Customs will also want accounts unless you have an exemption. As the name suggests, statutory accounts are a legal obligation and they must take a specific form. The accounting rules that govern them are called Statements of Recommended Practice (SORPs) drawn up by the relevant accounting standards board or regulator.

The statutory accounts are, formally speaking, a report by the directors or trustees to the members or shareholders of the company and any other interested parties. The income and expense account and balance sheet for the year are produced by an accountant and must be materially accurate. They are then examined by an auditor, who will do spot-checks on the things that

underlie the figures. For instance, if the balance sheet shows an asset of 'Stock £50,000', the auditor will test the existence and valuation of that stock. They won't look at every item of stock, but will randomly pick out some items so that can decide whether the £50,000 figure is reasonable. Normally the auditor will write a letter saying that the accounts give 'a true and fair view' of the company's finances (note: this is not a cast-iron guarantee that the accounts are accurate to the last penny, or even, in the case of Enron, to the last $100,000,000). If an auditor decides that they have been unable to form a complete opinion (for instance, let's imagine that the stock records were missing in the previous example) then they would 'qualify' the accounts – something that you definitely want to avoid because it is a sign of a badly run company.

You should think of your auditor as an ally. They are often a useful source of learning – some of them produce literature and run courses. But the relationship can also get too close and it is a good idea to change auditors every few years or at least to put the audit out to tender so that you are sure you are still with the best option.

'Financial procedures'

Every organization should have in place a set of procedures to minimize the risks of fraud and dishonesty, and to promote efficient management of the finances. You will need to make a list of procedures to suit your own individual case but, at the very least, it is a good idea to have these measures in place:

- The person who signs cheques should be different from the person who authorizes expenditure.

- Limits should be placed on individual authority to order goods or services.

- Large cheques should be signed by two (or more) people.

- Unpaid invoices should be highlighted and chased for payment.

- A reconciliation (meaning, do the two sets of figures match?) should be done regularly between the bank statement and what the financial system is telling you.

- Remember that you need specific procedures to govern internet banking: although you might have procedures in place for cheque signing, they can now be easily bypassed.

- Use someone other than the finance manager to open the mail.

- Make sure everyone involved with finances takes a two-week holiday every year – it's amazing how much wrongdoing comes to light when the perpetrator can no longer control their fraud.

There is another aspect to financial management and control, beyond setting procedures and understanding accounts. The financial operations of your organization ultimately rest on foundations of trust. When dealing with the finance specialists in your team, and beyond your team in the form of your accountants and bankers, you need to build a relationship where you are confident that they are not just truthful, but completely open and honest – in other words, you need to know not just that the good news is accurate, but that your finance manager will tell you the bad news as well. These kinds of working relationships can only be formed when you have the skills and knowledge to be able to ask the right questions and when the people you are dealing with know that you will treat them right, and not shoot the messenger.

161

Exercise

On your first day in the office at a new music venue, you find that the Finance Officer, who is inexperienced and has just been recruited from working in an insurance company, hands you a set of management accounts that you cannot fully understand. The accounts show monthly performance against budget and you see that there appears to be a healthy operating surplus. What further information do you need to assess the organization's financial health? You are not a financial expert yourself – how can you be certain that your assessment of your information needs is correct? Where can you turn for help?

7.6 MANAGING BUILDINGS AND HARDWARE

In the last decade of the 20th century, a period of steady growth led to the opening of new organizations and new buildings (or rebuilt old ones) across the developed world. In the UK a decaying cultural infrastructure was restored and enhanced through the National Lottery. Grand new cultural palaces

were erected, and leaky roofs repaired, across the land. Likewise across the globe. The pressures placed on cultural leaders to manage some of these large building projects were immense, and some organizations nearly broke down under the strain – one of the reasons why there was a fresh look at how to develop cultural leadership.

And everywhere the question is asked: once the building is built – what then? Many leaders of building-based organizations like theatre companies talk of a feeling of being 'trapped' by their buildings. Yes, they now have many new opportunities but bigger and better spaces mean that if you are, in the case of the theatre, a producing house, you are going to have to put on bigger and better productions to fill them. If you are a theatre or a concert hall or an art gallery that takes in work from elsewhere – in other words, a 'receiving house' – then you have to programme more work, and better work. And your new building will require just as much maintenance, if not more, than the old one.

Buildings have a tendency to produce nasty shocks, such as getting an electricity bill that has increased way beyond the rate of inflation, when on the income side your grant is limited to inflation itself (if you're lucky). Lots of shiny glass means lots of grumpy window cleaners. Three guiding principles are worth following when it comes to managing your building, or any other hardware such as vehicles, IT or movable performing spaces:

- The first is to build up a financial contingency in the form of a maintenance fund to act as a buffer when the big bills come in (as they will). The size of the fund, and the pace at which you need to build it, can be determined by an assessment of likely work in the future – it is not rocket science to work out the life of the carpeting or seating in your auditorium.

- The second is to insure against the completely unforeseen. Again, this can be helped by doing a forward-looking risk assessment that looks at the likelihood and impact of different risks. If your organization is a charity, the trustees are obliged by law to produce a risk assessment.

- And the third, as with managing finances, is to build a team of staff who you can trust to manage the building efficiently and effectively.

As with managing finance, help and advice are available. The NCVO has a specialist facilities management support team (see www.ncvo-vol.org.uk/advice-support facilities).

Exercise

Imagine the trustees of your organization, or the one you know best, have asked for a risk assessment covering buildings, operations, public liability, finance and funding. You have never done a risk-assessment before. Find out how one is done (see below) and then complete one for the organization, showing the risks themselves and how you can mitigate them.

7.7 RISK MANAGEMENT

Ultimately, creativity is all about risk and you will need to know how to manage it. Risk is no more and no less than the possibility that things will go wrong and will do damage to a lesser or greater degree. The damage can be anything from critical failure, to financial loss, to someone getting killed in an accident. You will wish to guard against all three, but challengingly, the fewer risks you take, the less creative you will probably be. If you are a charity, your trustees have a legal obligation to undertake a risk assessment and to say that they done so in your statutory accounts.

Risk is creativity from the other end of the telescope, and the conditions that apply to creativity that we described in Challenge 5 also affect risk.

Like creativity, risk will always have a *context*: you will need to know the circumstances that will make a project or an activity risky, and just how risky it will be. There may be external threats, like the weather, or internal threats, such as an under-performing member of staff, and it is up to you to decide what the principal threats are. You will use this context as the basis of a *risk assessment*.

Risk comes in two dimensions, *probability* and *impact*. By probability we mean how likely it is that a risk will occur – or recur. By impact, we mean how much damage is likely to be done if the risk materializes. The simplest form of risk assessment lists the possibility of something going wrong in numerical order, from one for very unlikely to five for very likely, and a similar range for the potential damage. If you want to be clever, you can arrive at a single figure by multiplying the probability factor by the impact factor. This is by no means an exact science, but the very fact that you are trying to think systematically about what you are doing is important, because it may save you from financial grief – or even loss of life. Concentrate on realistic risks and especially on those you can do something about. There is not much point in agonizing about being hit by a meteorite, but every reason to guard against food poisoning in your café.

A typical risk assessment looks something like this (but remember, just because you have assessed the risks you face in the abstract, and have even written out a risk assessment, risks are real and writing them down doesn't make them go away):

Table 7.2 Risk assessment matrix

Risk	Likelihood 1–5	Impact 1–5	Total score	Proposed Mitigation
Loss of grant funding	2	5	10	Maintain frequent contact; diversify income sources
Business interruption (for instance, if the building closes because of a flood.)	1	5	5	Insurance; disaster procedures in place
Bad critical review	3	2	6	Chair has been briefed to handle adverse press.

The point about risk, especially when it comes to creativity, is not to avoid risk altogether because that is impossible, but to know how to manage it. Americans like to use an acronym ACAT, which means:

Avoid – don't take the risk

Control – do your best to minimize the impact of the risk

Accept – take the risk

Transfer – get someone else to take the risk, or to share it with you.

Avoiding the risk altogether won't be very creative, nor would transferring the risk entirely, but sharing risk, especially financial risk, with other partners or organizations in a collaborative manner can be useful – and lead to fresh ideas and projects.

If you are going to accept risk then, like creativity, it should have a specific *purpose*: you have to have a reason for doing something risky. Again, as with creativity, risk comes from the act of *making*: something has to be made to happen and often that means taking, not rejecting, a risk.

The management of risk is built on *expert knowledge and experience*, some of which will come from understanding *tradition*. It is also built on *discipline*: self-discipline, so that you control your own urge to take risks, and that you build at least informal risk assessments into your thinking, and organizational discipline, so that everyone knows and follows the rules and regulations, particularly about health and safety.

But don't be afraid of risk, especially creative as opposed to technical or financial risk. The management of risk is just part of the creative process of understanding *constraints*. Risk is just another problem to be solved. A high level of risk can create a strong bond between people in an organization, provided they all know they are sharing it, and they are sharing it equally. There is always the risk of failure, but success does not come without risk, and even if a project does fail there is always something called 'creative waste'. We know of business organizations that build in a 10 per cent creative waste factor. If a certain amount of the things the business is trying to do doesn't go wrong, the organization isn't learning and won't be earning.

165

Exercise

Make a risk assessment of all the things you did last weekend. The exercise at the end of section 5.8 in Challenge 5 was about the respective roles of producer and director in a new production. Now make a risk assessment for the production.

7.8 COMMUNICATIONS

Throughout this book we have emphasized the need for openness and trust, and that depends on good communications, both internal, within the organization, and external, with the rest of the world. Informally, that means looking people in the eye and telling the truth about what they need to know. You must bring that approach to the slightly more formal situation of office and board meetings that we discussed in section 7.4. Don't rely on emails, office memos and notice boards to get your message across.

The values that you present to your colleagues in the organization should be the same that represent the organization to the outside world. And that means knowing what your organization is *for*. One way to articulate this is to have a *mission statement*. This can be quite short and sweet; the Jacob's Pillow Dance Festival, held every summer at Becket in Massachusetts, is the oldest dance festival in the United States. Its mission statement reads like this:

> *The Jacob's Pillow mission is to support dance creation, presentation, education, and preservation; and to engage and deepen public appreciation and support for dance.*

At the other end of the scale Britain's National Theatre has not so much a mission statement as a job description:

> *The National Theatre is central to the creative life of the country. In its three theatres on the South Bank in London, it presents an eclectic mix of new plays and classics, with seven or eight productions in repertory at any one time. It aims constantly to re-energise the great traditions of the British stage and to expand the horizons of audiences and artists alike. It aspires to reflect in its repertoire the diversity of the nation's culture. At its Studio, the National offers a space for research and development for the NT's stages and the theatre as a whole. Through the NT Education Department, tomorrow's audiences are addressed. Through an extensive programme of Platform performances, backstage tours, foyer music, exhibitions, and free outdoor entertainment it recognises that the theatre doesn't begin and end with the rise and fall of the curtain. And by touring, the National shares its work with audiences in the UK and abroad.*

Clearly, no member of staff could remember this. You need something short, something that tries to combine both your organization's function and its values. All the operations of the Tate are summed up as:

> *To increase the public's knowledge, understanding and enjoyment of British art from the sixteenth century to the present day and of international modern and contemporary art.*

The Anvil, a concert venue in Basingstoke, Hampshire has an admirably succinct and easily remembered mission statement that sums up exactly what the organization is dedicated to achieving:

> *Great Music Live.*

Work out what your organization's functions and values are. You will discover that finding a way to express them simply and clearly is in itself a useful exercise in internal communication. It is worth kicking off a company or board awayday by reviewing the company mission statement (if it has one) and checking it against reality.

Exercise

Write a mission statement, no more than 50 words long, for the organization you know best, or would like to lead.

External communications

This is not the same as marketing, which we discuss in section 7.9, although you have to be good at both. External communications involves the way you deal directly with the public through your box office staff, front-of-house staff or simply the person who picks up the phone. You have to have a system for dealing with complaints and making sure they are dealt with quickly. Respond to letters and emails promptly and politely, and keep a log of both of brickbats and bouquets. The size of the organization will determine whose responsibility it is, but whoever is dealing with the complaint is dealing with it in your name. Complaints are exhausting and exasperating, but they are an important measure of how your organization is doing. Deal with them badly, or ignore them, and you do the business damage.

The same goes for the press. There will be times when you want to tell them something – the good news – and times when they want to find out something from you – usually the bad news. In both cases, keep it simple and keep it honest. Journalists are busy people, so a clear message is best. A press release, for instance, should never be longer than one side of A4 paper, with a short headline that will catch the reader's attention and sum up what you want to get across in a positive and active way. The key facts must be in the first sentence and the key dates in bold. A couple of quotes, from the chair or the CEO or a familiar name involved with the story, helps a lot for often journalists will do no more than rewrite your press release with a bit of added colour, which is why it is worth putting effort into getting the press release right. Make sure your contact details are on the release, at the bottom, and that the key people are available if the press does follow it up.

Whatever the circumstances, count yourself lucky if they do. There are four kinds of journalists that you will be dealing with: the critics, specialist arts reporters, news reporters and feature writers.

The only thing that matters about *critics* is to get them to come. They are your free publicity, even if what they write about you this time is hostile. They are keeping you on the map and in the public eye. Next time they may be nicer. Make sure they know your programme well in advance and do your best to accommodate their needs. But don't pester them. And never complain about a bad review: it only encourages them.

Specialist *arts reporters* are a fairly cynical bunch, so don't assume that they will be on your side because it is their business to write about culture. Because of the way that newspaper editors think, it will be crises and disasters that attract their interest, rather than good news. That can be to your advantage if you need someone to campaign on your behalf, but be careful about what you say. Give them the facts for which they ask and access, if that is right in your judgement, to the people to whom they want to talk. Journalists are always in a hurry, so help them, and be tolerant when they get things wrong. It helps to cultivate the specialist reporter when times are good, in the hope that they will be sympathetic when times are bad. The odd invitation, free ticket or bit of hospitality helps.

News reporters are even busier than arts correspondents, and they will almost certainly have no specialist knowledge. But they are still human beings and will respond to help rather than hindrance. They will be contacting you because there is a 'story'. That might be a negative story about you, such as a scandal around a performance, or about an organization you are connected with – maybe a funder has cut your grant. Try to discover what the reporter thinks the 'story' is, and the angle that their outlet is likely to have on it. You can't necessarily change the story, but in order to shape the reporter's understanding the best way is to give them the facts as you understand them. Sometimes it is necessary to go 'off the record', that is to say tell the reporter something that will affect their understanding of the story, but which they agree not to report. Never assume that they will not report it, somehow or other. All this calls for patience, but you must never lose your cool. As with the critics, complaining about the way you are reported is usually counter-productive, unless there are factual errors, in which case you can demand a correction – which they will print in small type at the bottom of page 48.

Feature writers are gold dust. If someone in your local or national newspaper wants to write a feature about your organization, or interview you or one of the creatives you are working with, you are getting what is known as free 'editorial' coverage that your advertising budget could never pay for. (This is even more so with TV and radio.) The same principles apply to them as to critics, arts correspondents or news reporters: try to give them as much information as you think they will need (background, press cuttings, previous reviews), give them the access they need, make them comfortable and let them get on with it. Journalists are in a different profession to you and they will respect you if you respect them.

Who handles the press?

This will depend on the size of the organization. Even quite small operations need someone who can handle both press and marketing, because your external image will profoundly affect your success. As always, the ultimate responsibility is yours. If you really are facing a crisis, it is important to brief your chair, board members and senior staff, and work out 'a line to take'. You have to agree who will talk to the press and make sure that only that person responds on the record to press enquiries. As your organization grows, it will need a dedicated *press officer*, to whom – because that is the name at the bottom of the press release with the mobile phone and other contact details – all enquiries will be made. The press officer is both a filter to the leadership of the organization and its public face, so that person has to have considerable emotional intelligence. It may be that you will need to hire in a public relations agency, but these are expensive, and you must watch out for tension between your own communications people and outside consultants. But never be afraid of using specialists to advise you, here as with other aspects of the business.

Public affairs

The bigger your organization becomes, the more important will be your relationships with other public bodies – your funders, and ultimately the government itself. Whatever the relative size of you and the body that is supporting you, good communications are essential. Much of this will be done privately, and in confidence, and you should try to build up the same atmosphere of trust that you would wish to have within your organization. In many ways, at both local and national level, politicians are like journalists: they are busy people with many other matters that concern them. And like journalists (only more so) they can materially affect the success of your organization. You need to understand their needs and their agenda. You also need to pick your fights. That means understanding who you are up against, which means cultivating your connections with them and learning to see which way the political wind is blowing. At the highest level, organizations will employ political lobbyists to keep them informed and to make their case. But whatever level you are operating on, you need to keep an eye on the political weather.

Communications – the brand

Whether you are communicating to individuals (including within your organization) or to the public at large, you need to be able to project an

image of the whole organization – its mission, its values and what it actually does – in a complete and accessible way that is known in the commercial world as 'the brand'. The brand, when you think of the associations of simple words like Nike or Google, has enormous commercial value. Some creative individuals, notably the artist Damien Hirst, have turned themselves into a brand where it is not so much the individual artwork that is being bought for its own sake as much an attachment to a certain reputation, celebrity – or even lifestyle. Hence, as in the case of Andy Warhol, the artist's individual touch is almost unnecessary and assistants carry out most of the work.

You should be thinking of the Cultural Value of what you do. If you become known for making a certain kind of work, and acquire a reputation for the quality of that work, every new piece of work that you do has a head start, and you will succeed in both the publicly funded and commercial sectors. The letters 'RSC' are the most recognized theatre name in the United Kingdom. The letters 'BBC' are one of the most powerful brands in the world.

Peer review

Finally, the value of your brand is created, not by you, but by what people think of you. For most of section 7.8 we have been talking about you communicating *to* people, individually or as an audience. But you have to be able to listen as well as talk. Ticket sales alone won't tell you what your audience really thinks about you. It is worth probing their thoughts more deeply by conducting an audience survey or, alternatively, getting someone to conduct a series of focus groups or set up citizen's juries.

If you really want to put yourself on trial, arrange a peer review. You will need to gather together a group of people whose work and ideas you respect – not more than ten – who may be in the same type of business as you, but who are not deadly rivals or likely to run off with your secrets. It helps if they represent a range of skills – finance, programming, marketing, etc. Persuade the one you trust the most to chair the review and then invite them into your organization, let them talk to anyone they want (without you being there), look through the books and talk to knowledgeable observers. It can be a disruptive process and it is best if it is done quite quickly, but however long it takes there should be a written report and some recommendations for improvement. A peer review can be quite painful, but it is better to inflict one on yourself rather than have one imposed on you, as can happen with government ministries and funding bodies.

Once the peer review is over, don't put it in a drawer and forget it. Act on its recommendations. These outside advisors have given their time and their ideas (usually for free), and they should be listened to.

Exercise:

* Write a one-page press release for an event that you want to promote.

* Your organization has been told that it will no longer be funded by the local government that has funded it since 1980. Write a one-page press release in response to this news.

7.9 MARKETING AND INTERACTIVITY

Give them good work, and a strong brand, and your marketing people can turn that into commercial success. Marketing, like finance and HR, is an immense subject with its own literature and its own professional structures and practices. In the UK the website of the Arts Marketing Association (www.a-m-a.org.uk) is a good place to start if you want to learn more about the subject – and you don't have to be in the UK to take advantage of it. They run workshops, conferences and meetings, produce publications and assist professional development. Wherever you are, it is likely that there is a local or national government organization – usually located within departments dealing with tourism – who are keen to help arts organizations with their marketing efforts by giving advice on marketing strategies, the implementation of those strategies, and how to collect and use data about audiences.

In the recent past there has been a big shift in marketing. Marketing culture used to be about getting information to potential audiences through brochures, flyers, print and other media. Selling tickets, increasing audience numbers and gaining 'new audiences' was the name of the game. 'Audience development' was about either creating a bigger audience or moving an existing audience into new territory – programming a Stockhausen piece between Haydn and Mozart, for example.

But all of these examples of marketing were predicated on the idea that the cultural organization was providing a predetermined product *to* an audience. The word 'delivery' – beloved by local and national governments – suggests that culture can be put in a package and sent from one person to another. But we all know that culture is not like that. Culture is really an interaction, something that is created together, in the space where the performer or

artwork meets the viewer or listener. Your website, for instance, isn't just a notice board: it is the start of a two-way communication.

In *The Art of With* (Leadbeater 2009, available at www.charlesleadbeater.net) the writer Charles Leadbeater describes a new contract between 'culture' and audience. His idea is that people want three things in relation to culture: Enjoy, Talk and Do. Sometimes they want to be fairly passive and to watch or listen or view; sometimes they want their culture to have a social element; and sometimes they want to participate, or make, or shape the experience for themselves. There is no moral hierarchy here, just the recognition of a changed reality, and many cultural organizations are responding to, and indeed anticipating, the direction of travel towards a more interactive culture. Now, as well as in the future, marketing will increasingly involve a relationship and a conversation with people. The idea of the arts organization having a series of transactions with its audience – selling tickets to them – will be replaced with that of a much richer relationship between them and their the public. 'Marketing' will feed back into programming and learning: the connection between the cultural expert or professional and the member of the public will become a two-way street, enriching the experience of both sides.

Exercise

You have just been appointed as the director of a museum in a small town. There are limited resources to promote the programme, but you do have a marketing assistant. Special exhibitions are advertised by placing flyers in public places like the library and the town hall, and by distributing them to shopkeepers. The museum's Friends' Society has a mailing list and flyers are also posted to those names. Attendance is not particularly impressive and your local government funders are keen to see the numbers increase. What are you going to do?

7.10 LEARNING

Learning is what the arts and culture are all about. There are two aspects to this. In the first place, culture is a learning activity – any cultural experience takes you somewhere new (you may have seen *Hamlet* twenty times, but there is always something fresh to find). This is why learning and education functions are not 'add-ons' to the main endeavour of cultural organizations, but lie at their heart. So individual self-development, as practitioner or punter, is key.

The second aspect of learning is that of *organizational* learning. As the RSC's Artistic Director Michael Boyd says, 'the person who has nothing to learn is certainly incapable of creative dialogue' (Boyd 2008). All organizations – in other words, everyone within them – should be learning all the time: learning from their mistakes, learning from each other and learning from the world around them. And don't forget more formal training, known in the trade as 'Continuous Professional Development'. This should be a line in your budget, and every member of staff should have an annual sum of money that they can spend on courses that will improve their skills. That includes you. It is a great way to refresh people, give them space to think about what they do and enhance their contribution as a result.

Since the 1960s, learning and education, sometimes referred to as 'outreach', have developed as specialisms within the cultural world, with their own professional associations and career paths. The movement began in the theatre, with Theatre in Education, or TiE, as it is known, with a parallel development in museums. There is a wealth of literature concerning learning within each specific cultural discipline, from dance to heritage. Many of the studies, such as Eilean Hooper-Greenhill's *What Did You Learn at the Museum today?* (Hooper-Greenhill 2005), are the result of evaluations of practice.

Nowadays, almost every cultural organization takes learning and education seriously and devotes some of its energies to working with schools or in the community. There are many cogent reasons why culture should form part of every child's education. In our view, a life cannot be lived fully without understanding and enjoying culture. But even from the narrowest of perspectives cultural organizations should be interested in education, because young people are the audiences of the future.

Over the last decade, a considerable body of evidence about the effects of cultural learning has been gathered, not least as part of the UK's Creativity, Culture and Education initiative – an independent charity that began life as 'Creative Partnerships', a scheme to bring professional artists into schools to work on arts projects. In Britain, with the arts being squeezed out of the school curriculum and being denied teaching funding in higher education, and with cultural organizations facing cutbacks, learning and education could face real difficulties that will cause long-term damage. One of your jobs as a creative leader will be to defend the next generation's right to a cultural life.

The way to do that is always to consider yourself a learner, leading a learning organization. The man who made the idea of the learning organization famous, Peter Senge (the former engineer and now director for Organizational

Learning at the Massachusetts Institute of Technology in Boston) defines a learning organization as one where:

> *People continually expand their capacity to create the results they truly desire, where new and expansive patterns of thinking are nurtured, where collective aspiration is set free, and where people are continually learning to see the whole together. (Senge 1990: 3)*

As we have argued throughout this book, this calls for an open and trusting form of leadership, where responsibilities are shared by the whole team, where ideas come from the whole team and where success belongs to the whole team. The only way for you and your organization to be able to adapt to the rapid changes that technology, politics and economics are bringing to what we have called the cultural sector – but which is really the whole of life – is to be flexible in your thinking and fleet of foot when you put your ideas into action. The way to stay fit for purpose is not to assume that you know it all, but to recognize there are always things to learn.

7.11 TOOLBOX

This whole challenge must feel like one long toolbox, as we took you through the practical skills that you will need to fulfil your mission. Those skills are individually different, but there are certain guiding principles that will help you put them into practice.

- Don't be afraid to seek out the best specialist advice: from your mentor, from a professionally qualified individual or from a professional organization that can recommend where to get help. Consider setting up a peer review.

- Respect that person or group's knowledge – while recognizing that the ultimate responsibility for a decision or action is your own.

- Respect is a form of trust, and you must do everything within and outside your organization to create an atmosphere of trust.

- To generate trust:
 - you must be ready to share risk;
 - you need a lot of patience;
 - you need to show openness;
 - you need to show enthusiasm.

Acquire all these skills – you must always be ready to learn.

7.12 CASE STUDY

You have just been appointed as the Director of a large regional museum, and you discover that the heads of departments guard their own areas of interest very closely. All expenditure is controlled by the Head of Finance, on the grounds that strict cost control is necessary, and little information is released to the rest of the organization. At board meetings, the Head of Finance reports directly to the Trustees. There is a tradition of having a weekly meeting, attended by the Museum Director, the Head of Finance and the Head of Programming. Each head of department is then responsible for communicating what happened at the meeting to staff within their own areas of responsibility. Curatorial staff report direct to you, Finance controls the building, HR, operations and catering; Programming controls Education and Marketing. As Director, you have ultimate responsibility for the programme. Your predecessor has already set up an eclectic programme of shows for the next three years, but has left a potential funding gap because sponsors rarely confirm their support that far ahead.

Question 1: What problems would you expect to encounter in an organization run in this way, and why would they occur?

Question 2: What actions can you take to improve the organization? Make a list of what needs to be done, and then rank the actions in three ways: decide on the most urgent, the most important and the ones that will give the most visible 'quick wins'.

7.13 SUMMARY

This challenge has been about acquiring the practical skills you need to put everything you have learned in this book – about yourself and about how creative organizations work – into practice. We have taken you through the principles of planning, decision-taking, running meetings, managing your money, coping with the demands of buildings as well as people, communications, marketing and learning – both as something your organization offers as an experience to other people and as an essential element in the way the organization itself is run. Each one of these aspects of creative leadership is a skillset in its own right, and you are going to have to be able to work with other people in an open and trusting way so that you know you can rely on their specialist knowledge. In our final challenge, we bring the principles that have guided this book together and offer a way for you to check that the organization you lead is doing its best to create Cultural Value.

7.14 READING AND RESOURCES

As we have pointed out while going through this challenge, there are plenty of places to go to for help with understanding financial issues and the management of third-sector companies. In Britain three really useful websites are those of the Charity Commission (www.charity-commission.gov.uk), the Directory of Social Change (www.dsc.org.uk), and the National Council for Voluntary Organisations (www.ncvo-vol.org.uk). Those three organizations also run some good training events that are well worth attending. If you want to do some reading, then look at Charity Commission publications CC8, *Internal Financial Controls for Charities* (Charity Commission 2010b); CC15 and CC15b, *Charity Reporting and Accounting: The Essentials* (Charity Commission 2007); and CC35, *Charities and Risk Management: A Guide for Trustees* (Charity Commission 2010a). From the NCVO, try the *Good Financial Management Guide for the Voluntary Sector* (National Council for Voluntary Organisations 2005).

Your bank and your accountant should also be helpful (though in our experience banks can also be extraordinarily *unhelpful* at times). Some accountants produce written advice and run training sessions. Two publications written by the UK accountant Kate Sayer are helpful: *Practical Guide to Financial Management* (Sayer 2007) and *Managing in a Downturn: Staying Solvent and Surviving Well* (Sayer 2009).

If you visit your local bookshop, or search online, you will find dozens of 'Accounting for buffoons'-type publications. Have a look at them and see which one suits your level of need and your capacity to endure business-book prose.

It's important to remember in all this, though, that rules and regulations change, and that the details of finance – though not the principles that underpin them – need regular updating.

The UK's Public Relations Consultants Association (www.prca.org.uk) offers contacts and training; the Chartered Institute of Public Relations (www.cipr. co.uk) provides professional qualifications and is part of the Global Alliance for Public Relations and Communication Management. The successive editions of Frank Jefkins' *Public Relations* (Jefkins 1998) since 1980 have offered a comprehensive introduction to the business. Nicholas Comfort's *How to Handle the Media* (Comfort 2003) is an amusing guide to being on the receiving end of media attention. For an example of a critical peer review, see Arts Council England, *Report of the Peer Review* (Arts Council England 2005).

The UK's Arts Marketing Association (www.a-m-a.org.uk) is a membership organization dedicated to raising professional standards in the field, and is a good place to go to find out about how to set about it. One of the few studies of how to charge for your work is Richard Ings' collection of essays, *Call It a Tenner: The Role of Pricing in the Arts* (Ings 2007). In 2010 a new website designed to help the cultural sector bring in more customers went online: www.theticketinginstitute.com.

The website of the Cultural Learning Alliance (www.culturallearningalliance. org.uk) provides a good portal into the subject of culture and learning, with plenty of case studies, data and links to specialist organizations that are involved in this area. You can sign up to the Alliance and keep abreast of what's happening – and the scene is changing fast.

The importance of creativity in education is evidenced (along with a lot of other data about cultural education) on the website of Creativity, Culture & Education (www.creativitycultureeducation.org). There is also lot of literature available about learning in museums from the website of the Group for Education in Museums (www.gem.org.uk) and also at Museums, Libraries and Archives' website, particularly the Inspiring Learning for All section (www. mla.gov.uk/what/support/toolkits/inspiring_learning_for_all).

Peter Senge's *The Fifth Discipline: The Art and Practice of the Learning Organization* (Senge 1990) and his *The Fifth Discipline Fieldbook* (Senge 1994) will take you through all you need to know about how to become a learning organization.

8 Challenge: Taking the Lead

'Leadership is the property and consequence of a community rather than the property and consequence of an individual leader.'
Keith Grint (Grint 2005: 38)

8.1 INTRODUCTION

So, you have read the book, done (some) of the exercises, worked through a case study or two and followed up on some of the links and further reading that we suggested. Do you still want to be a leader? Do you feel you have the entrepreneurial flair to cope with the very different conditions that are emerging in the cultural sector? Only you can answer that, but what we have tried to do is to get you to put yourself in the position of a cultural leader and a creative entrepreneur, and get you to work out these problems in your own mind. As we progressively took you through the challenges that you will face, we have offered our best advice on how to meet them but, in the end, leadership is something that you have to discover in yourself.

In this final challenge we offer no tests and no toolbox, but we do present one last triangle because we want to bring things together in such a way that you will be able to know whether the organization that you lead is creating Cultural Value.

8.2 HOW YOUR ORGANIZATION CONNECTS

In Challenge 4, at 4.6, we talked about Institutional Value as one of the three factors in generating Cultural Value. As a way into discussing how organizations can create that value, we need to look more closely at how

they connect both with the public in general and with individuals, especially individuals who are themselves part of the organization. An organization's interaction, with groups or individuals, can be expressed in terms of three kinds of relationship:

- Engagement

- Service

- Trust.

Engagement: by engagement we mean the interaction between an organization and its audience when it mounts a performance, stages an exhibition, issues a publication or provides a service of some kind – in other words, what it does when it performs its self-defined function as a cultural organization. More and more, this is a two-way process: it is launched by the organization, but has to be genuinely responsive to the needs and opinions of the audience. To really work, this engagement has to be judged successful both by the organization and its public. And that will depend not only on the competence of the organization and its willingness to respond, but the creative way in which it approaches that engagement.

Service: your organization will relate to your audiences, and other groups and institutions that you will be doing business with, in ways that extend well beyond simply doing what you do, your core activity. How members of the public are treated is almost as important in shaping their decision to support you as the quality and price of what you offer. You need to give them clear information, choice and, as we have argued already, an opportunity to influence what they are offered. As we saw in Challenge 7, at 7.9, marketing is a much more sophisticated form of communication than it once was, and you need to use all the possibilities that interactive technology offers. We are also talking about service in a quite literal sense: how you look after your audience, make them welcome, make them safe, make sure the washrooms are clean, the food is good and the coffee hot. Whether you are a for-profit or not-for-profit organization, you have genuinely to see yourself at the service of the interests of the public – because that is where your support has to come from. If you are a not-for-profit, when dealing with your stakeholders – which here will also mean purse-holders – you will need to give them the information they need, in the form that they need it, and when they need it.

Trust: productive engagement and good service will generate a sense of trust between your organization and its stakeholders, and a sense of loyalty from your public. It is hard to generate trust and it is difficult to quantify, but it

is the most important relationship of all and can easily be destroyed. Trust is a form of social capital – the more trust there is between individuals and groups in a society, the stronger it will be. In this case, trust creates a sense of identification between your organization and those with whom it connects, often expressed as a form of 'ownership' on the part of the public. That can be very helpful when times are hard and your public funding may be under threat. There are benefits to the community, too. Your organization can do more than entertain and stimulate people: it can contribute to local or national pride; it can add to a strengthened form of collective identity and local distinctiveness. Loss of trust is the quickest way to destroy your reputation, and diminish Cultural Value.

8.3 THE INSTITUTIONAL VALUE TRIANGLE

Engagement, service and trust are mutually supporting aspects of the relationship between an organization, its audience and its stakeholders. But how can we express the interdependence of these three values and translate them into practice? The answer is to set up another triangle, with three vectors to express the forms of interaction that will best produce them, namely:

- Creativity

- Continuity

- Care.

Creativity: we devoted a whole challenge to creativity, Challenge 5, but the point we want to make here is that you will achieve nothing if the primary creative purpose of your organization is not achieved. As we argued at section 5.9, different types of cultural organization will have different purposes and exercise different functions, from preserving the past as a museum or academy, to exploring the future, as part of the avant-garde. What matters is that they should perform that function in a creative way. They have to make sure that their cultural entrepreneurship does not gradually harden into bureaucracy. Becoming 'established' can sometimes be halfway to becoming brain dead. So, as we argued in Challenge 6, you have to be sure that your organization has the right kind of administrative structure and governance that will keep it fit for purpose (section 6.8), and that your board members are really contributing (section 6.9).

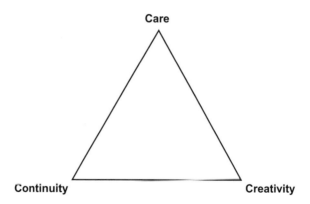

Figure 8.1 Institutional value triangle

Continuity: for an organization to remain creative, it must embrace change. Yet, paradoxically – and this shows that, like the other triangles in this book, the relationship between its vectors is always dynamic, allowing for different viewpoints at different times – organizations, while pursuing constant change in what they make, also have to deliver consistency of quality. An artist's reputation is not built on one canvas or a gallery's on one exhibition. It is in this context that precisely those bureaucratic procedures that can stifle creativity turn out to be needed to underpin it. As we argued in Challenge 7, order, reliability, good internal and external communications and, above all, financial responsibility are essential. A balance sheet (7.5) may only be a snapshot of the past, but no organization can rationally plan for the future without knowing where it has come from. That means not only making sure that all its management systems and record keeping are up to scratch, but there is a constant process of self-evaluation to make sure everything is working properly. You need long-term, consistently gathered information about yourselves and your audience.

You need this sound body of knowledge in order to be able to sustain your continuity. This relates to the service aspect of your relationship with your stakeholders, who need to know that your information is reliable. Similarly, there must be a consistent and reliable standard of service for your audiences. You can achieve that by learning from your experiences – you will, after all, be a 'learning organization' in both senses of the word (7.10) – and by valuing those who work with you. Consistency requires a secure sense of your place and purpose – your values (3.5) and that of your organization (3.6). You need to be able to tell a story about the organization that secures its identity across time. (It is remarkable how few organizations are aware of their history, even in the short term.) Your aim should be sustainability, which calls for sound management, investment in training and understanding risk (7.7). That does

not contradict the need for a cultural organization to constantly recreate itself, for that too is part of its continuity as it develops and grows.

Care: care means a lot more than knowing what the Health and Safety regulations are – though that is vital. True care is shown when an organization thinks of its dealings with its audience in terms of a relationship, not a transaction. This is nothing to do with not wanting to make a profit on your activities. As we argued in our introduction, not-for-profit organizations have to be aware of the bottom line just as much as anybody else. It is the attitude you bring with you that matters, and that includes an obligation not just to meet your audience's known needs, but to show some leadership by also offering the unfamiliar and challenging them with something new (we are back to creativity again).

By providing high quality work and good service, you will build up a relationship that will generate loyalty and trust. Good governance and good decision-taking (7.3), based on good planning (7.2), reinforces confidence in your organization. The principles of care apply equally internally as well as externally. As the sociologist Richard Sennett has argued:

> *Loyalty is a participatory relationship; no business plan alone, logical as it may be, will earn the loyalty of those on whom it is imposed, simply because the employees have not participated in its gestation. (Sennett 2006: 64)*

Employee loyalty will help you survive a downturn in the business cycle – and the shrinkage of public funding.

'Corporate responsibility' is a buzzword in commercial organizations, but this is much more important when the organization needs a measure of public subsidy to sustain its existence. The principle of care and the practice of service are not a threat to the professionalism or creativity of people working in cultural organizations. Their ability to deliver these values will depend on the kinds of expertise and skills that we have described in this book. In turn, the legitimacy of their position is reinforced by the positive response from the public. The public gives you your mandate, and the democratic political process has an entirely legitimate role to play. The challenge to you is actively to engage with this, creatively and consistently, providing service and gaining trust.

8.4 AN INSTITUTIONAL VALUE SCORECARD

Finally, somewhere between a toolbox and a case study, we offer a way to evaluate how well your organization is doing in terms of creativity, continuity and care. Different organizations will do things differently, with a greater emphasis on one or other dynamic. A museum will have a different overall mission to that of a community arts theatre company, and the evidence they will use and the outcomes they are seeking will differ. But all will have a mission, and all will be doing most of the things described below – or they should be. Some of these elements will contribute to the creation of more than one specific value. In all cases, what organizations do to promote their values is also a means of evaluating how successfully they are producing them. For instance, your mission statement will express your values, but you will also want to compare what you aspire to do with what you achieve.

The scorecard has another purpose: it is a checklist to use when thinking about the future, such as generating a strategic plan (7.2). The areas listed below and the evidence of progress they offer is a useful way to help design the specific policies that you need. Some of the information, such as box office returns or sales in your shop, can be expressed in figures; audience surveys, media reviews and peer reviews can produce quantitative and qualitative evidence; others will need more subtle qualitative analysis. To help you, we have referred back to places in the book where we have discussed the sort of issues we raise.

Creativity

The social and cultural dividend of creativity is generated through the core activity of the organization. It leads to *engagement* with audiences, and stakeholders more generally, making possible both self-expression on the part of artists, performers and the organization, and participation from the audience.

Ways to evaluate your creativity, as an approach, and in practice:

- Your mission statement. (7.8)

- Your programme. (5.9)

- Your audience figures. (6.7)

- A media review – how are the critics treating you? (4.8, 7.8)

- A peer review – how do others you respect rate you? (7.8)

- An artistic risk review – how edgy is your programme? (5.9)

- How diverse is your organization and your audience? (1.3, 2.12)

- When did you last review your management structure? (2.7, 2.12, 5.9)

- Your publications and website. (7.9)

- How much Intellectual Property have you created? (1.3, 5.10)

- Learning – how are your learning programmes doing, and are you yourselves learning? (7.10)

- How many and what kind of partnerships have you created with other organizations? (1.3)

- When did you last use an awayday to conduct a self-assessment – and what were the results? (7.4)

- What kind of contribution are you making to the local or national economy? (4.5)

- What awards have you won?

Continuity

The social and cultural dividend that comes from continuity takes the form of *service* to audiences and stakeholders; it can be found in the all-round 'health' of the organization, and the sense of engagement from its staff.

Ways to evaluate your continuity, as an approach, and in practice:

- The quality of your governance. (6.8, 6.9)

- Your strategic plan. (7.2)

- Your business plan. (7.2)

- Your information management, especially longitudinal data. (8.2)

- Your audience figures. (6.7)

- A media review. (4.8, 7.8)

- A peer review. (7.8)

- Your relationship with funders and the spread of funding sources. (1.8, 6.7)

- Your financial position and cash flow. (7.5)

- Do you give value for money? (3.2)

- Are you exploiting the Intellectual Property you have created? (1.3, 5.10)

- What is the rate of your staff turnover? (6.5)

- Are you investing in staff training? (7.10)

- How successful is your volunteer's programme? (5.2, 6.6)

- Do you have a friends' organization? (6.7)

- What is your contribution to the quality of life? (4.5, 4.10)

- What is your contribution to local distinctiveness? (1.4)

- What is the value of your brand? (7.8)

Care

The social and cultural dividend comes in the form of *trust*, the growth of social capital, trust from stakeholders, loyalty from staff and audience, and positive responses to the organization.

Ways to evaluate your care, as an approach, and in practice:

- Audience surveys. (7.9)

- Media reviews. (7.8)

- Peer review. (7.8)

- Focus groups. (7.8)

- Citizen's juries. (7.8)

- Your learning programme. (7.10)

- Your volunteers. (6.6)

- Your friends' organization. (6.7)

- The extent of your networks. (1.7)

- The amount you receive in donations. (1.8, 6.7)

- Your contribution to the quality of life. (4.5, 4.10)

- Your Health and Safety record. (8.3)

- Your impact on the environment. (3.11)

You will find other ways in which you will be able to evaluate the success of your organization, and your contribution to it through your creativity and leadership. It is up to you to work out what they are. Remember that cultural leadership is one of the most rewarding and exciting things anybody can take responsibility for. There is immense satisfaction to be had from helping the public connect with the culture of the past and with the art that is being created right now. There are wonderful moments awaiting you as you watch your organization and your staff perform at their best. But you will feel most satisfied, and justifiably proud, when you know that you have done your own job well.

The exercises are over. It is time for you to take the lead.

Bibliography

Americans for the Arts (2009) 'Arts & Economic Prosperity III Calculator', www. artsusa.org/information_services/research/services/economic_impact/005. asp.

Anderson, Derrick and Allison, Martyn (eds) (2007) *Inspiring our Ambitions through Sport, Art, Culture and Place*, London: Solace Foundation.

Arts & Business (2011), press release, 27 January.

Arts Council England (2005) *Report of the Peer Review*, London: Arts Council England.

Arts and Health: An International Journal for Research, Policy and Practice, London: Routledge.

Arts Council England (2011) *Regularly Funded Organisations: Key Data from the 2009/10 Annual Submission*, London: Arts Council England.

Association of Chief Executives of Voluntary Organisations (2007) *A CEO's Guide to Board Development*, London: Association of Chief Executives of Voluntary Organisations.

Bakshi, Hasan, Freeman, Alan and Hitchen, Graham (2009) *Measuring Intrinsic Value*, www.missionmodelsmoney.org.uk.

Bannerman, C., Sofaer, J. and Watt, J. (2007) *Navigating the Unknown: The Creative Process in Contemporary Performing Arts*, London: Middlesex University Press.

Barrett, Richard (2009) *Values Based Leadership*, www.valuescentre.com/docs/ ValuesBasedLeadership.pdf.

Belbin, R. Murray (1993) *Team Roles at Work*, Oxford: Butterworth-Heinemann

Belfiore, Eleonora and Bennett, Oliver (2008) *The Social Impact of the Arts: An Intellectual History*, Basingstoke: Palgrave Macmillan.

Bennis, W. (1989) *On Becoming a Leader*, Reading, MA: Addison-Wesley Publishing.

Bilton, Chris (2006) *Management and Creativity: From Creative Industries to Creative Management*, Oxford: Blackwell

Boden, M. (1990) *The Creative Mind: Myths and Mechanisms*, London: Weidenfeld and Nicolson.

Boyd, Michael (2008) Speech at New York Public Library, 20 June.

Brown, Alan S. and Novak, Jennifer J. (2007) *Assessing the Intrinsic Impacts of a Live Performance*, WolfBrown/Engage, www.wolfbrown.com/mups_downloads/Impact_Study_Final_Version_Summary_Only.pdf.

Carey, John (2005) *What Good are the Arts?* London: Faber.

CASE (2009) Culture and Sport Evidence Programme, www.culture.gov.uk/case/case.html.

Castells, Manuel (1996) *The Rise of the Network Society*, Oxford: Blackwell.

Charity Commission (2005) *The Essential Trustee: What You Need to Know*, publication CC3, London: Charity Commission.

Charity Commission (2007a) *Charity Reporting and Accounting: The Essentials*, publication CC15 and CC15b, London: Charity Commission.

Charity Commission (2007b) *Trustees, Trading and Tax*, publication CC35, London: Charity Commission.

Charity Commission (2008a) *Trustee Expenses and Payments*, publication CC11, London: Charity Commission.

Charity Commission (2008b) *Registering as a Charity*, publication CC21, London: Charity Commission.

Charity Commission (2010a) *Charities and Risk Management: A Guide for Trustees*, publication CC26, London: Charity Commission.

Charity Commission (2010b) *Internal Financial Controls for Charities*, publication CC8, London: Charity Commission.

Christakis, N. and Fowler, J. (2009) *Connected: The Amazing Power of Social Networks and How They Shape our Lives*, London: Harper Press.

Comfort, Nicholas (2003) *How to Handle the Media*, London: Politico's.

Cowling, J. (ed.) (2004) *For Art's Sake? Society and the Arts in the 21st Century*, London: Institute for Public Policy Research.

Daloz, L. (1986) *Effective Teaching and Mentoring – Realising the Transformational Power of Adult Learning Experiences*, London: Jossey-Bass.

DCMS (1998) *Creative Industries Mapping Document*, London: DCMS.

DCMS (2003) *Building Tomorrow: Culture in Regeneration*, London: DCMS.

DCMS (2004) *Culture at the Heart of Regeneration*, London: DCMS.

DCMS (2005) *Culture at the Heart of Regeneration: Responses*, London: DCMS.

Demos (2003) *Valuing Culture*, conference papers, www.demos.co.uk/publications/valuingculturespeeches.

Eastwood, Mike (2010) *Charity Trustees Handbook*: London, Directory of Social Change.

Farber, D. (2005) *From Option to Opening: A Guide to Producing Plays Off Broadway*, New York: Limelight Editions.

Fishel, David (2003) *Boards that Work*, London: Directory of Social Change.

190

Florida, Richard (2002) *The Rise of the Creative Class and How It's Transforming Work, Leisure, Community and Everyday Life*, New York, NY: Basic Books.

French, John and Raven, Bertram (1959) 'The Bases of Social Power', in D. Cartwright (ed.) *Studies in Social Power*, Ann Arbor, MI: University of Michigan Press.

Goleman, Daniel (1996) *Emotional Intelligence*, London: Bloomsbury.

Grint, Keith (2005) *Leadership: Limits and Possibilities*, Basingstoke: Palgrave Macmillan.

Hagoort, Giep (2000) *Arts Management Entrepreneurial Style*, Delft, Netherlands: Eburon.

Hartley, John (ed.) (2005) *Creative Industries*, Oxford: Blackwell.

Hesmondhalgh, David (2007) *The Cultural Industries* (second edition), London: Sage.

Hewison, Robert (2006) *Not a Sideshow: Leadership and Cultural Value*, London: Demos, www.demos.co.uk/publications/notasideshow.

Hewison, Robert and Holden, John (2004) *Challenge and Change: HLF and Cultural Value*, London: Demos, www.demos.co.uk/publications/challengeandchange.

Hewison, R., Holden, J. and Jones, S. (2010) *All Together: A Creative Approach to Organisational Change*, London: Demos, www.demos.co.uk/publications/all-together.

Heywood, Vikki (2010) 'Job Ladder', *Arts Professional*, No.211 (15 February), p.6.

Higher Education Academy Art Design Media Subject Centre and NESTA (2007) *Creating Entrepreneurship: Higher Education and the Creative Industries*, Brighton: Higher Education Academy Art Design Media Subject Centre and NESTA, http://www.adm.heacademy.ac.uk/projects/adm-hea-projects/creating-entrepreneurship-entrepreneurship-education-for-the-creative-industries.

Hill, Leslie (2009) Interview, *Guardian*, 30 July.

Hodgson, Geoffrey (2006) 'What are institutions?', *Journal of Economic Issues*, Vol.XL, No.1 (March).

Holden, John (2004) *Capturing Cultural Value*, London: Demos, www.demos.co.uk/publications/culturalvalue.

Holden, John (2006) *Cultural Value and the Crisis of Legitimacy*, London: Demos, www.demos.co.uk/publications/culturallegitimacy.

Holden, John (2008) *Democratic Culture*, London: Demos, www.demos.co.uk/publications/democraticculture.

Hooper-Greenhill, E. (2005) *What Did You Learn at the Museum Today?* London: Museums, Libraries and Archives Council.

Horne, M. and Stedman Jones, D. (2001) *Leadership: The Challenge for All?* London: Institute of Management and Demos.

Howkins, J. (2001) *The Creative Economy: How People Make Money from Ideas*, London: Penguin.

Hudson, Mike (2003) *Managing at the Leading Edge*, London: Directory of Social Change.

Hutter, Michael and Throsby, David (eds) (2008) *Beyond Price: Value in Culture, Economics and the Arts*, Cambridge: Cambridge University Press.

IFACCA (2006) *Art and Culture in Regeneration: D'Art Topics in Cultural Policy*, No.25, www.ifacca.org.

Independent Theatre Council, Society of London Theatre, Theatrical Management Association (2005) *Capturing the Audience Experience: A Handbook for the Theatre*, London: New Economics Foundation, www.itc-arts. org/page204.aspx.

Ings, Richard (ed.) (2007) *Call It a Tenner: The Role of Pricing in the Arts*, London: Arts Council England.

James, Clive (2008) *Cultural Amnesia*, London: Picador.

Jefkins, Frank (1998) *Public Relations* (5th edition, revised by David Yadin), London: Pearson.

Jonas, Peter (2006) Interview, *In Tune*, BBC Radio 3, 28 August.

Jura Consultants (2005) *Bolton's Museum, Library and Archive Services: An Economic Valuation*, Edinburgh: Jura Consultants.

Kaiser, Michael (2009) 'Artistic Directors versus Executive Directors', *Huffington Post*, 24 August, www.Huffingtonpost.com.

Knell, John (2007) *The Art of Living*, London: Mission, Models, Money, www. missionmodelsmoney.org.uk/papers/the-art-of-living.

Knell, John and Oakley, Kate (2007) *London's Creative Economy: An Accidental Success?* London: Work Foundation.

Koestler, Arthur (1975) *The Act of Creation*, London: Picador.

Kotter, J.P. (1990) *A Force for Change: How Leadership Differs from Management*, New York, NY: Free Press.

Kouzes, James and Posner, Barry (2007) *The Leadership Challenge* (4th edition), Hoboken, NJ: Jossey-Bass.

Landry, C. and Matarasso, F. (1996) *The Art of Regeneration: Urban Renewal through Cultural Activity*, York: Joseph Rowntree Foundation, www.jrf.org.uk/ publications/art-regeneration-urban-renewal-through-cultural-activity.

Landry, C. and Matarasso, F. (1999) *Balancing Act: 21 Strategic Dilemmas in Cultural Policy*, Council of Europe Policy Note No.4, Strasbourg: Council of Europe.

Lavender, A. (2001) *Creative Producing: A User's Guide*, London: Central School of Speech and Drama.

Leadbeater, Charles (2000). *Living on Thin Air: The New Economy with a Blueprint for the 21st Century*, London: Penguin.

Leadbeater, Charles (2009) *The Art of With*, Manchester: Cornerhouse, www. charlesleadbeater.net and www.cornerhouse.org/media/Learn/The%20 Art%20of%20With.pdf.

Leadbeater, Charles and Oakley, Kate, (1999) *The Independents: Britain's New Cultural Entrepreneurs*, London: Demos.

Local Government Association (2008) *A Passion for Excellence: An Improvement Strategy for Culture and Sport*, London: Local Government Association, www.lga.gov.uk/lga/publications/publication-display.do?id=337596.

Man, John (2010) *The Leadership Secrets of Genghis Khan*, London: Bantam.

Marshall, C., Prokesh S. and Weiser C. (1995) 'Competing on Customer Service: An Interview with British Airways' Sir Colin Marshall', *Harvard Business Review*, 1 November.

Marturano, A. and Gosling, J. (eds) (2007) *Leadership, The Key Concepts*, London: Routledge.

Matarasso, François (1997) *Use or Ornament*, Stroud: Comedia, http://web.me.com/matarasso/one/downloads/Entries/2009/2/19_Use_or_Ornament.html.

McCarthy, H., Miller P. and Skidmore, P. (eds) (2004) *Network Logic: Who Governs in an Interconnected World?* London: Demos, www.demos.co.uk/publications/networks.

McCarthy, Kevin, Ondaatje, Elizabeth, Zakaras, Laura and Brooks, Arthur (2004) *Gifts of the Muse: Reframing the Debate About the Benefits of the Arts*, Santa Monica, CA: Rand Corporation, www.rand.org/pubs/monographs/MG218.

McLeod, Angus (2003) *Performance Coaching – The Handbook for Managers, H.R. Professionals and Coaches*, Carmathan and New York, NY: Crown House.

McMaster, Brian (2008) *Supporting Excellence in the Arts – From Measurement to Judgement*, London: Department for Culture, Media and Sport.

Mintzberg, Henry (1973) *The Nature of Managerial Work*, New York, NY: Harper & Row.

Moore, M.H. (1995) *Creating Public Value: Strategic Management in Government*, Cambridge, MA: Harvard University Press.

Mulder, Bert (1998) 'Towards a Creative Society', in Ray Orley and Jennifer Williams (eds) *Common Threads: The Arts for Life*, London: British-American Arts Association.

Mulgan, Geoff (2005) *The Other Invisible Hand: Remaking Charity for the 21st Century*, London: Demos.

Museums, Libraries and Archives Council (2008) 'Inspiring Learning For All' toolkit, www.inspiringlearningforall.gov.uk.

Myerscough, John (1988) *The Economic Importance of the Arts in Britain*, London: Policy Studies Institute.

National Council for Voluntary Organisations (2005) *The Good Financial Management Guide for the Voluntary Sector*, London: National Council for Voluntary Organisations.

National Council for Voluntary Organisations (2008) *The Good Trustee Guide*, London: National Council for Voluntary Organisations.

National Council for Voluntary Organisations (2010a) *The Good Guide to Employment*, London: National Council for Voluntary Organisations, www.ncvo-vol.org.uk.

National Council for Voluntary Organisations (2010b) *Providing Training for Volunteers*, London: National Council for Voluntary Organisations, www.ncvo-vol.org.uk/advice-support/workforce-development/hr-employment-practice/managing-volunteers/providing-training.

National Health Service (2007) 'East Kent Hospitals' mentoring policy', quoting Daloz (1986), www.ekhut.nhs.uk/EasySiteWeb/GatewayLink.aspx?alId=21628, accessed 22 June 2009.

Negus, Keith and Pickering, Michael (2004) *Creativity, Communication and Cultural Value*, London: Sage.

Oakley, Kate (2009) *'Art Works' – Cultural Labour Markets: A Literature Review*, Newcastle upon Tyne: Creativity Culture and Education.

Office of the Third Sector (2006) *Charities Act 2006: What Trustees Need to Know*, London: Office of the Third Sector, www.cabinetoffice.gov.uk.

Pink, Dan (2010) *Drive: The Surprising Truth about What Motivates Us*, Edinburgh: Canongate.

Pope, Rob (2005) *Creativity: Theory, History, Practice*, London: Routledge.

Ross, Andrew (2003) *No Collar: The Humane Workplace and Its Hidden Costs*, New York, NY: Basic Books.

Rothwell, Brian (2007) *Leadership 101*, London: Directory of Social Change.

Sayer, Kate (2007) *Practical Guide to Financial Management*, London: Directory of Social Change.

Sayer, Kate (2009) *Managing in a Downturn: Staying Solvent and Surviving Well*, London: Directory of Social Change.

Seabright, James (2008) *So You Want to Be a Theatre Producer?* London: Nick Hern Books.

Seltzer, K. and Bentley, T. (1999) *The Creative Age: Knowledge and Skills for the New Economy*, London: Demos.

Selwood, Sara (2002) 'The Politics of Data Collection', *Cultural Trends*, No.47, London: Policy Studies Institute.

Senge, Peter (1990) *The Fifth Discipline: The Art and Practice of the Learning Organization*, New York, NY: Doubleday.

Senge, Peter (1994) *The Fifth Discipline Fieldbook: Strategies and Tools for Building a Learning Organization*, London: Nicholas Brearley.

Sennett, Richard (2006) *The Culture of the New Capitalism*, New Haven, CT: Yale University Press.

Sennett, Richard (2007) *The Craftsman*, London: Allen Lane.

Sonnenfeld, Jeffrey (ed.) (1995) *Concepts of Leadership*, Aldershot: Dartmouth Publishing.

Stage One (n.d.) *So You Wanna Be a Producer?*, www.stageone.uk.com/guide.

Taylor, S. (2005) 'To Provide the Best Customer Service, Put Customers Second', McCombs School of Business, www.mccombs.utexas.edu/news/pressreleases/barrett_wrap.asp.

Thelwall, Sarah (2009) 'Cultural Entrepreneurship', *Arts Professional*, No.185 (12 January), p.7.

Thomas, Marilyn Taft (2008) *Leadership in the Arts: An Inside View*, Bloomington, IN: Authorhouse.

Throsby, David (2002) *Economics and Culture*, Cambridge: Cambridge University Press.

Throsby, David (2003) 'Determining the Value of Cultural Goods: How Much (or How Little) Does Contingent Valuation Tell Us?', *Journal of Cultural Economics*, Vol.27, Nos 3–4 (November).

Throsby, David (2010) *The Economics of Cultural Policy*, Cambridge: Cambridge University Press.

Tyndall, Kate (2007) *The Producers: Alchemists of the Impossible*, London: Arts Council England/Jerwood Foundation.

van Noord, Gerrie (2002) *Off Limits: 40 Artangel Projects*, London: Merrell/Artangel.

Wai-Packard, Becky, (2009) *Definitions of Mentoring*, Advance Science Serving Society, http://ehrweb.aaas.org/sciMentoring/Mentor_Definitions_Packard.pdf.

Whitaker, Claire (2008) 'The implications of working in a mixed economy for creative practice in the performing arts: with special reference to The Sage Gateshead, Sadler's Wells and Bigga Fish', MA Thesis, London: Department of Cultural Policy and Management, City University London.

Williams, Raymond (1983) *Keywords: A Vocabulary of Culture and Society* (revised edition), London: Fontana.

Work Foundation (2007) *Staying Ahead: The Economic Performance of the UK's Creative Industries*, London: Work Foundation.

Index

If you have found this book useful you may be interested in other titles from Gower

Gower Handbook of Leadership and Management Development
Edited by
Jeff Gold, Richard Thorpe and Alan Mumford
Hardback: 978-0-566-08858-2
e-book: 978-0-7546-9213-3

Bullying in the Arts
Vocation, Exploitation and Abuse of Power
Anne-Marie Quigg
Hardback: 978-1-4094-0482-8
e-book: 978-1-4094-0483-5

The Ashgate Research Companion to Heritage and Identity
Edited by
Brian Graham and Peter Howard
Hardback: 978-0-7546-4922-9
e-book: 978-0-7546-8807-5

Visit **www.gowerpublishing.com** and

- search the entire catalogue of Gower books in print
- order titles online at 10% discount
- take advantage of special offers
- sign up for our monthly e-mail update service
- download free sample chapters from all recent titles
- download or order our catalogue

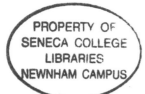